IMAGES
of America

LAKE OF THE OZARKS

VINTAGE VACATION PARADISE

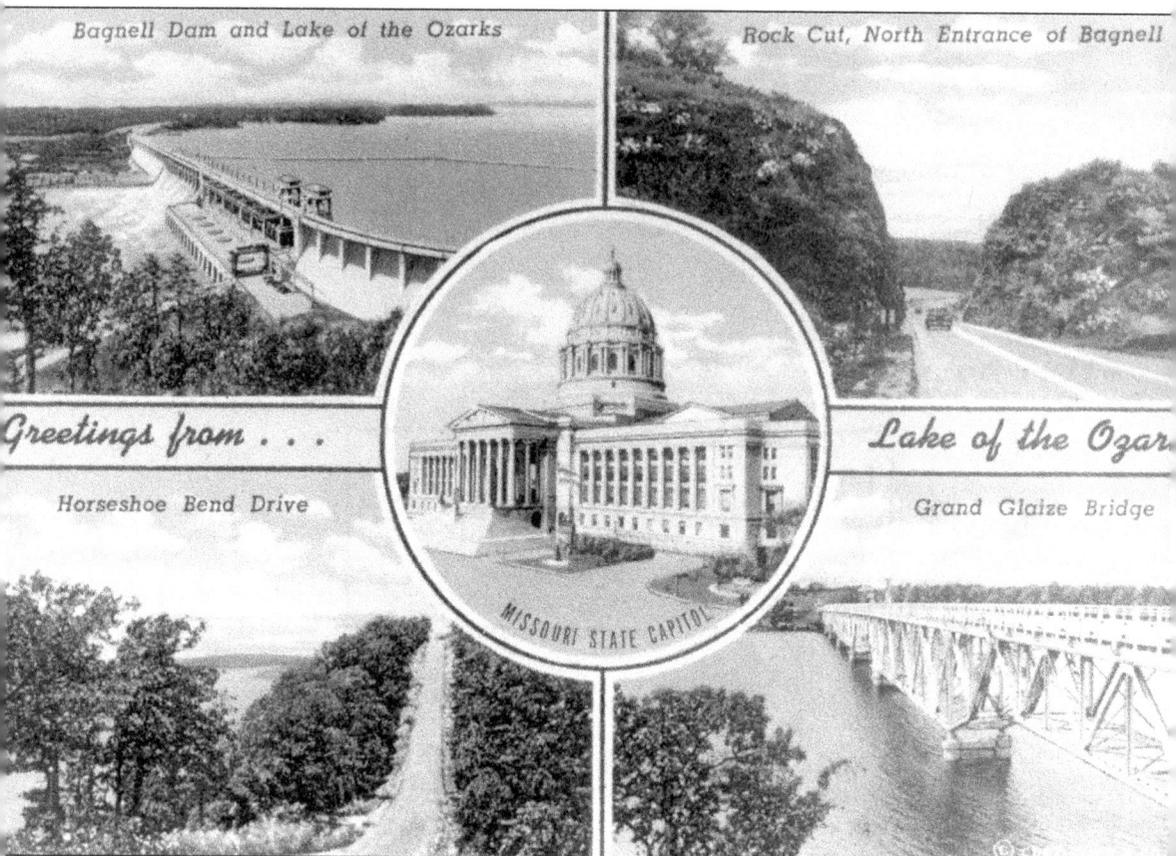

Bagnell Dam and Lake of the Ozarks

Rock Cut, North Entrance of Bagnell

Greetings from . . .

Horseshoe Bend Drive

MISSOURI STATE CAPITOL

Lake of the Ozar.

Grand Glaize Bridge

A popular Lake of the Ozarks greetings postcard sold throughout the lake region in the 1950s. The center photo is the Missouri State Capitol. Pictured in the postcard are (top left) Bagnell Dam, (top right) North Approach to Bagnell Dam through the U.S. Hwy. 54 road cut, (bottom left) Horseshoe Bend, and (bottom right) Grand Glaize Bridge.

This book is dedicated to the men and women of the 1950s and '60s who came to the Lake of the Ozarks and provided the lake area with a variety of roadside attractions that no longer exist. They brought fun and entertainment to thousands of vacationers and left a legacy of wonderful memories and images.

IMAGES
of America

LAKE OF THE OZARKS

VINTAGE VACATION PARADISE

H. Dwight Weaver

ARCADIA
PUBLISHING

Published by Arcadia Publishing
Charleston, South Carolina

Library of Congress Catalog Card Number: 2002101265

For all general information contact Arcadia Publishing at:
Telephone 843-853-2070
Fax 843-853-0044
E-mail sales@arcadiapublishing.com
For customer service and orders:
Toll-Free 1-888-313-2665

Visit us on the Internet at www.arcadiapublishing.com

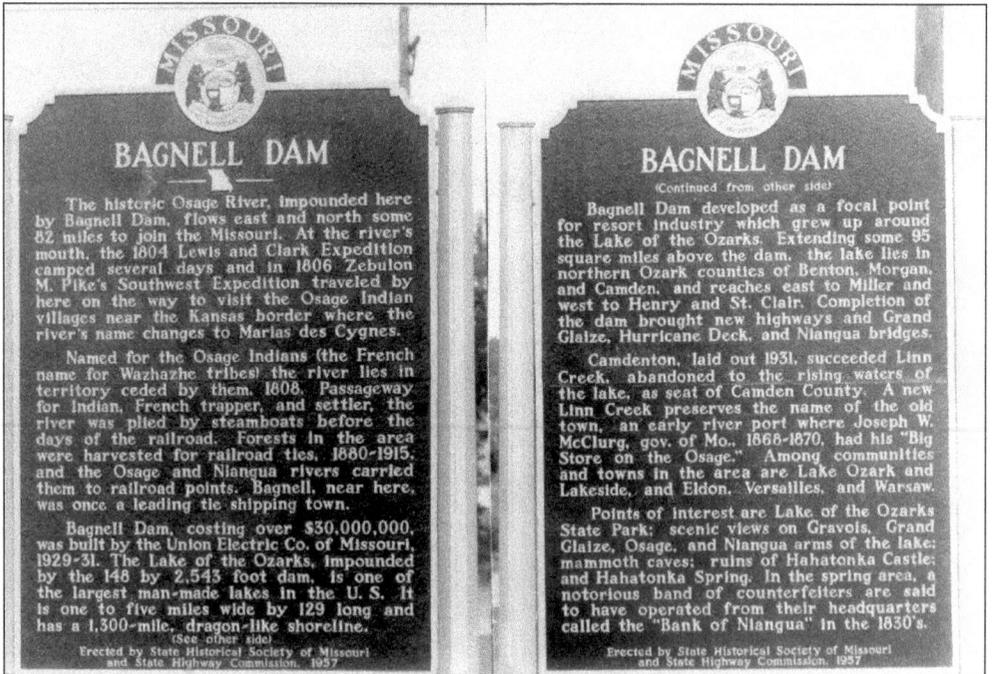

This historical marker was erected in the Lake of the Ozarks area in 1957 by the State Historical Society of Missouri and the State Highway Commission. Both sides were used as a single picture on this real photo postcard made by the late Frank E. Gress, a local photographer, and sold by various resorts and gift shops in the lake area.

CONTENTS

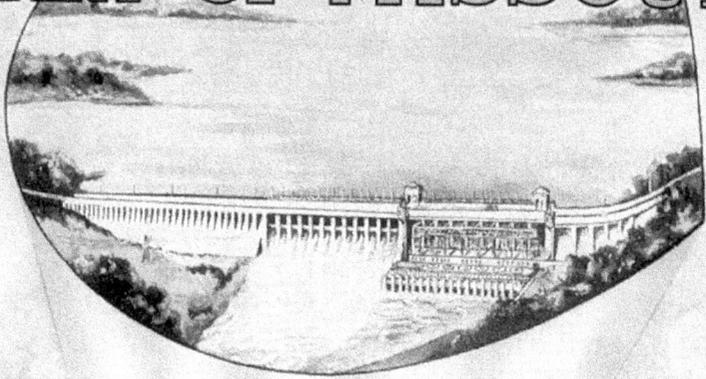

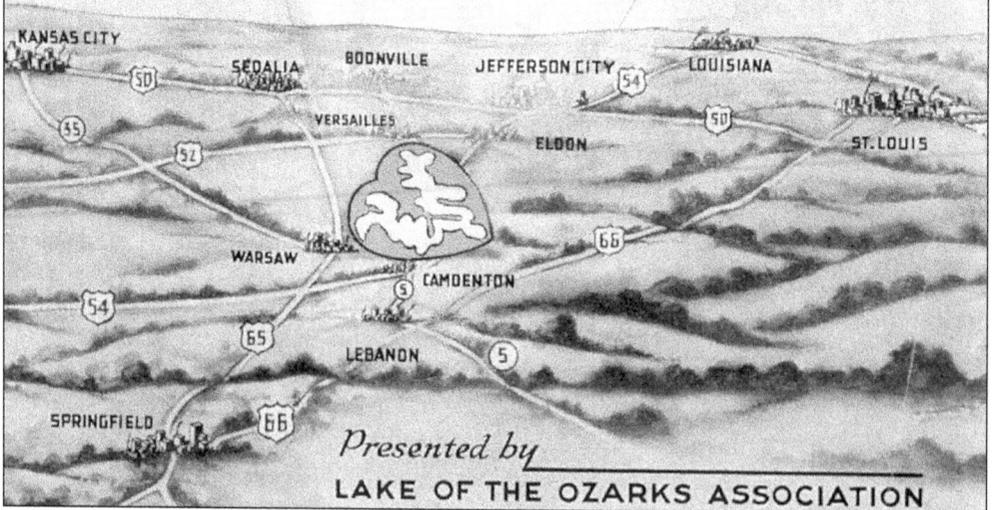

Front cover of the 1939 Lake of the Ozarks Association 74-page promotional booklet. The booklet features business ads and maps for the region.

INTRODUCTION

Lake of the Ozarks is Mid-America's premier family vacation and fishing destination—and for good reason. The lake covers 54,000 acres and is fed by three ancient rivers: the Osage, Big and Little Nianguas, and the Glaize. It is set deep into the heart of rolling, forested hills of emerald oak green and bordered by majestic, erosion-chiseled bluffs of Ozark bedrock. Alluring caves and springs can be found in the hills all around the lake, which offers a scenic panorama and a multitude of leisure and water activities that excite and enchant its visitors. It is a haven for sport fishing and a superb vacation paradise.

The word "paradise" was first used by ancient Persians to describe their luxurious summer resorts around the Persian Gulf and later borrowed by the Greeks for a similar purpose. It is the perfect word to describe the Lake of the Ozarks, which attracts millions of Ozark-loving people to its tranquil hills, forested shoreline, and luxurious resorts every year. And they come for a million different reasons.

The men of the Union Electric Company who looked upon this land early in the 20th century and imagined its hydro-electric potential and then set to work to build Bagnell Dam were visionaries of their day. They dreamed of more than electrical power for industry. They also wanted to create a marvelous recreational Ozark playground with a vast and beautiful lake at its heart. Dam construction was hardly underway in August of 1929 when they formed the Union Electric Land and Development Company to encourage recreational development. They built the first luxury hotel, the first rental cabins, the first boat dock, the first lakeside restaurant, and established the first speedboat and excursion boat service. That was all the spark that was needed despite the fact that it was the beginning of the Great Depression. The flame of inspiration had been kindled, and the lake has since seen three full generations of growth and development that has transformed the region into a true vacation paradise for all of Mid-America.

Many in each generation of visitors, it seems, begin their love affair with the lake as a child when their parents bring them to the lake to fish, swim, boat, and indulge in all of the whims and recreations that the vacation paradise has to offer. They grow up, marry, and return to the lake with their own children and so the cycle continues. The years pass and their passions for the lake grow and the paradise becomes irresistible. More and more of them make Lake of the Ozarks first a summer home instead of just a few days fling and then a permanent home as retirement approaches. But something else also happens as they age; they begin to remember what it was like in the "old" days when they were young. Oh my, how the lake has changed, they say. Do you remember when...?

Lake of the Ozarks: Vintage Vacation Paradise is the "remember when." It explores some of the memories and images of the first two generations. As the travelogue of images in this book unfolds, it follows U.S. Hwy. 54 west from Eldon to Camdenton, and then north on Hwy. 5 to Versailles, and finally ends at Warsaw at the headwaters of Lake of the Ozarks, 91 miles to the west upstream from Bagnell Dam.

In this book, you will find visual reminders of the Ozark rock masonry building styles of the 1930s and '40s that have left us giraffe rock and cobblestone edifices to admire, and from an even earlier period, rustic suspension bridges. They tie together the extreme ends of Lake of the Ozarks from the upper end of the Grand Glaize Arm to Warsaw at the foot of Truman Dam.

People came to the lake in the 1930s and '40s to fish, hunt, dine, and dance to get their minds off the troubles of their day—the Great Depression of the 1930s and World War II of the 1940s.

The 1950s and '60s are among the most romantic of the early days at the Lake of the Ozarks for they were the heydays of mom-and-pop attractions that proliferated along the highways and in the towns of the lake region. There were private roadside animal parks to enjoy, remarkable new show caves to tour, strange mystery houses where gravity didn't seem to work right, water ski shows with incredibly talented young people doing daring stunts, romantic excursion boat cruises, raucous graduating high school senior classes inundating the region in the spring, thriving scout camps, lively square dancing activities, country music shows with local entertainers, and some of the finest rodeo entertainment ever staged in the Ozarks. A vacationer could even tour Bagnell Dam free of charge any day of the week and see its innermost workings.

Here also are captured images of two ghost towns that are legendary at Lake of the Ozarks—Damsite and old Linn Creek—as well as historic images of the area's most outstanding natural wonder: Ha Ha Tonka.

Lake of the Ozarks: Vintage Vacation Paradise takes you back to the days of your parents and grandparents to relive in memory and images some of the reasons why they, too, found Lake of the Ozarks a playground for all seasons and all occasions.

One

ELDON, AURORA SPRINGS, AND EL RANCHO JUNCTION

In 1931, Eldon, 12 miles north of Bagnell Dam, began promoting itself as the northern gateway to Lake of the Ozarks on U.S. Hwy. 54. Iowa and Illinois are large markets for the lake. Most people who came to the lake from these two states in the early years came by way of Hwy. 54.

"The town of Eldon is a wide awake town…," said a 1940 promotional map. "Here you will find all the conveniences of the city, yet, the quiet of the country, good hotels and camps, service stations, stores, garages…and the…headquarters for the Ozark Information and Service Bureau."

By the 1960s, Eldon boasted of having two railroads, two bus lines, various agricultural and industrial enterprises, nine motels, eleven restaurants, and a string of roadside attractions and nightclubs along Hwy. 54 south of town. It also had the first Model Air Park ever built in a small community.

Tourism was very much a family phenomenon in the 1950s and '60s. The farmers of Iowa and Illinois found Eldon attractive because it was so much like the towns from which they came. On weekends, the motels filled up. But in the 1970s, major highway construction bypassed Eldon, which had a serious impact upon tourist-oriented businesses. Today, the railroads and roadside attractions are gone, but the town is growing and still very much a part of the lake's economic fabric. The modern pursuit of antiques and collectibles has overtaken the community and brought to town a whole new kind of tourism industry.

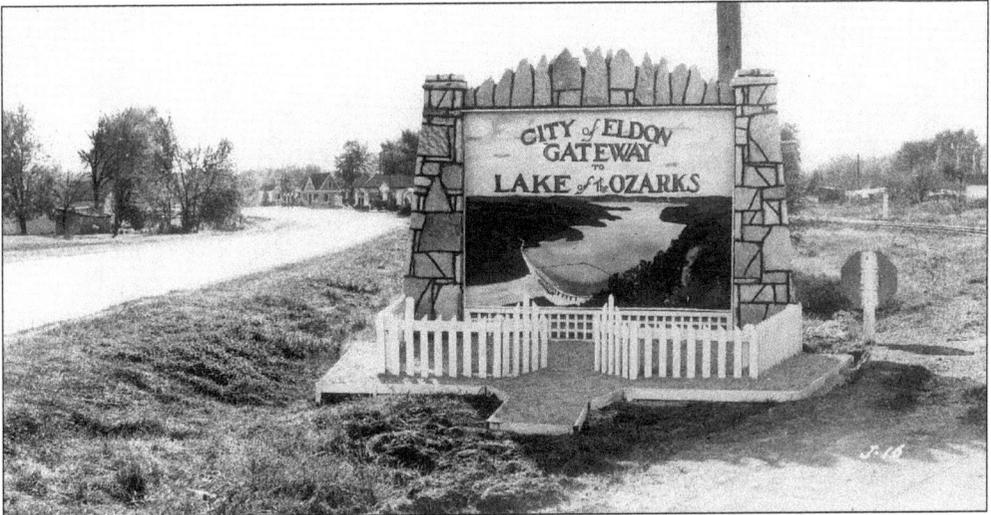

Expecting a welcome influx of tourists to their town, in 1931 the Eldon Chamber of Commerce erected this "gateway" sign along U.S. Bus. Hwy. 54 just north of town. The quaint rock structure still stands, but the wording has changed and the mural is gone. To the left, in the distance, are two gas stations. They still exist, one abandoned, the other with new facilities. Today, the Capitol Regional Medical Center is located directly behind the sign.

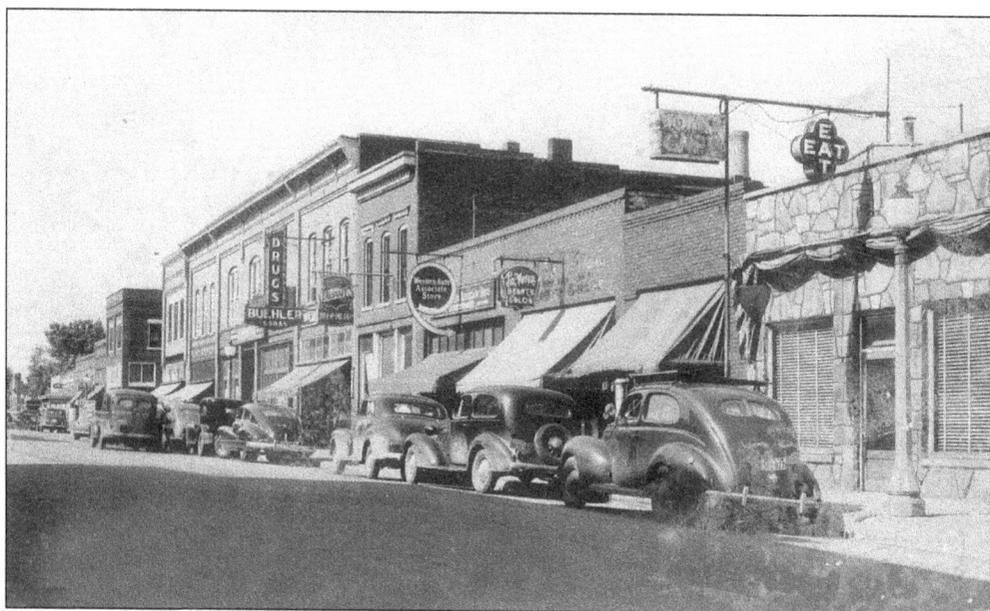

Pictured is a vintage look at downtown Eldon. These buildings are a century old and still in use. The Korner Café is now the Eldon News Agency. Beuhler Drugs was originally the Carpenter Drugstore. It became Buehler's Drug in 1917 when it was purchased by Carl T. Buehler Sr. Dr. Carl T. Buehler Jr., now retired, had his medical office above the drug store for many years. Today, downtown Eldon has a number of antique shops and malls.

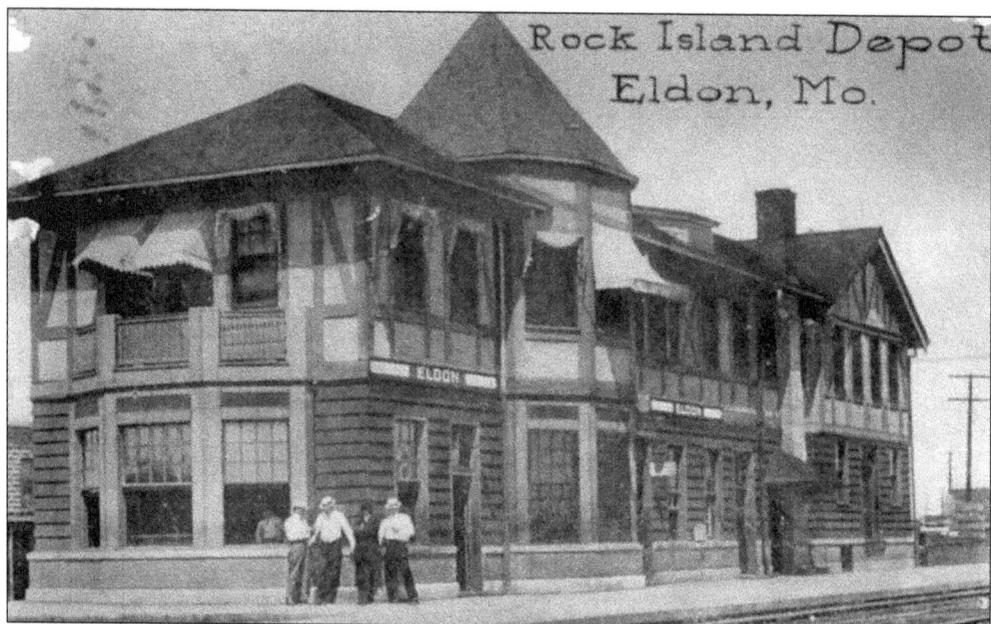

The Missouri Pacific and Rock Island railroads played important roles in the early growth of Eldon and were vital to the construction of Bagnell Dam. A testament to changing times is the fact that the railroads are now gone from Eldon and so is the Rock Island Depot shown above. It was built in 1904 and was once the hub of Eldon's agricultural and freight industries. Today, everything is shipped by truck and even Eldon's bus service is just a shadow of its former self.

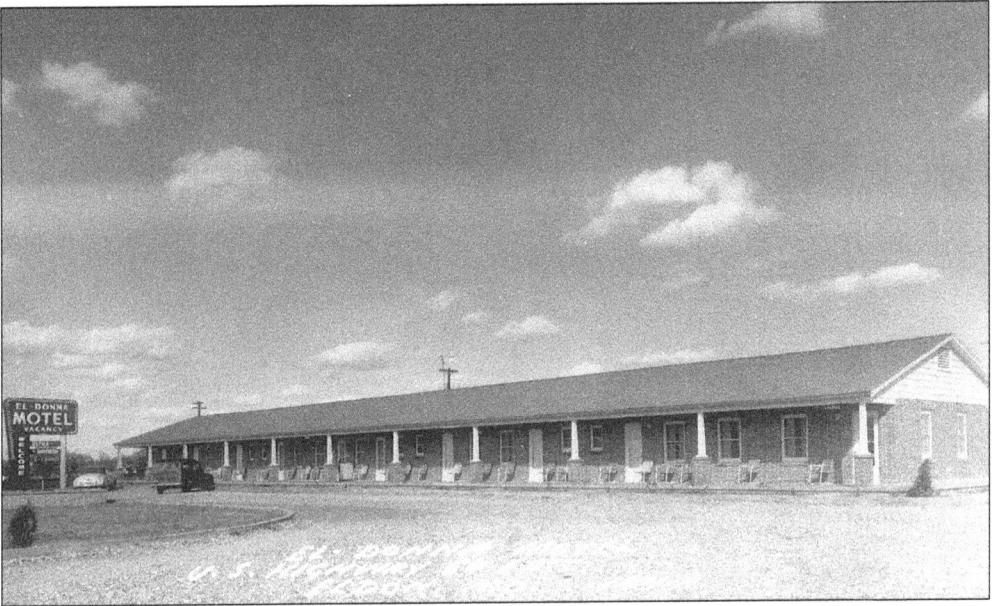

El Donna Motel, known today as the Eldon Inn, is one of the early motels of Eldon. It is located on Bus. Hwy. 54 at the north end of town. El Donna Motel was an award-winning business, owned and operated in the 1950s by the Louis Gerharts. In 1959, it was nationally recognized by the Duncan Hines company as one of the outstanding lodging places in North America. In later years, a second row of units were built behind these units.

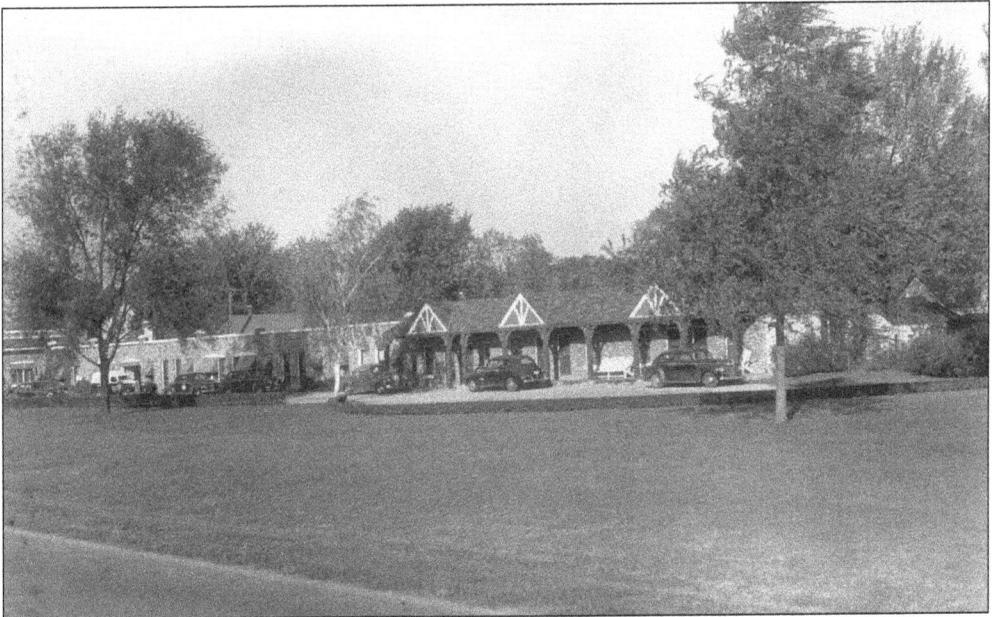

In 1930, Loyd A. Boots, a flamboyant and prominent Eldon business man, built the Boots Cottage Court which included a filling station at the west end (not visible in this photo), a restaurant, and a series of connected cottages. The architecture was cobblestone. Later, the business was purchased by Helen Randle and it became Randle's Court, the name it still has to this day. (Photo by Massie; courtesy of the Missouri State Archives.)

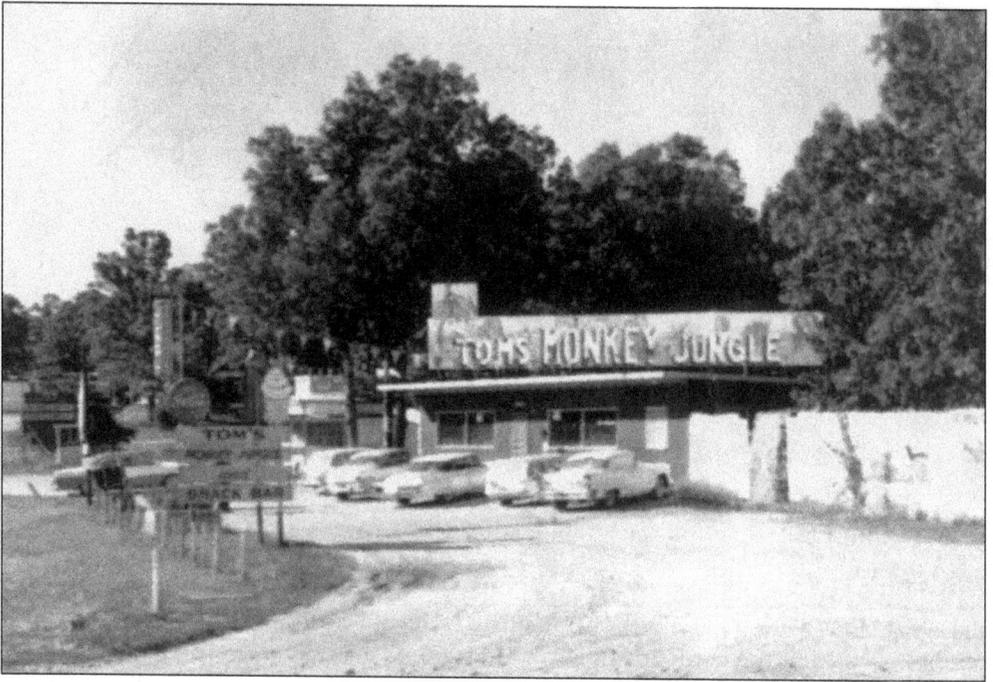

Tom's Monkey Jungle was an early roadside attraction at the south edge of Eldon along Hwy. 54 next to the former Corral Drive-In Theater. Both Tom's Monkey Jungle and the theater (entrance not visible in this photo) were owned and operated by Tom Edwards, a colorful, Eldon entrepreneur of the 1940s and '50s. The Monkey Jungle was an attraction that especially appealed to children, which was Tom's hook for getting people to stop and spend money at his business.

"You Are Never Too Old For"
TOM'S
MONKEY
JUNGLE

2½ Acres Of Shady Garden
On Hiway 54 Near Eldon, Mo.
10½ Miles No. Bagnell Dam
Next To
Corral Drive-In Theatre.

On the left is the cover of one of the attraction's pocket-sized brochures. Tom's Monkey Jungle featured the Coati Mundi, a herd of white deer from India, deodorized pygmy skunks, guinea pigs, chimpanzees, exotic birds, and "monkeys galore." The attraction, and its competitor, the Ozark Deer Farm located further south, were privately-owned roadside animal parks, which were popular in the 1950s and '60s. Tom's Monkey Jungle had monkeys for sale and Tom would "instruct you in the best method of raising and training them."

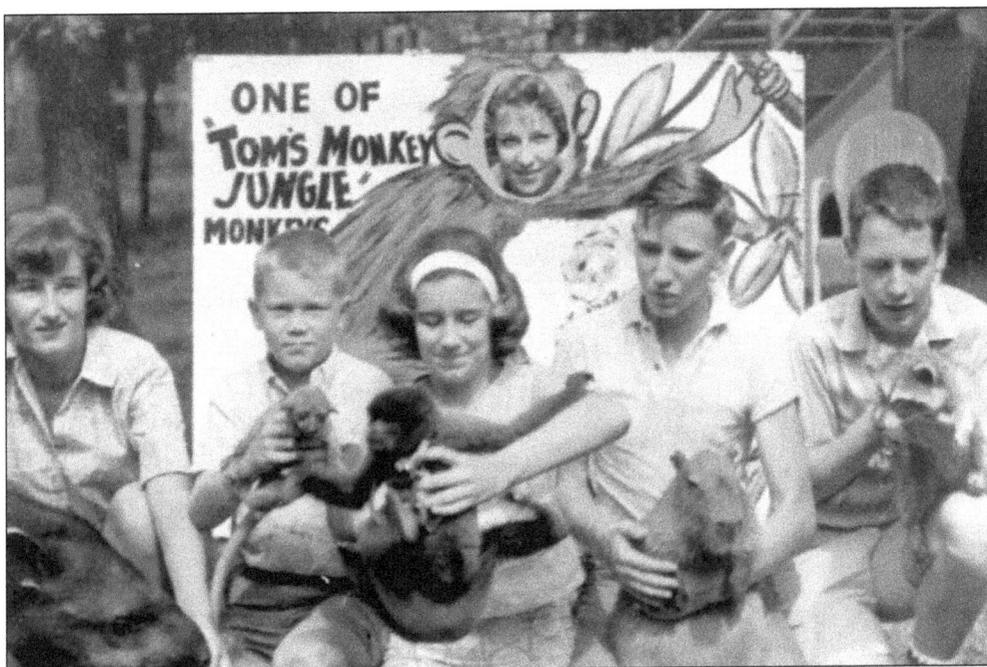

Above, a group of visitors at Tom's Monkey Jungle hold some of the young animals that people were allowed to pet. The attraction's literature said there were "no dangerous animals on the grounds" and that the animals all came from foreign lands. One of the activities children enjoyed at the attraction was watching monkeys race in miniature automobiles.

"TOM'S MONKEY JUNGLE"
Hi-Way 54 ELDON, MO.
Next to Corral Drive In Theatre
9½ Miles No. of Bagnell Dam

EVOLUTION
THE MONKEYS VIEWPOINT

Three monkeys sat in a Cocoanut tree
Discussing things as they're said to be.
Said one to the others: "Now listen you two,
There's a certain rumor that can't be true.
That man descended from our noble race—
The vary idea! It's a dire disgrace.
No monkey ever deserted his wife,
Starved her baby and ruined her life.
And you've never known a mother monk
To leave her baby with others to bunk,
Or pass them on from one to another
'Til they hardly know who is their mother.
And another thing! You will never see
A monk build a fence 'round a cocoanut tree
And let the cocoanuts go to waste,
Forbidding all other monks to taste.
Why if I put a fence around this tree
Starvation would force you to steal from me.
Here's another thing a monk won't do,
Go out at night and get on a stew,
Or use a gun or club or knife
To take some other monkey's life.
Yes! man descended, the ornery cuss,
But brother he didn't descend from us."

One of the humorous postcards sold at Tom's Monkey Jungle was this one, which poked fun at evolution. Tom Edwards, noted for his sense of humor and his love of gimmicks (which he used to attract visitors), gave away Nazi hunting licenses at his theater during World War II.

13

"Lover's Ford," shown here in 1910, was a stretch of barren rock along Saline Creek. Locating it today is difficult because development has changed the landscape so much. It was located about 300 feet from the mineral springs at Aurora Springs, a community separate from Eldon in the early 1900s. Early advertising promoted Aurora Springs as a place of "scenic drives easily made . . ." and featuring "large springs, caverns and clear-water streams . . ."

Aurora Springs, now just a small, private park at the south edge of Eldon, was a sizable community in the early 1900s when it was a popular mineral springs spa area. It had a population larger than Eldon. Unfortunately, the railroad bypassed Aurora Springs and the community died. There is hardly a foundation stone left to tell where the former businesses of Aurora Springs stood, but a few concrete remnants can be seen in the small park.

Klinger Cave, now called Vernon Cave, is east of Aurora Springs along Saline Creek. It gained popularity during the mineral spring craze of the early 1900s. Lynn Tremain, an Aurora Springs resident, dammed the cave stream at the entrance to create a small, shallow lake in the cave so he could give tours by boat. Years later, after boat tours ceased, a board walk was built over the cave's shallow water and deep mud. The board walk was in bad shape when this photo was taken in the early 1950s.

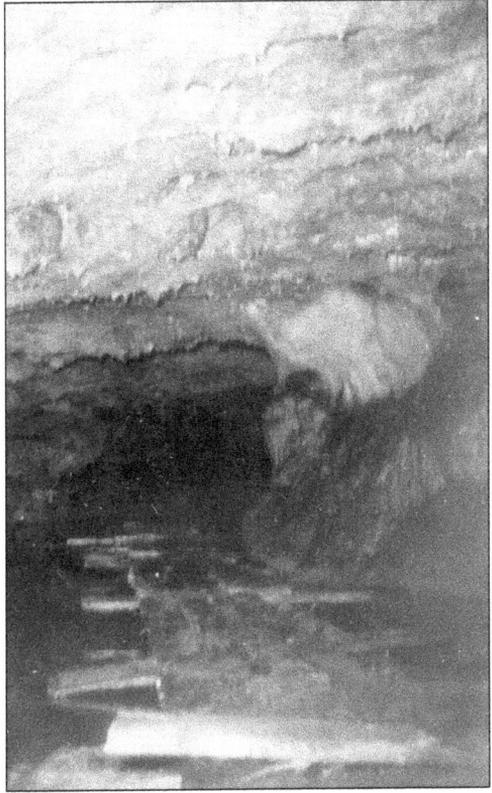

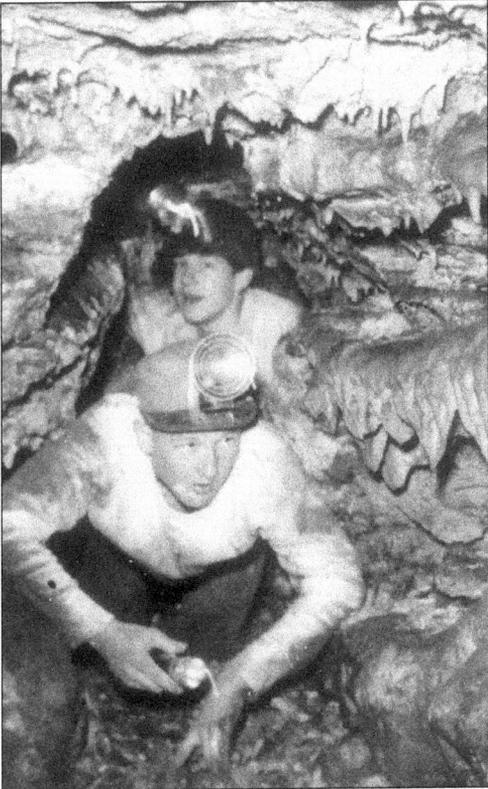

Two teenage spelunkers, Bob Rothwell (in the lead) and John Kratochvil, explore Vernon Cave beyond the lake section in 1958. The cave is not extensive but does have two levels and some interesting features. When Tremain gave boat tours in the early 1900s, he gained notoriety for turning out his lantern during the tour and plunging the group into total darkness to frighten them. He would then entertain the group by singing songs in the darkness.

15

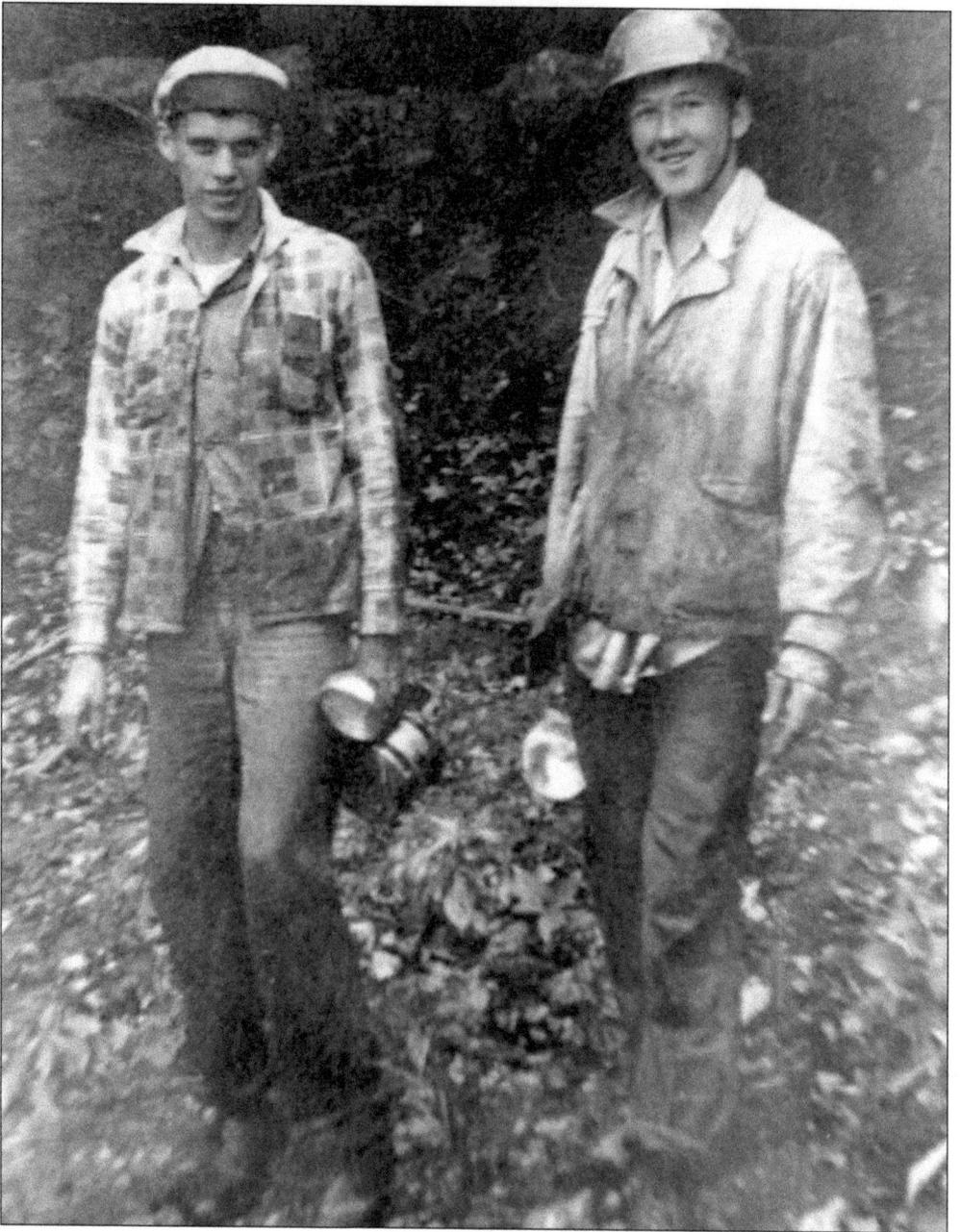

Mineral springs and caves drew the first tourists to Eldon and this was several decades before Lake of the Ozarks was created. Klinger Cave (Vernon Cave) was named for William Klinger who operated a watch repair shop at Aurora Springs in the boom days. He was noted for his invention of the eyelet hook that was in general use when high-top shoes were in vogue. He sold his patent for $1,200 and thought he was doing well. Later, the owners of the patent made a fortune. The cave was located near the Harry Kersey Minnow Hatchery, which no longer exists. In the photo above, taken in 1954, the dam that Tremain built across the cave's entrance can be seen behind the two teenage spelunkers, Dwight Weaver (on the left) and Bob Rothwell (on the right). The cave is wet and muddy, which always delights its younger fans.

16

One of the first filling stations opened at the junction of Hwys. 54 and 52 three miles south of Eldon (traditionally called El Rancho Junction) was this one built by William Cahill. It later became Gay's Tavern. It was raised when Musser's Ozark Tavern Company bought the property and built the Musser's Ozark Resort complex at this location in 1936.

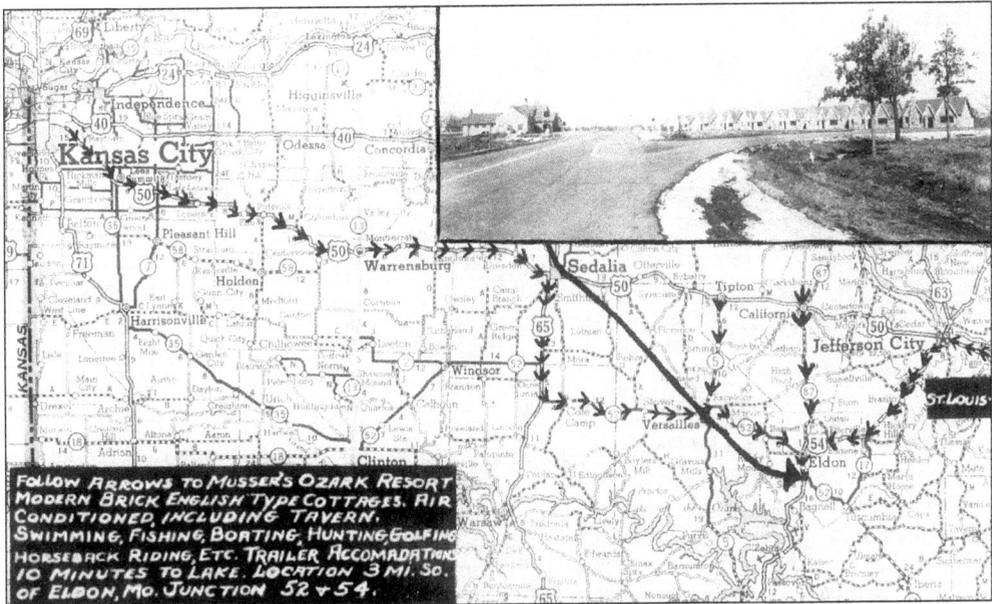

FOLLOW ARROWS TO MUSSER'S OZARK RESORT MODERN BRICK ENGLISH TYPE COTTAGES. AIR CONDITIONED, INCLUDING TAVERN. SWIMMING, FISHING, BOATING, HUNTING, GOLFING HORSEBACK RIDING, ETC. TRAILER ACCOMADATIONS 10 MINUTES TO LAKE. LOCATION 3 MI. SO. OF ELDON, MO. JUNCTION 52 & 54.

This interesting map postcard, distributed in the late 1930s and through the early 1940s by Clarence Musser, was used to promote his business: Musser's Ozark Resort. Musser was from Kansas City and promoted heavily in the Kansas City area. This card was used almost exclusively for the Kansas City market, as the route to the resort suggests.

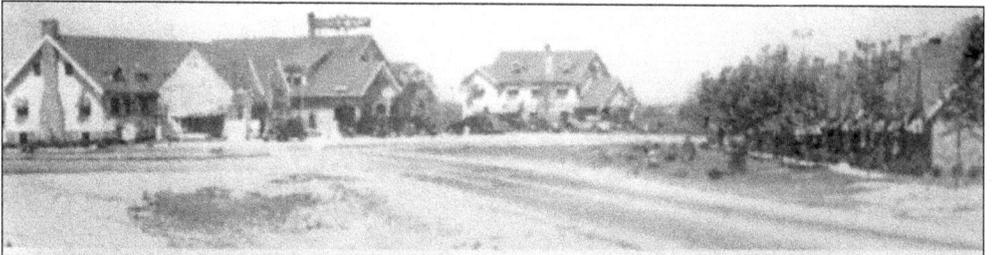

Keep Happy and for Health's Sake Spend Your Vacation
at the LAKE OF THE OZARKS
ENJOY CLEAN SPORTS, AMUSEMENTS
AND ENTERTAINMENT AT ... **MUSSER'S OZARK RESORT**
Such as Dancing, Roller Skating, Golf Practice, Tennis,
Riding, Boating, Fishing, Swimming, Hunting in Season

From 1936 to 1946, Musser's Ozark Resort was one of the most impressive roadside attractions and lodging places north of Bagnell Dam. A devastating fire nearly wiped out half of its buildings during this period. They were rebuilt but on a smaller scale. For a time, Musser's became the best known nightclub-resort in the lake region. The resort included a 14-room hotel, 8 English-style brick cottages, a tavern, dance pavilion, filling station, trailer court, tennis court, café, golf course, and a lavish swimming pool 36 by 60 feet in size. Ballroom entertainment featured big bands from Kansas City. Although the Eldon area was not accommodating to African Americans in the 1930s and '40s, Musser paid little attention to local taboos and often had black jazz bands perform at his place. This site later became known as El Rancho and is today the location for a truck stop and chain restaurant.

18

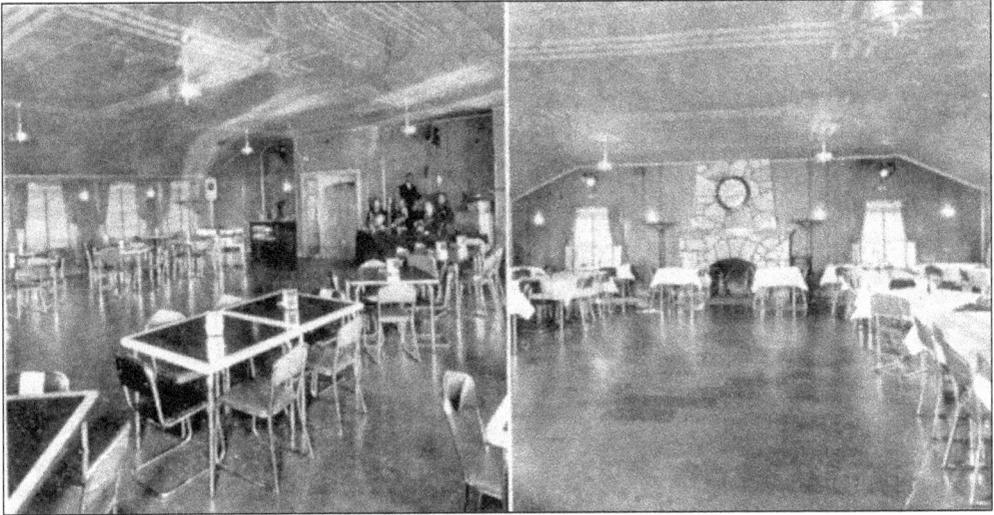

This photo shows the Crystal Ballroom before the devastating fire. Employees managed to drag out most the furniture before the fire claimed the building. Political meetings, dinners, banquets, and even conventions were held in the spacious room. It was the most elaborate privately-owned, public building Miller County ever had, said one 1940s account. (Photo courtesy of James Lawrence.)

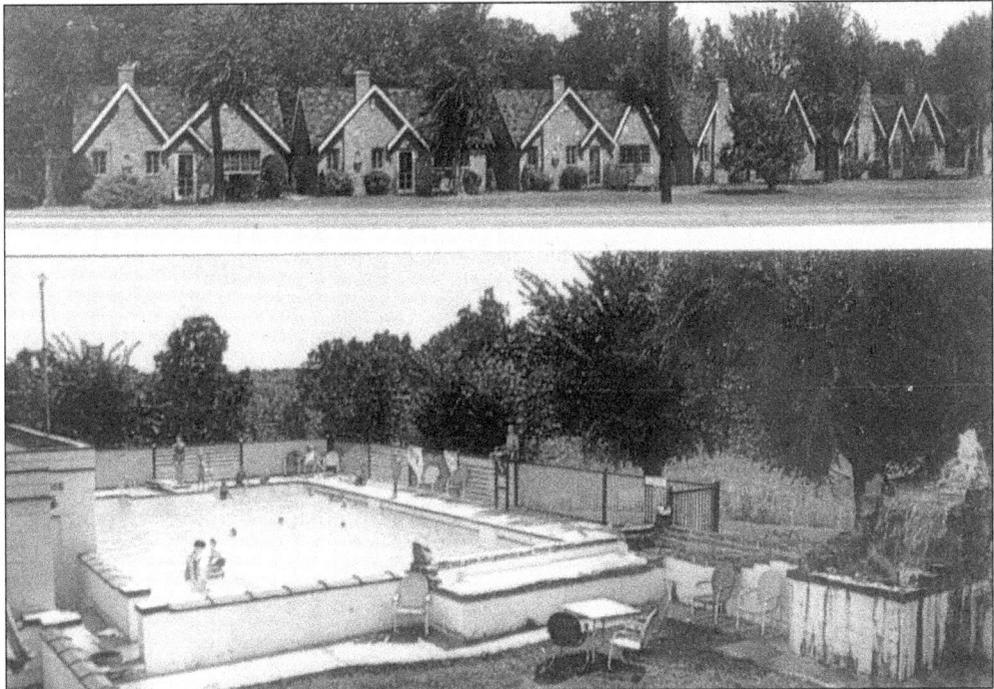

This postcard was circulated after Musser sold the resort in the late 1940s. It became known as El Rancho and the swimming pool became one of the most popular in the Eldon area. Local people were as welcome at the pool as motel guests. When Clarence Musser owned it, the waterfall structure at the right was illuminated by colored lights at night. (Photo courtesy of James Lawrence.)

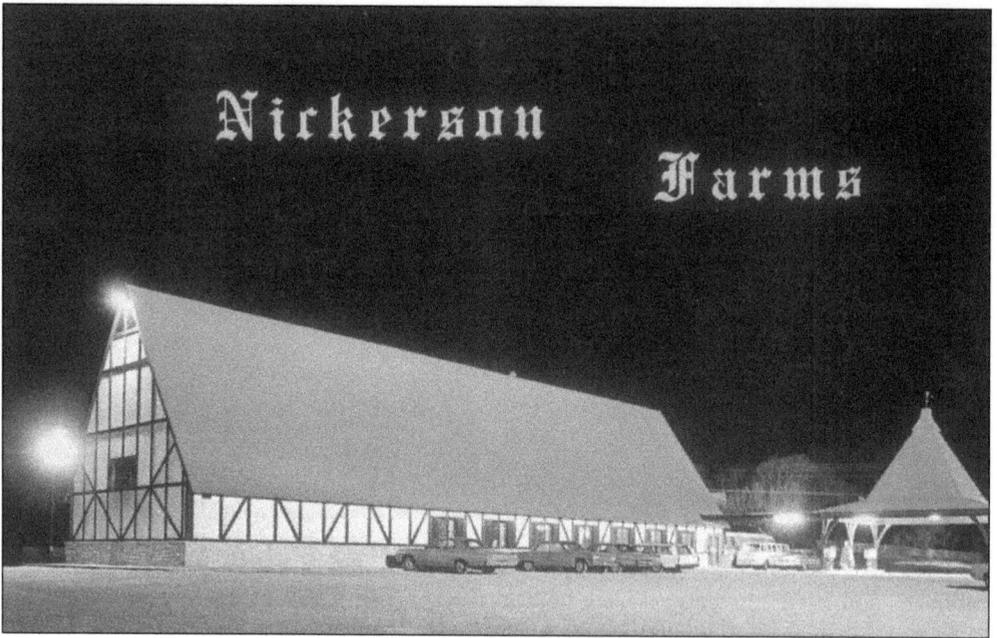

In the 1960s, Interstate highway travelers passing through Missouri, Kansas, Nebraska, Colorado, Arizona, Illinois, and Texas often ate at a Nickerson Farms Restaurant. The company had distinctive, highly-visible, red-roofed, barn-like buildings. The chain got its start in this Nickerson Farms building just south of Eldon on Hwy. 54 near El Rancho Junction. Only a concrete slab now marks where it once stood.

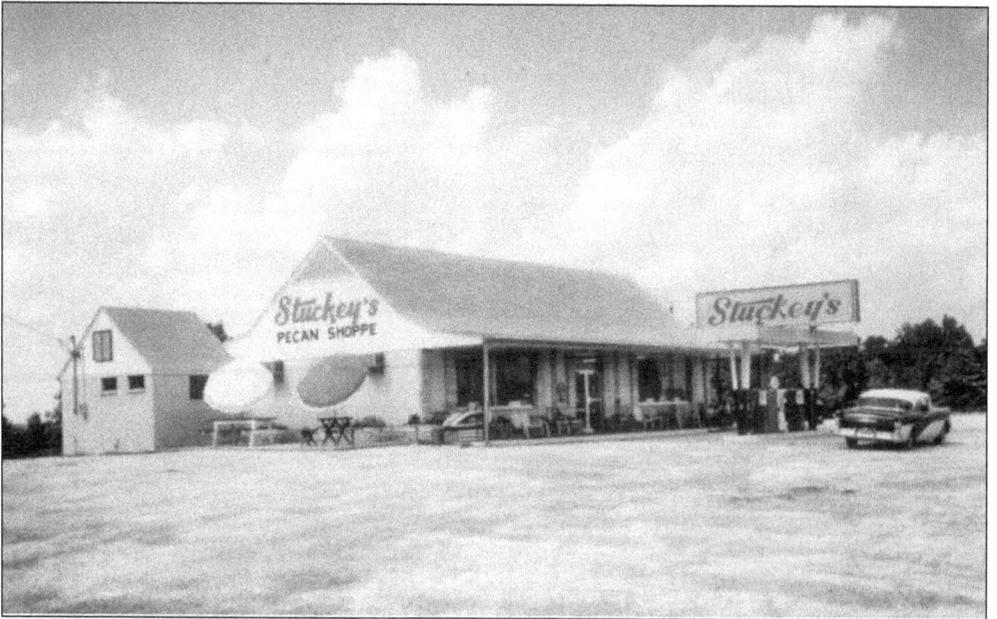

The short-lived Nickerson Farms chain also built Stuckey's Pecan Shops along the same Interstate highways. This one, south of Eldon, was the first Stuckey's shop built by Nickerson Farms. The gift shops sold a variety of candies, jellies, and smoked meats, and had working hives of live bees behind glass. Their service stations sold either Mobile, Skelly, Citgo, or DX gas and oil products.

Adjacent to Nickerson Farms was the Ozark Reptile Gardens, which was later named Max Allen's Zoological Gardens after Max Allen, the son of the Nickerson Farm family. Today, thousands of people going to the lake rush along Hwy. 54 on its divided lanes never realizing what attractions once existed here. Only occasionally does someone venture onto the old highway section and become curious about the abandoned buildings and ruins that remain along that stretch.

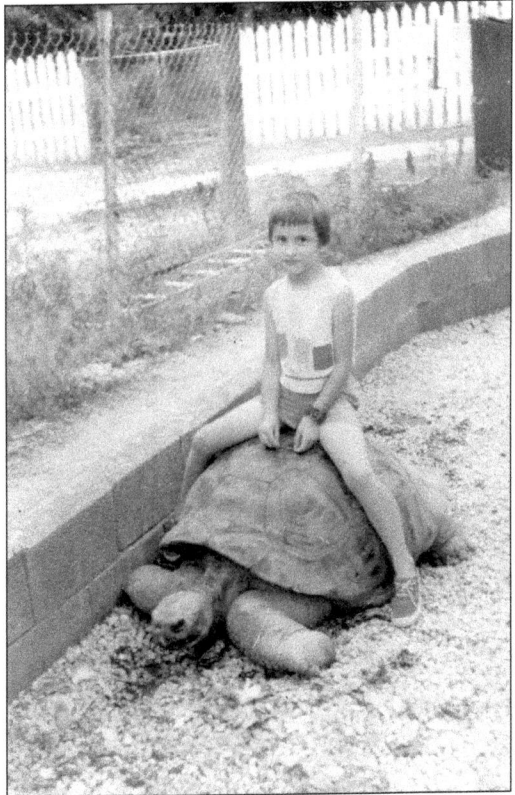

Max Allen Nickerson grew up in Eldon and went on to become a professor of zoology; working at the reptile gardens was his summertime employment. Besides exhibiting highly poisonous reptiles, gila monsters, and alligators, he had a big turtle named George imported from the Galapagos Islands. The turtle weighed 250 pounds and was very docile. Here, Karen Weaver, age 8, has her picture taken on George. The gardens also featured monkeys, apes, giant birds of prey, and seals.

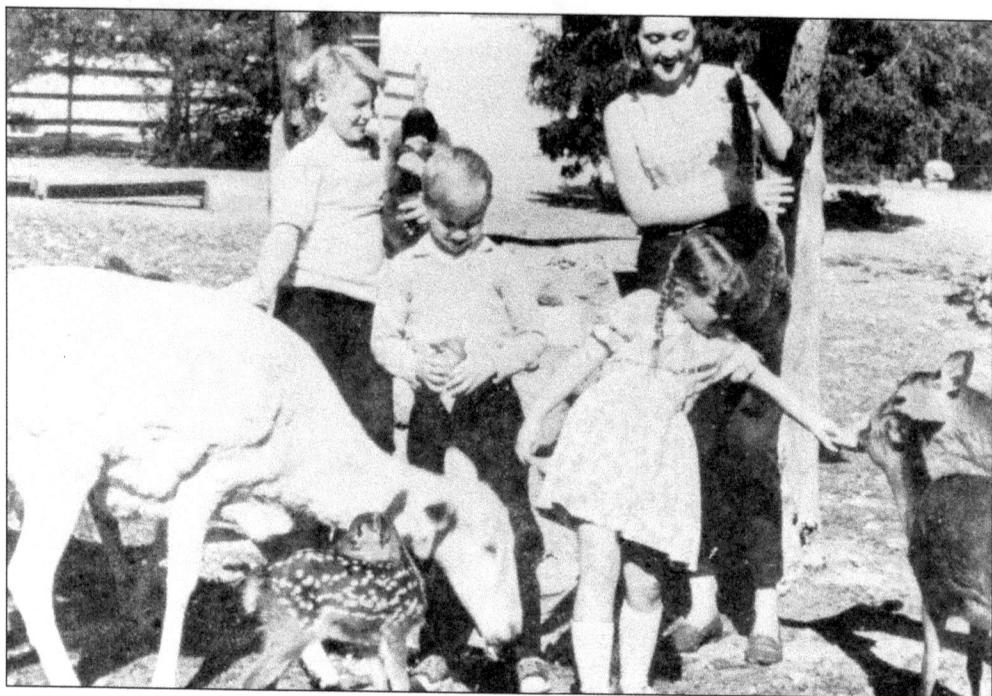

Adjacent to Max Allen's Zoological Gardens was the Ozark Deer Farm, which later became known as Animal World. It was owned and operated by the Simon Fedojan family. Simon's talent for working with animals came from his prior experience as an employee at the St. Louis Zoo. Above, their daughter Sonya, at age 16, takes a group of youngsters on a tour of the Farm.

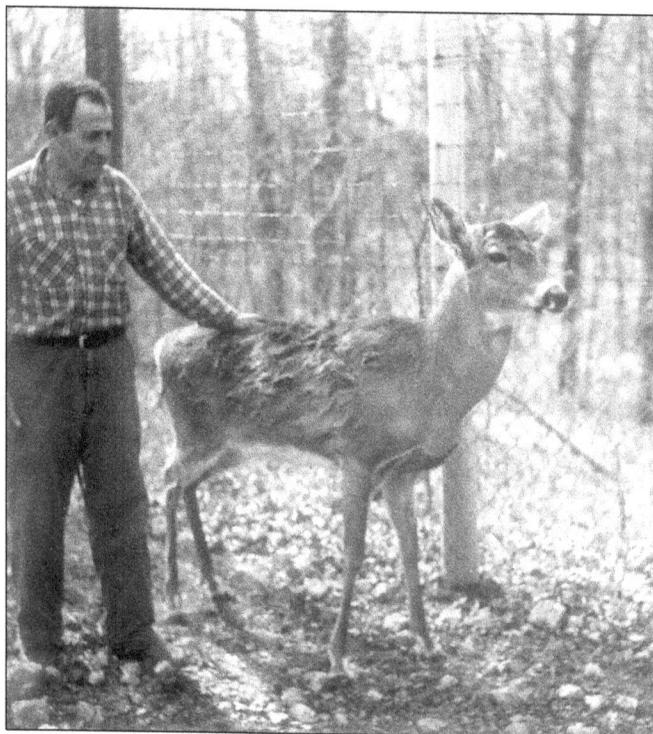

Here, the late Simon Fedajon gives an affectionate pat on the back to Rudolph, who is beginning to shed. In the 1950s and '60s, small privately-owned animal parks proliferated along America's highways. They exhibited a great variety of animals. Today, such parks that remain tend to be large, such as the Exotic Animal Paradise located near Springfield, Missouri. There are no longer any small private animal attractions at Lake of the Ozarks.

After visiting Max Allen's Zoological Gardens and the Deer Farm, tourists of the 1950s and '60s could also visit Stark Caverns in the same area. The cave was named for Elisha Stark, the original owner of the property. During the heyday of Aurora Springs, it was often called Aurora Springs Cave and had a dance pavilion inside. The cave gained notoriety in 1901 when three boys got lost in the cave and had to be rescued. The photo above was taken in 1950.

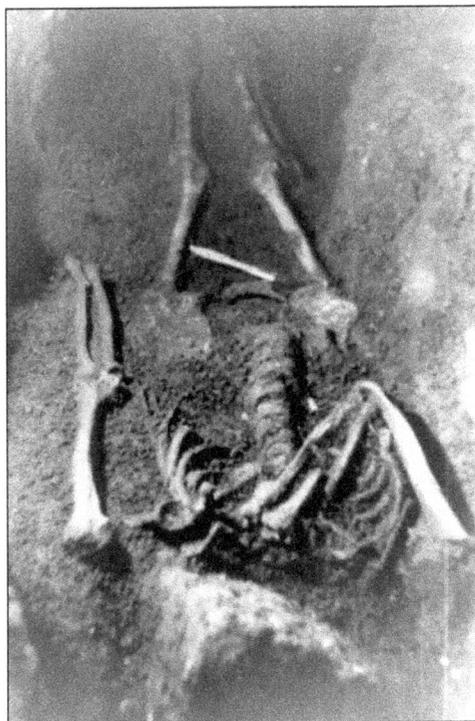

In 1947, E.H. Shepherd, editor of the *Eldon Advertiser* said "One of these days some venturesome investor may attempt to make Aurora Cave...one of the main attractions in the Lake of the Ozarks area." He didn't have to wait long. That happened on May 12, 1950. In the 1960s, two guides, Kent Buehler and Glenn Bashore, discovered Indian burials in the cave and its local fame grew. The burials were exhibited just inside the cave's large entrance.

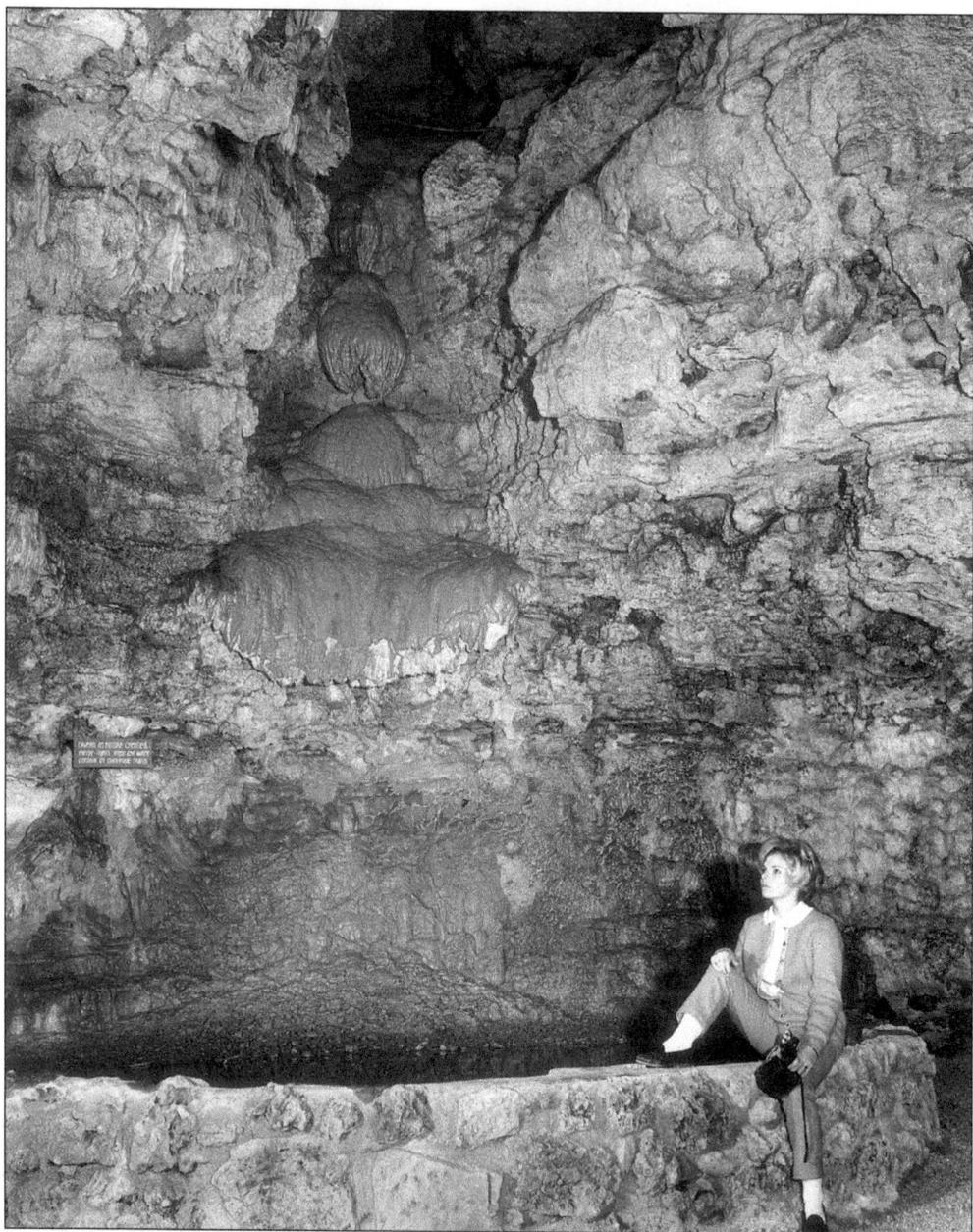

Stark Caverns was opened to the public by Jim Banner and R.L. Wilkerson of Camdenton, and Floyd L. Hammitt and sons of Eldon. Banner and Wilkerson had been involved in the commercial development of Bridal Cave near Camdenton in 1948. They would later be instrumental in the development of Ozark Caverns near Linn Creek. Kenneth B. Sweet of Waynesville, a town about 40 miles east of Eldon, gave technical assistance because he had helped develop two show caves in the Waynesville area near Route 66. Stark Caverns was sold to the late Harvey Fry in the 1950s and then again in the 1970s to a corporation who redeveloped the cave and named it Fantasy World Caverns. In the above photo, taken by Gerald Massie in the late 1950s, the daughter of Harvey Fry poses beneath the cave's Onyx Falls formation. (Photo by Walker, Missouri Commerce.)

Two

OLD BAGNELL, DAMSITE, AND BAGNELL DAM

It is hard to imagine that the tiny hamlet of "Old" Bagnell off Hwy. 54 at the end of V road north of Bagnell Dam was ever anything more than a fishing village. It grew up after 1882 when a spur of the Missouri Pacific Railroad was built here to the river's edge for the railroad tie shipping industry. But in the late 1920s, the construction of Bagnell Dam briefly transformed the little town into an Ozark metropolis. The end of dam construction, several destructive fires, and Osage River flooding soon diminished the town to its present-day status.

Another town, now long vanished, once stood upriver about three miles from Old Bagnell and was known as Damsite. It was a town made up of "hundreds of lean-to and up-and-down board cabins" birthed by dam construction efforts. "The cabins... housed the men who comprised the common labor. Here lived the real worker, his wife and children, striving to support them," said the local paper in 1933. The town had a population of several thousand people and some of its buildings were connected to sewer lines, water mains, and electricity, a fact which irritated some of the citizens of Old Bagnell who did not have such utilities. But at the end of construction, the town vanished and the land was reclaimed as farmland. Today, Hwy. 54 crosses the Osage River on a bridge below Bagnell Dam where the town of Damsite once stood.

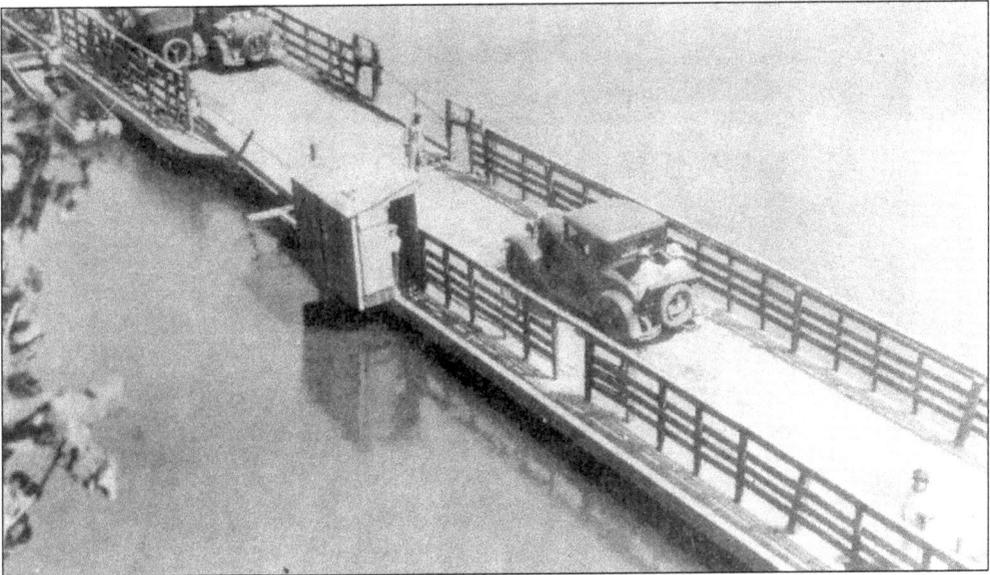

The Bagnell Ferry began operation across the Osage in 1882 with Samuel Umpsted as contractor. The operation prospered until the completion of Bagnell Dam, after which Hwy. 54 was routed across the top of the dam. The ferry was the scene of several significant accidents during its existence, one of which resulted in people drowning. J.L. Howser ran the ferry from 1932 to about 1940 for the benefit of local farmers who had farms on the opposite side of the river.

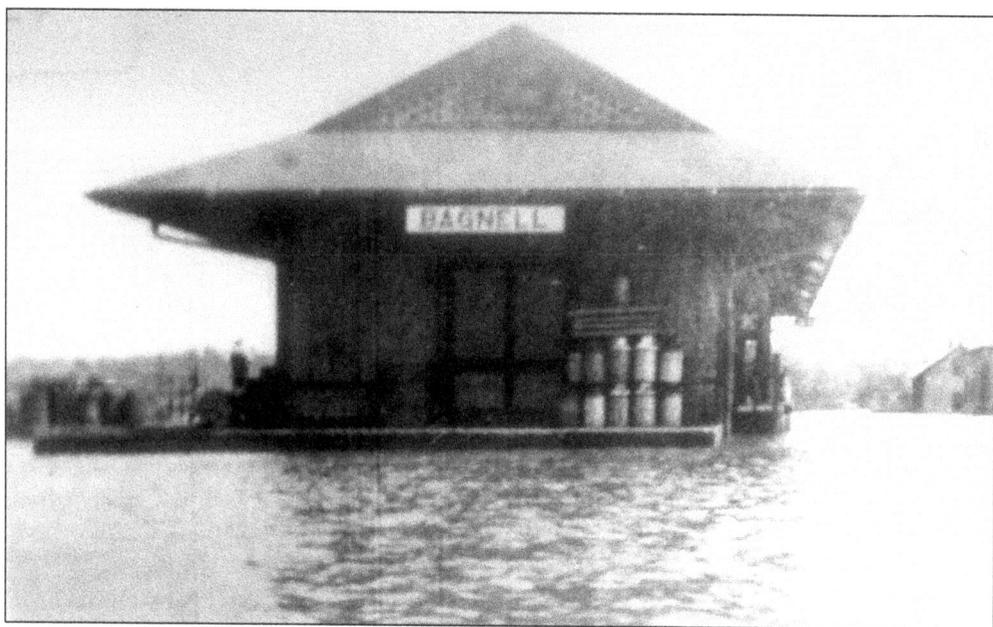

The Bagnell Depot, which marked the end of the main line for the Bagnell Branch spur of the Missouri Pacific Railroad, is seen here during one of the almost yearly floods of the Osage River. The railroad ceased operation in 1954. Only a few foundation stones remain where this depot once stood. (Photo courtesy of Bruce James.)

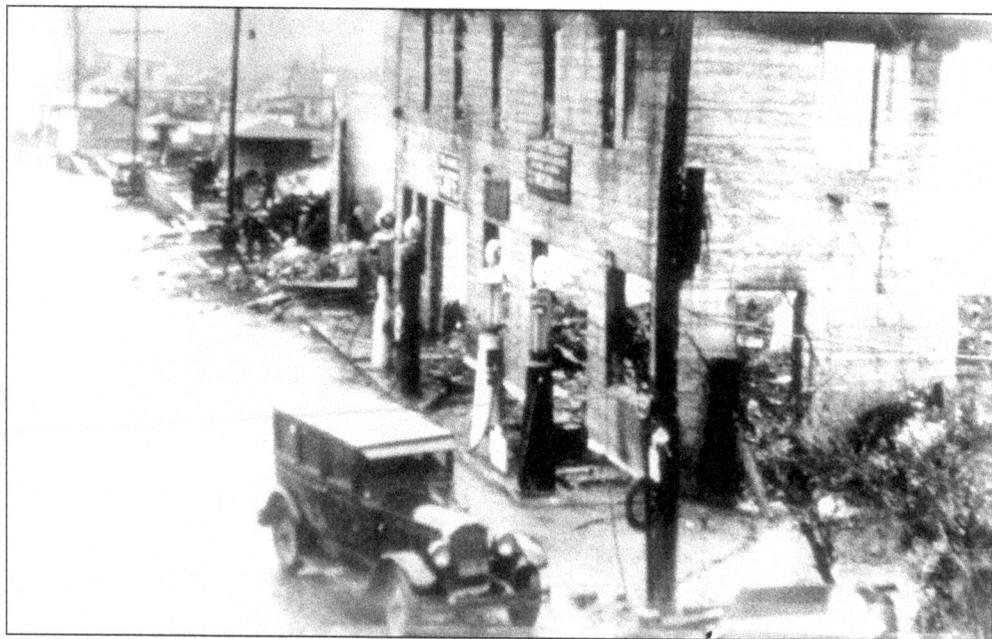

Two disastrous fires in 1931 virtually destroyed the town of Bagnell. This photo shows the ruins of the Oscar Boots Service Station. Boots also operated a freight boat on the Osage and ran the Boots Hotel, formerly the Brockman Hotel. It was one of three hotels in Bagnell when construction of the dam began. In 1927, the hotel advertised 22 rooms at $2.00 per day. (Photo courtesy of Bruce James.)

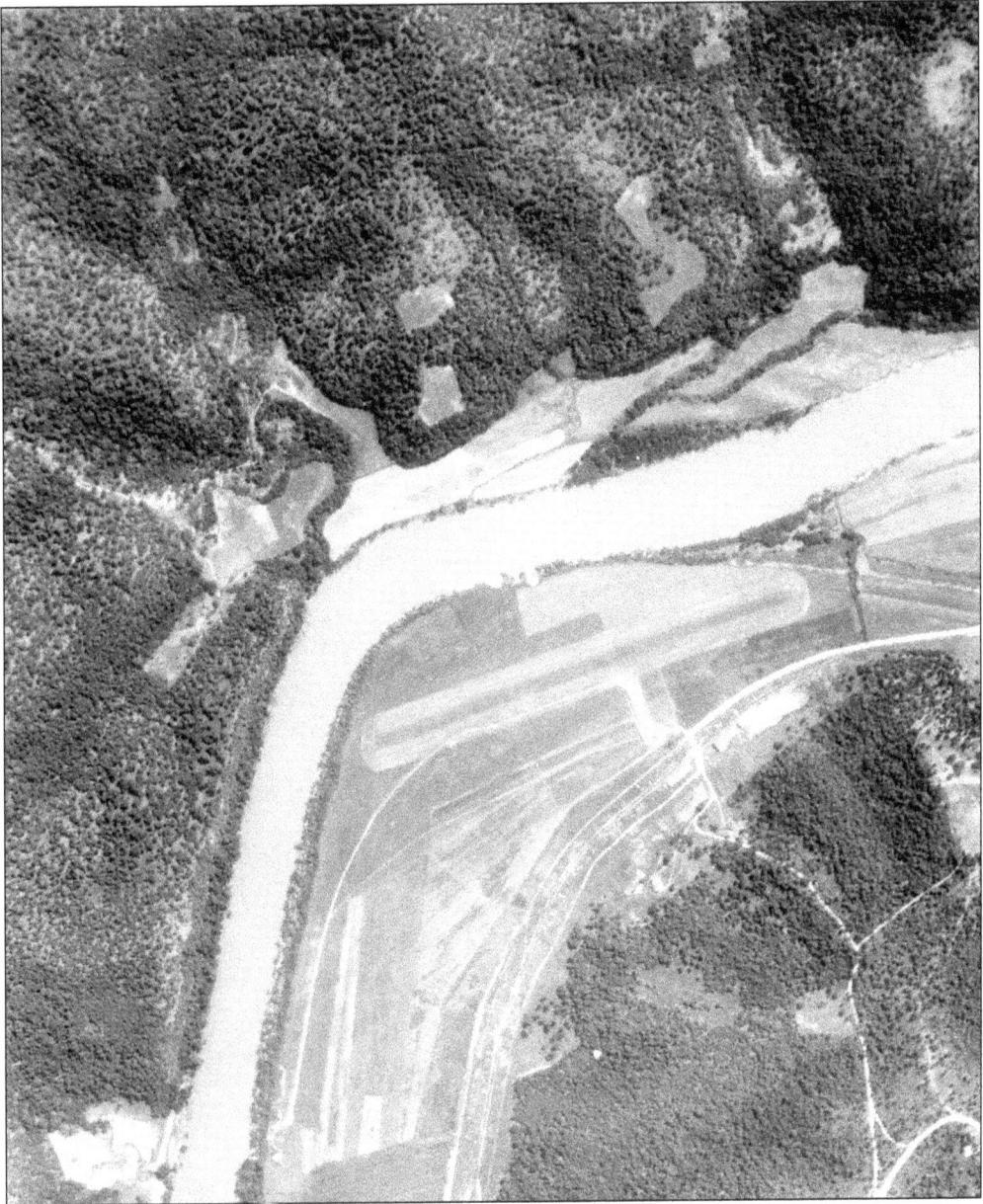

About three miles of fertile floodplain separated Old Bagnell from the town of Damsite, but to get to Damsite, it was necessary to take a road out of Old Bagnell that ran along the river. This road then divided into several roads as can be seen in this aerial photo, which also shows the Sky Lake Airport runway. The airport was constructed by the Union Electric Land and Development Company for the use of its planes, which carried company VIPs from St. Louis to the construction site. The airport did not appear on maps as "Sky Lake Airport" until after the dam was completed. In the 1940s, when Union Electric was forced by the federal government to divest itself of "other" enterprises, the airport land was sold to the Johnny Mead family, who converted the land back to agricultural use. They still farm this land. (Photo courtesy of AmerenUE. AmerenUE is a subsidiary of Ameren Corporation, formed by the 1997 merger of Union Electric Company and CIP-SCO Inc., a parent of Central Illinois Public Service Company.)

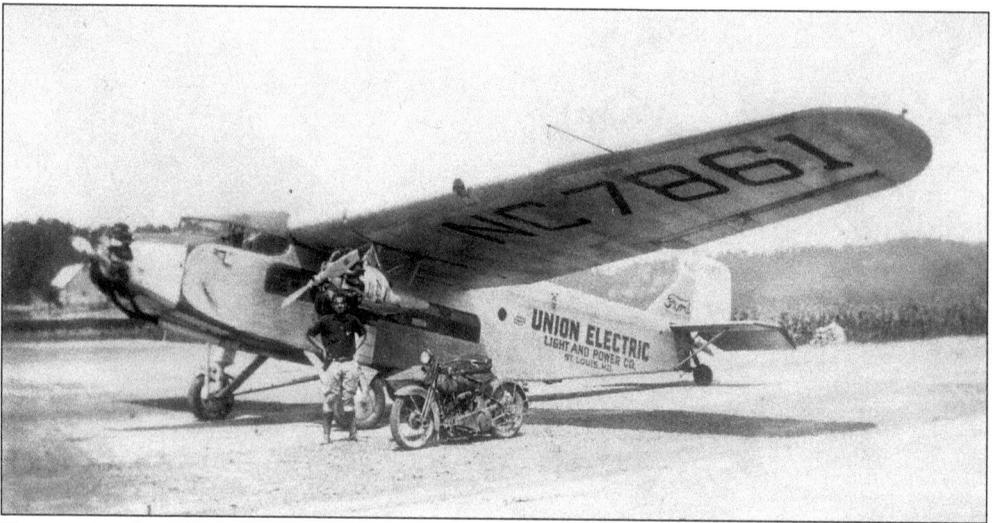

During the dam construction period, the sheriff of Miller County maintained a substantial force of officers who kept law and order on the dam construction site, as well as within Old Bagnell and Damsite. The airport was a regular stop on the patrols' route. Here, an armed security officer poses while his photo is taken beside his motorcycle and Union Electric's Ford Tri-Motor plane.

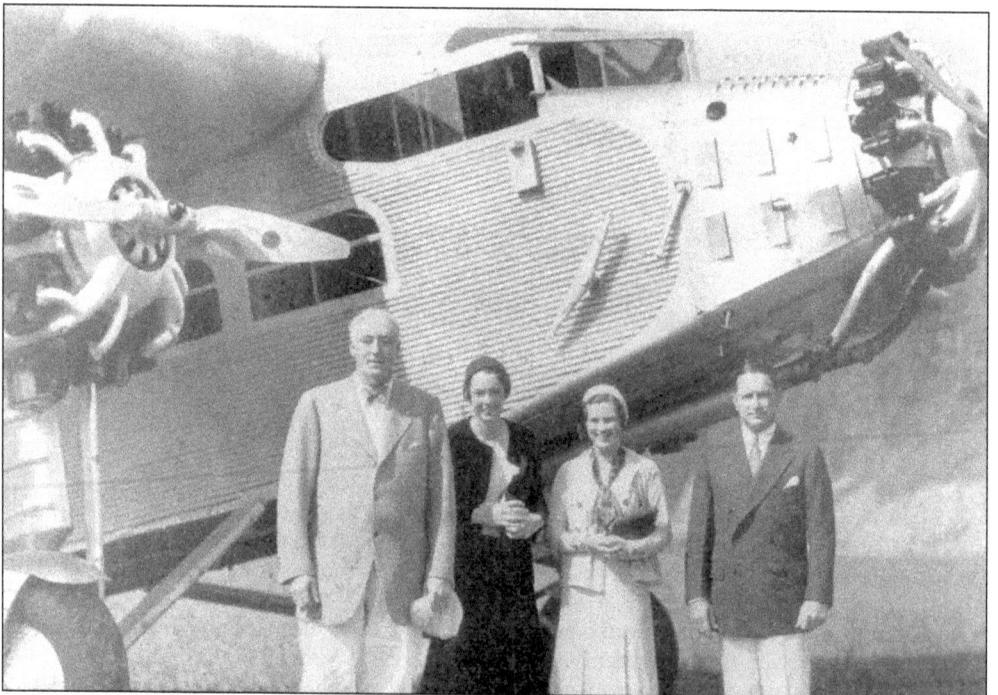

Louis H. Egan (on the left) was president of Union Electric during the construction of Bagnell Dam. He is shown here beside the company's plane and his wife, Elizabeth. With them is M.S. Sloan, President of the Brooklyn Edison Company, and his wife, Lydie. The plane had a cruising speed of 110 miles per hour, and its three Wright Whirlwind J6 motors were similar to the motors in Charles Lindbergh's *Spirit of St. Louis* plane. (Photo courtesy of Union Electric Magazine.)

After building the airport and buying the plane, they hired E.G. Bahl to pilot the plane. He was 36 years old and had a distinguished flying record. He was born near Lincoln, Nebraska, and was the pilot who taught Charles Lindbergh how to fly. The two of them became good friends and as a consequence, Lindbergh paid a few visits to Bagnell Dam during its construction. (Photo courtesy of Union Electric Magazine.)

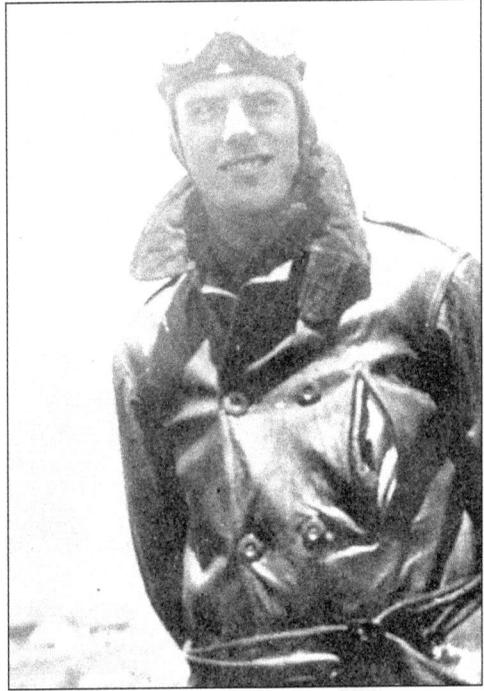

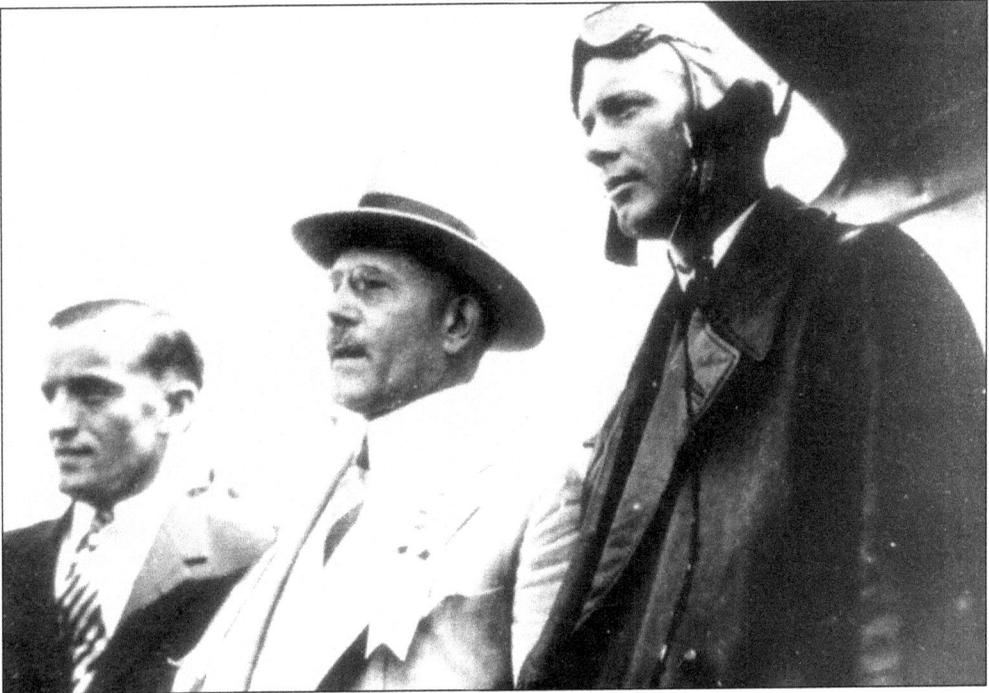

The men shown here with Lindbergh in his aviator hat at Sky Lake Airport have not been identified but may have been Union Electric officials. Lindbergh's plane is not the only plane that landed at Sky Lake Airport that is at the Smithsonian Museum. Union Electric's Boeing 247D plane also made aviation history in the 1930s and was, at one time, part of the museum's "Milestones of Flight" exhibit. (Photo courtesy of the City of Osage Beach.)

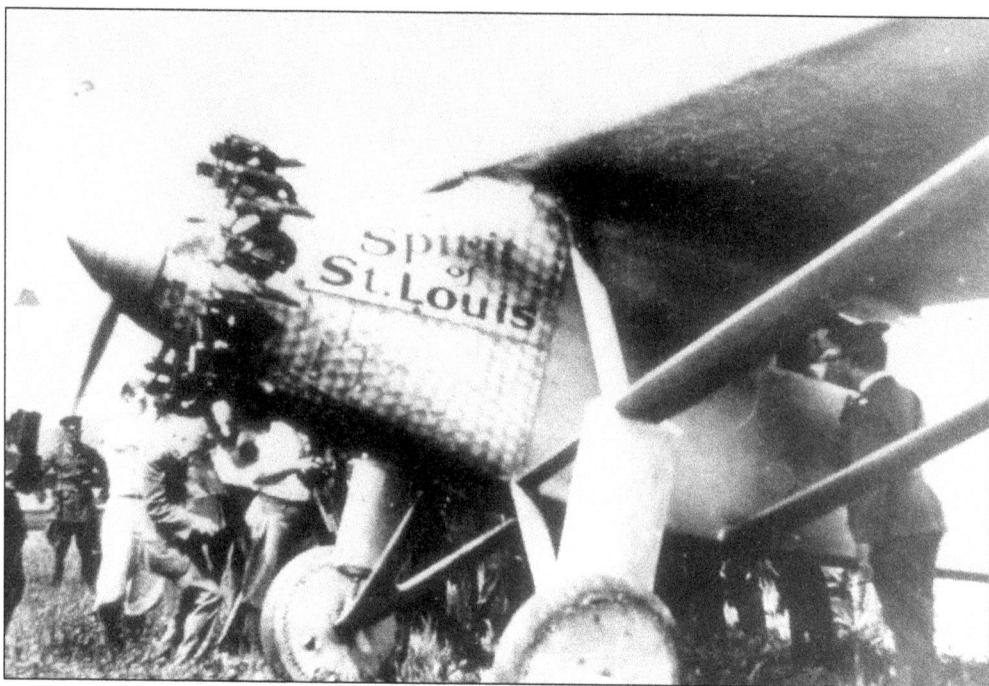

Charles Lindbergh flew in and out of Sky Lake Airport without fanfare most of the time because neither he, nor Bahl, let anyone know when he was going to be there. They were good friends but tragedy was soon to strike them both. Bahl, ironically, died in an automobile wreck in Oct. 1930, and Charles Augustus Jr., the son of Charles A. Lindbergh, was kidnapped and killed in 1932. (Photo courtesy of the City of Osage Beach.)

The only road to the Bagnell Dam construction area was through Damsite, the "lean-to" town, as some people called it. Even the merchants of the town and their families who were not dam employees still had to pass the "guard house," which stood beyond the town and controlled all traffic into and out of the valley. The local police were hired and supervised by the Miller County sheriff's office but paid by the Union Electric Company.

30

During its short life, the town created quite a stir locally with its rough lifestyle. Gambling, bootlegging, and violence were problems. There was, however, plenty of legitimate entertainment, including well-organized wrestling matches. One wrestler, Homer Wright, was called "The Tiger." By day he was a dam worker and by night a wrestler with a reputation for toughness. The winter of 1929 was cold and bitter for the residents. (Photo courtesy of the Camden County Historical Society.)

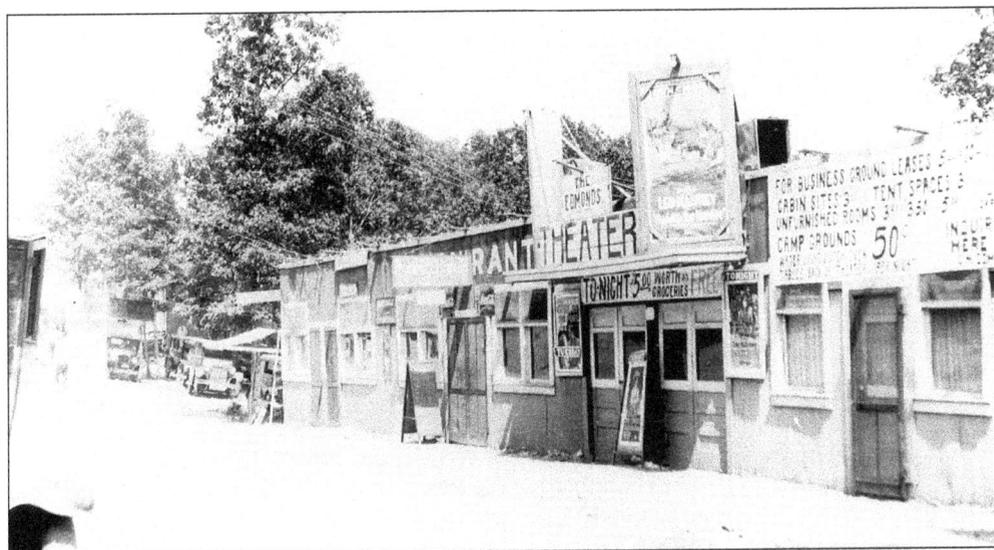

The town of Damsite was one mile downstream from Bagnell Dam on the properties of Henry Lemuel and Rebecca Strange. Property leases were written for a 3-year period with an option for renewal, but the options were never exercised because the town vanished when dam construction ended. The Edmond's Theater, shown here, could seat 150 people and showed the latest movie releases.

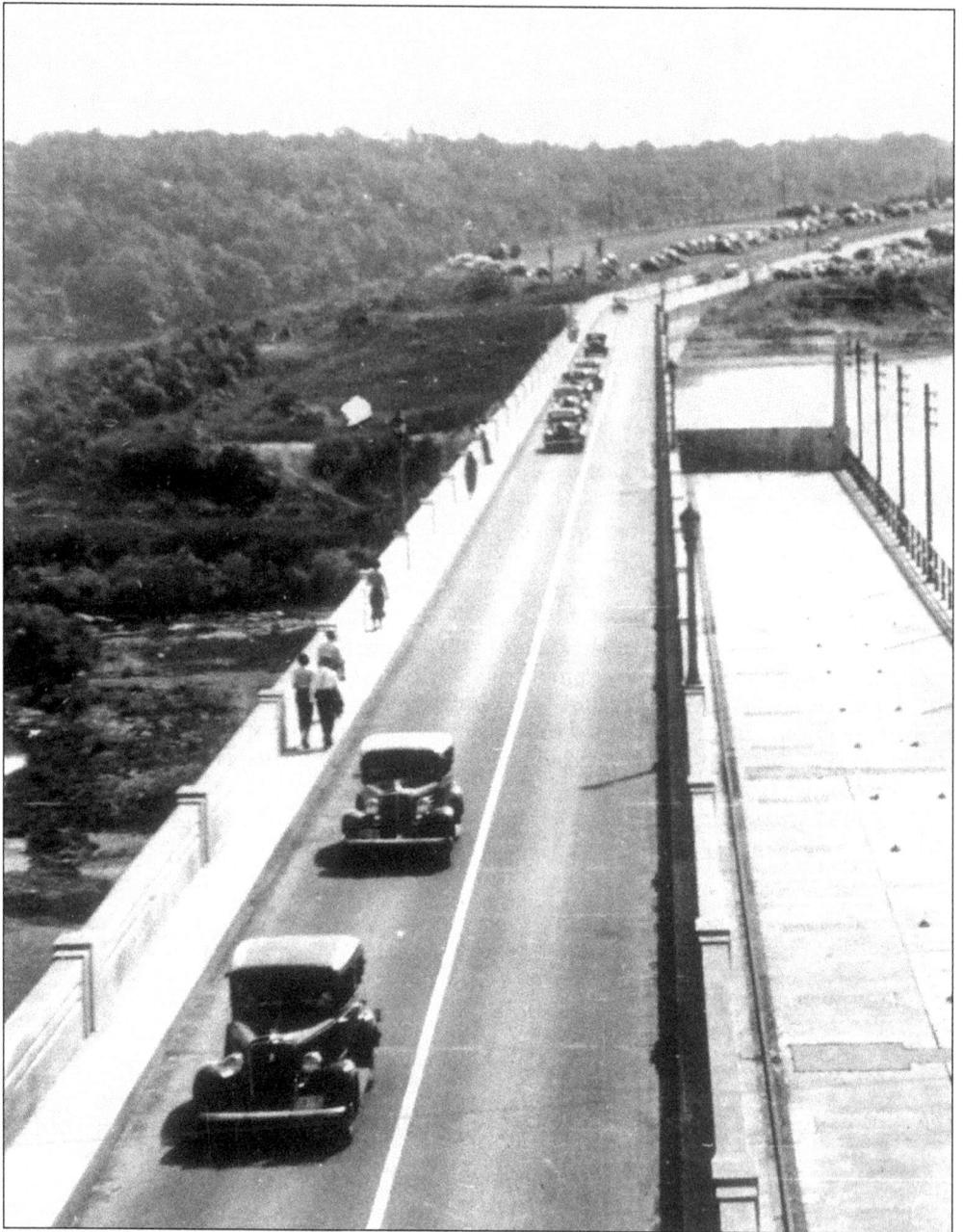

A busy weekend in the 1930s reveals many cars parked on the Union Electric parking lot at the west end of the dam. There were no other large man-made lakes in the Midwest in the 1930s. Even during the Great Depression, weekends attracted thousands of people to the Lake of the Ozarks. In 1932, the lake's business community organized the Lake of the Ozarks Improvement and Protective Association, predecessor to today's Lake of the Ozarks Association. Quality development was encouraged: "Every developer should not only be careful to produce the best results on his own property, but should be watchful on every other piece of property within the district, because ugly or cheap developments have an effect far beyond their immediate locations," said an early editorial in the *Lake of the Ozarks News*. (Photo courtesy of AmerenUE.)

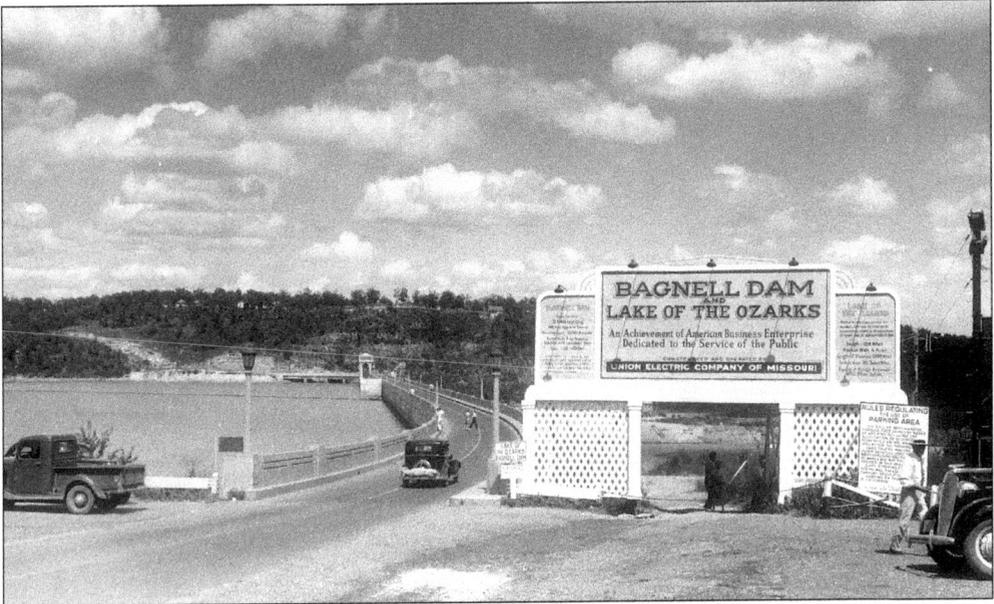

Union Electric erected this sign in the 1930s at the west end of the dam. Through the decades, it has seen various modifications and, at one time, had a bright-red neon Reddy Kilowatt on the face. A road to the area below the dam along the west side of the river can be reached by driving around this sign. Many tourists have posed before this sign to have their picture taken for a souvenir of their visit to Bagnell Dam and Lake of the Ozarks.

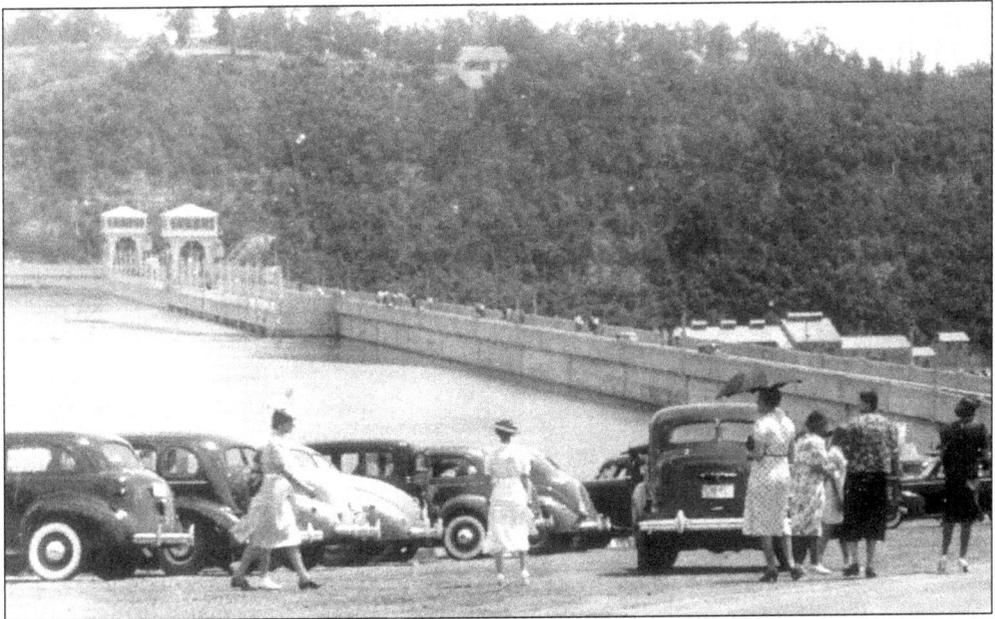

In the 1930s, the Great Depression was in full throttle, but on weekends during the summer months the dam area was crowded with sightseers. Midwesterners were in love with the place. They often just called it the "Big Lake" because they still weren't used to the name Lake of the Ozarks. On the 4th of July 1932, an estimated 2,500 cars crossed the Grand Glaize Bridge, and Brill's Hill, the biggest resort up-lake at Warsaw, reported huge crowds. (Photo courtesy of AmerenUE.)

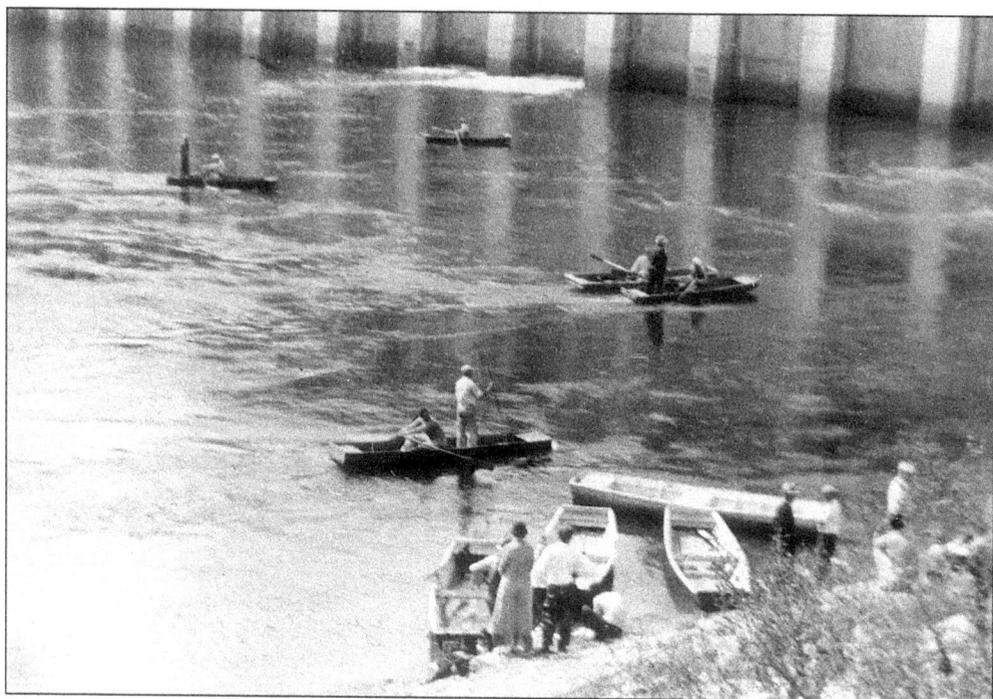

In the early years, nearly everyone who came to the lake for an extended period came to hunt and fish. Today there are many other competing forms of recreation. During the early years, most of the fishing boats had no motors and the fishermen used oars. The box-like wooden Ozark johnboat, a tradition in the Ozarks until the 1970s, was then the standard as can be seen in this photo. (Photo courtesy of AmerenUE.)

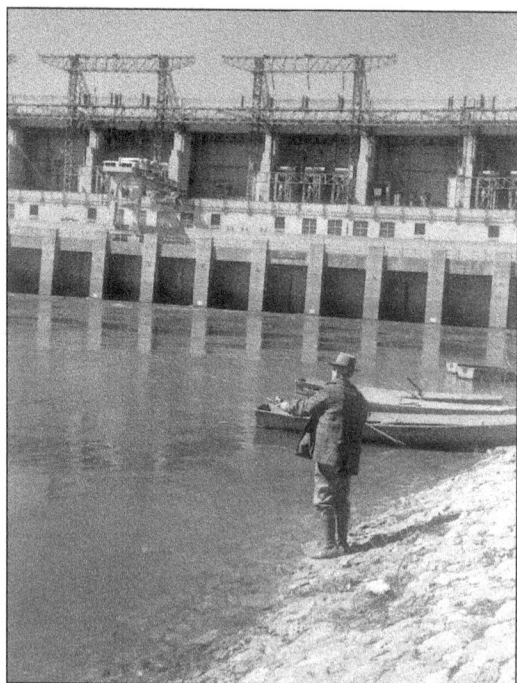

The johnboat was popular because it was stable, had a wide bottom, and rode high in the water, thus it wasn't so apt to ground in shallow water. The boats were designed for long eddies, quiet floating, and fishing in a limited area. Their drawback was their weight: they were heavy. Wood eventually gave way to aluminum. Here, a bank fisherman tries his luck. He wears the kind of hat fashionable for men in the 1940s and '50s. (Photo by Massie; courtesy of the Missouri State Archives.)

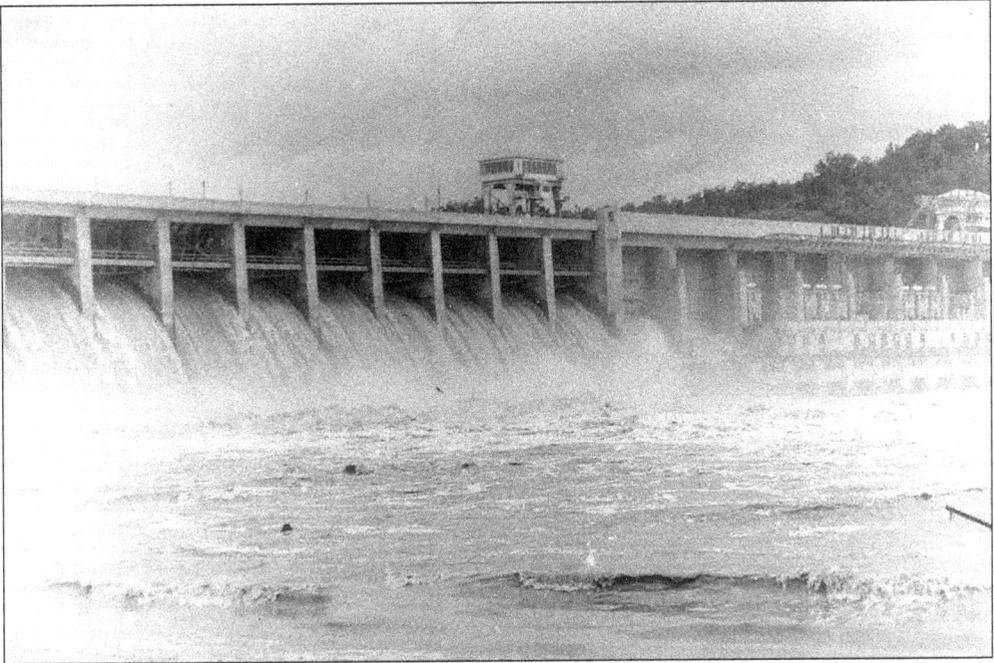

Annual floods were a curse to the farmers of the Osage River valley. Bagnell Dam did not alleviate the problem. The flood of 1943 is the worst on record. This photo shows the flood before it reached its peak. In five days, 648 billion gallons of water passed the dam, a flow greater than that at Niagara Falls in the same length of time. The construction of Truman Dam 91 miles upstream near Warsaw in the 1970s has reduced the severity of floods. (Photo courtesy of Bruce James.)

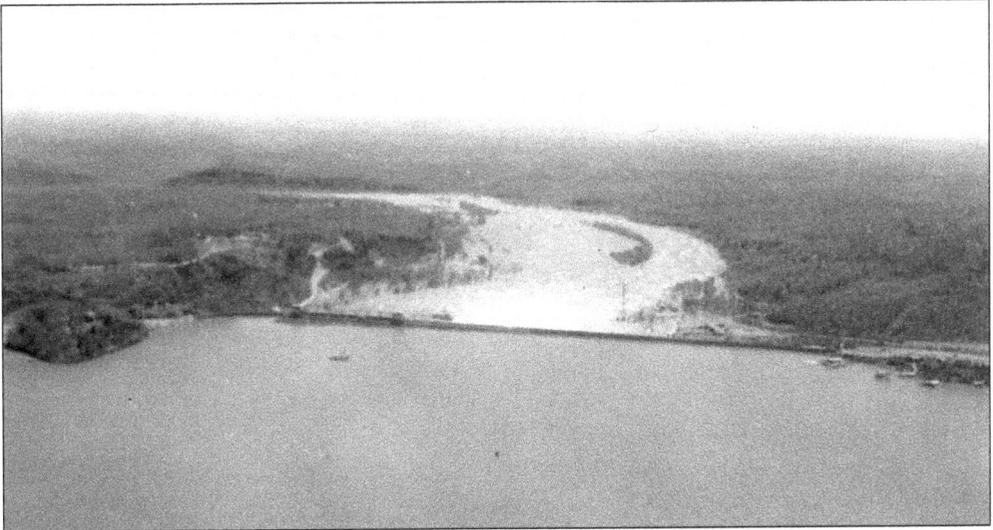

From May 17 to May 22, 1943, a horrendous fight was fought to control the water passing through the dam and flooding the Osage River all the way to its confluence with the Missouri River 80 miles downstream. The biggest problem was keeping water and driftwood out of the dam's powerhouse. This rare photo shows the water in the lake within 5 feet of topping the dam, which, fortunately, it never did.

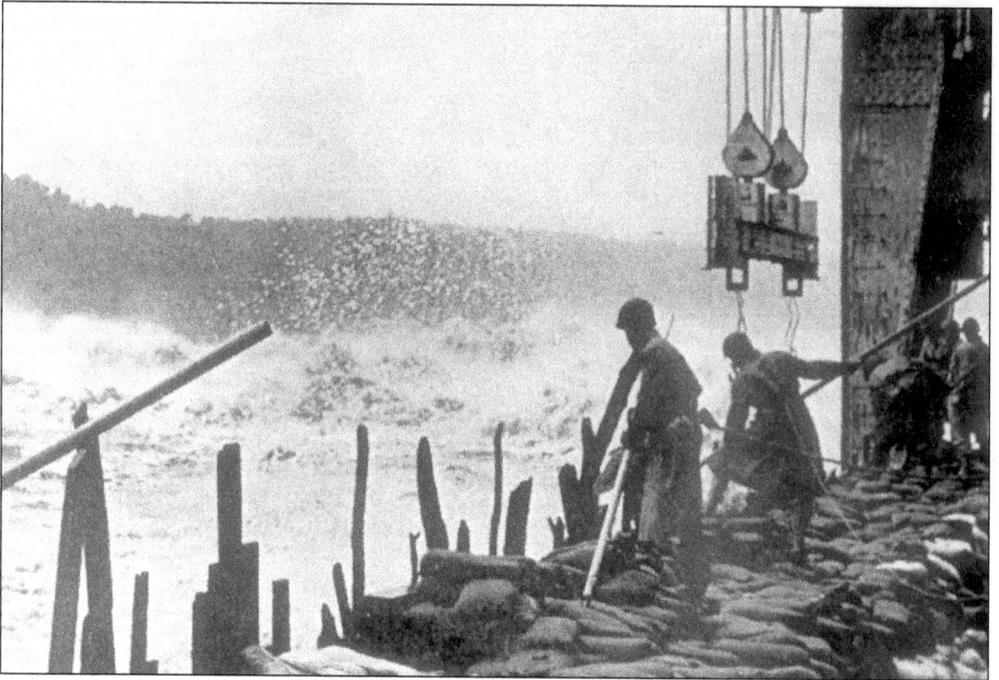

One hundred and fifteen limited service men from Fort Leonard Wood and later, a battery of 130 artillery men, assisted in the effort to save the powerhouse, because the electricity being generated by the dam was helping run the factories in St. Louis that were supplying materials to the war effort in Europe. There were also hundreds of civilian helpers. (Photo courtesy of Union Electric Magazine.)

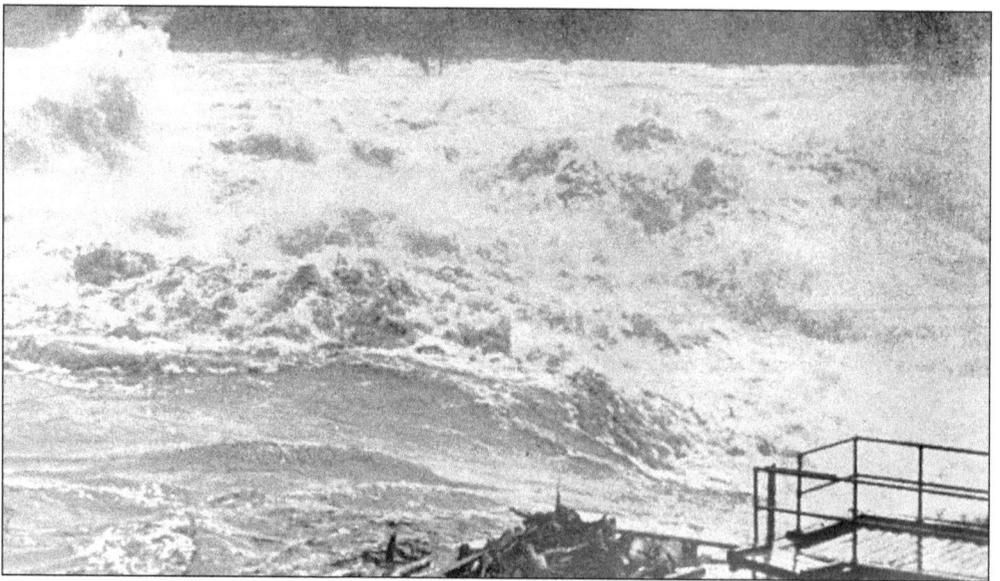

The huge waves of angry water carried enormous pieces of driftwood that pounded at the 25,000 sandbags used to hold back the flood and keep it out of the powerhouse. While today's tourist often wishes he or she could see all of the floodgates fully open at once, the reality of it can be frightening. (Photo courtesy of Union Electric Magazine.)

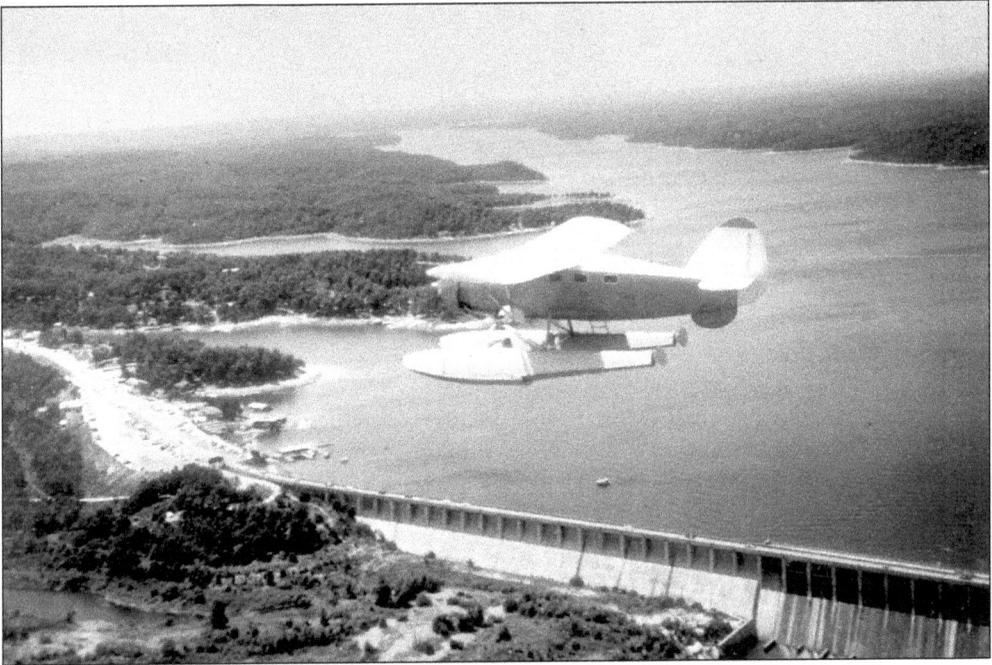

What tourists can do and have been able to do since almost the day the dam was finished is take an airplane ride. The higher one flies, the more impressive the lake becomes, looking like a many-armed dragon of sparkling blue set within a carpet of green forest. (Photo courtesy of Bruce James.)

This air photo by the late Gerald Massie of the old Missouri Resources and Development Commission was turned into a picture postcard and sold in the Lake of the Ozarks area for many years. Massie was fond of flying over the lake, and his photos were used by the Commission to promote Missouri tourism in numerous publications and guidebooks issued by the state.

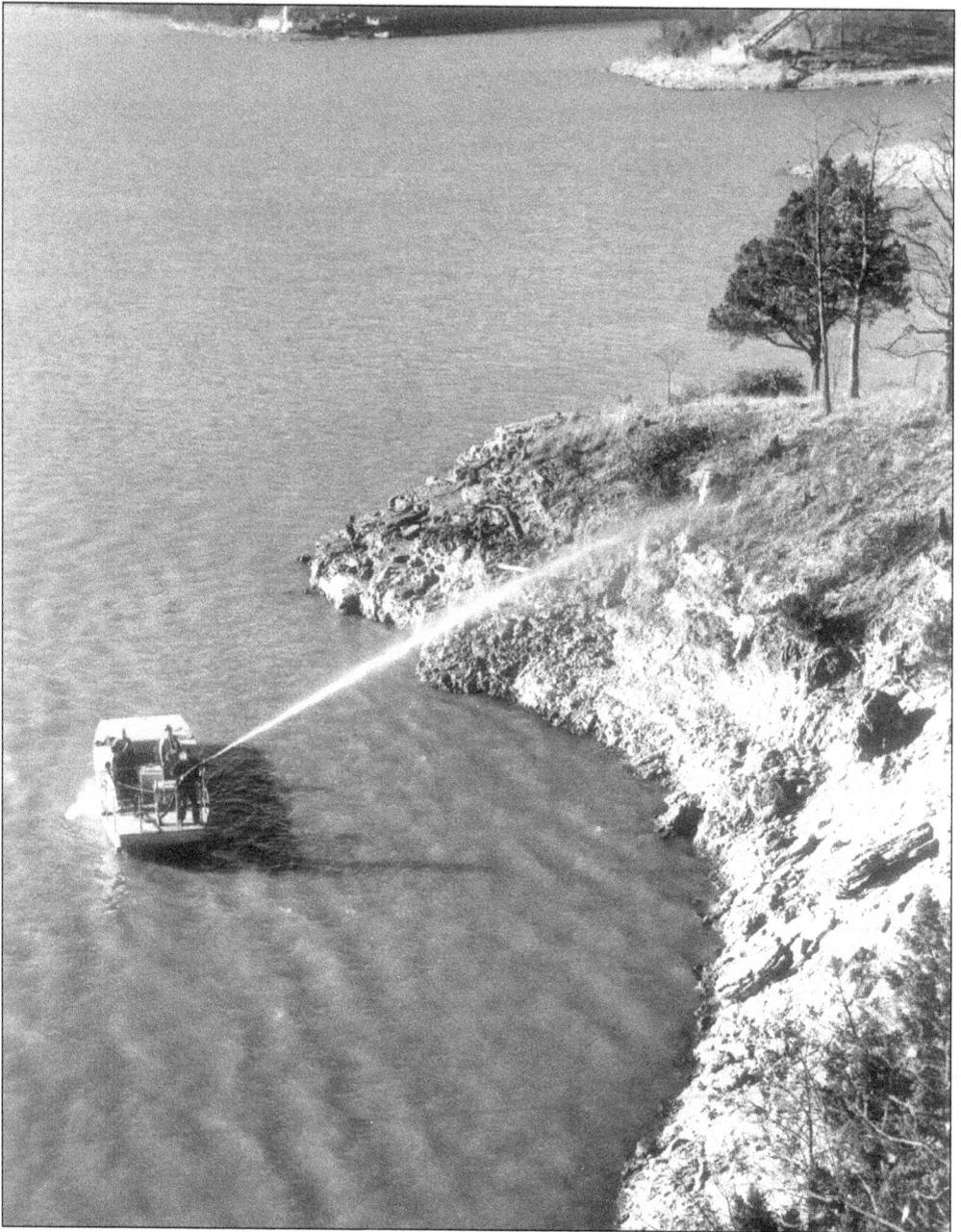

Along with flooded land, lakes, and shallow coves come mosquitoes and mosquitoes are not popular. They also breed disease, so the Union Electric Land and Development Company launched what became known as the "Mosquito Fleet" in 1932. Originally, the fleet was composed of 15 boats and 60 men that sprayed the entire shoreline of the lake at least every 8 days with a mixture of kerosene and water to destroy mosquito larvae. The fleet operated for many decades and also sent men around the lake collecting mosquito larvae to determine how successful their efforts were. The annual cost in the early days was about $60,000 per year. The work was greatly appreciated by the lake's tourism industry. Less expensive, more effective procedures are used today. Photo c. 1950. (Photo by Massie; courtesy of the Missouri State Archive.)

Three

LAKESIDE AND LAKE OZARK

"A new town has sprung up at the southwest end of Bagnell Dam," said the *Versailles Statesman* newspaper on Aug. 4, 1932. "The name chosen by Uncle Sam is Lake Ozark." Even though Lake Ozark acquired its name in 1932, it took decades for the community to achieve a true identity of its own. It has long been regarded as the "Bagnell Dam Area" and even promoted that way by its Bagnell Dam Chamber of Commerce.

In 1941, Lakeside was described as "a village built and maintained by the Union Electric Light and Power Company, owner of Bagnell Dam," even though it wasn't a typical village with a main street. Lake Ozark was a single row of one and two-story buildings, hotels, restaurants, dance halls, taverns, and shops with seemingly endless possibilities for development.

In 1932, the *Lake of the Ozarks News* declared there were three classes of people visiting the new lake: "The tourist out of work...the middle class...and the rich man." The middle class "chooses the cabin camp" and the rich man the "high grade lake hotel, inn, or lodge. The first class will take what you have, willing to rough it a bit, the second class expects some modern improvements and excellent service. The rich man expects what he has been used to." Lakeside was accommodating to the rich man, and Lake Ozark was taking care of everyone else. Today, with the near demise of mom-and-pop tourist camp operations, such class distinctions aren't much noticed.

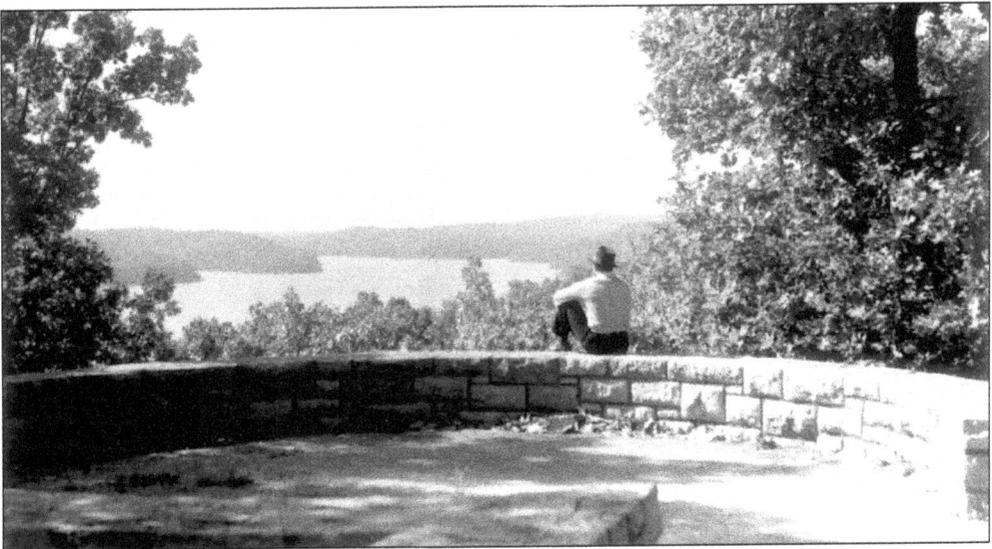

Before the 1970s, tourists driving southwest on Hwy. 54 from Eldon found this little roadside park on the property of Roots County Store three-quarters of a mile before they reached the dam. It was their first opportunity to see Lake of the Ozarks. The wall this man sits on still exists, but the store is out of business, trees have grown up to block the view, and Hwy. 54 bypasses this section. (Photo by Massie; courtesy of the Missouri State Archives.)

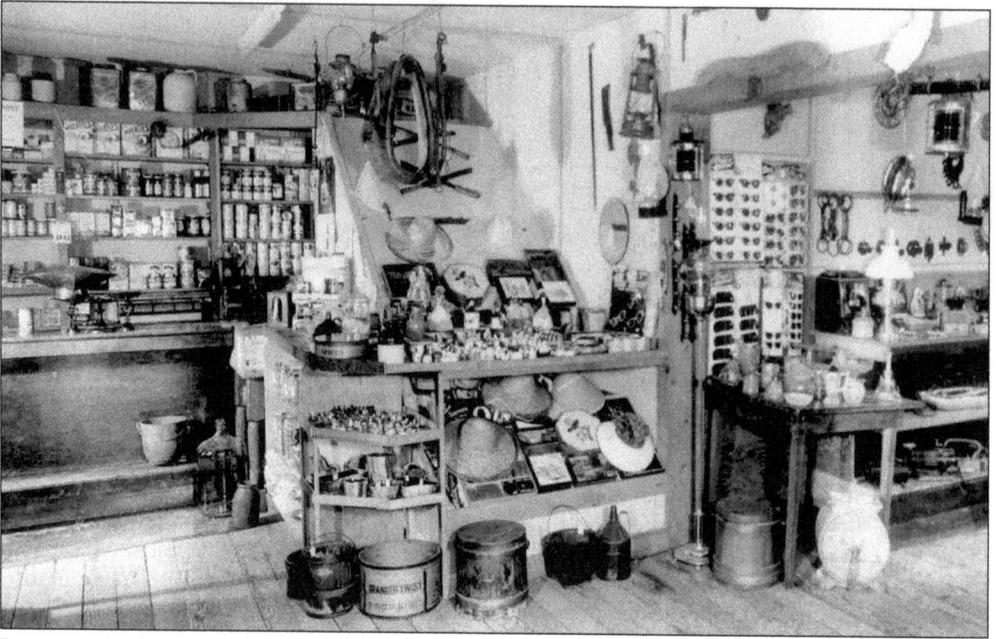

Roots Country Store, with its quaint interior, was a good place for fisherman at Bagnell Dam to buy food and other lunch supplies in the early days. But they had to go elsewhere to buy bait and tackle. Ann Roots, who ran the store, was well known. Unfortunately, the store's business died after the main highway bypassed it. (Photo courtesy of John Bradbury.)

Sutton Motel, even closer to the dam than Roots Country Store, was operated by Leonard and Flo Sutton. Leonard was a retired Union Electric employee. Today, this building is used as a dentist office and still looks much the same. The playground for children to the left and the telephone booth are long gone, and so is the "Tourist Camp Approved" sign next to the telephone booth.

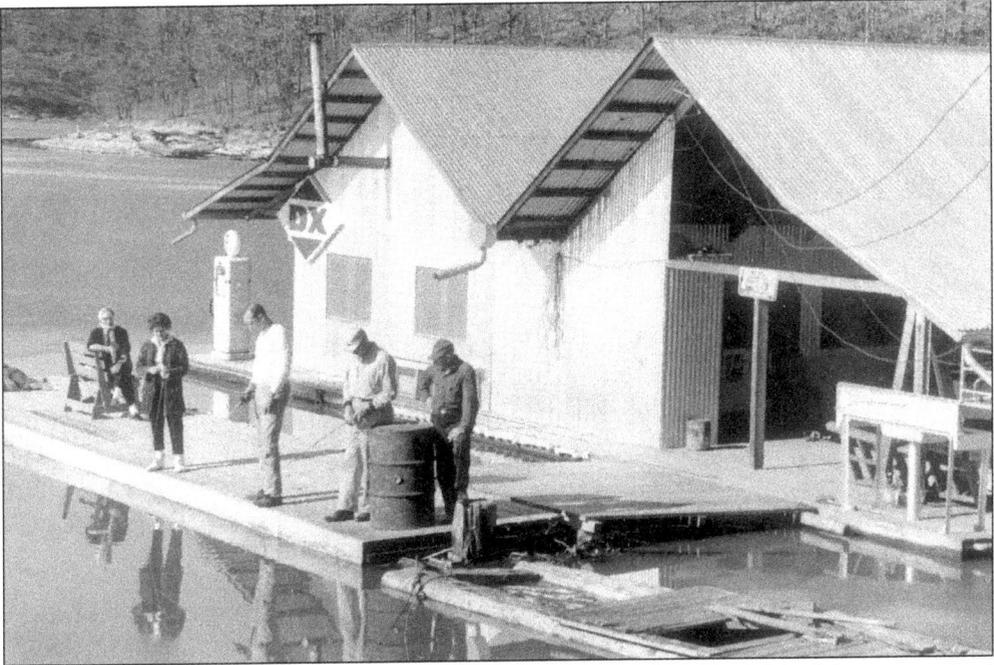

Among the memorable—but vanished—businesses along the shoreline of the lake just north of Bagnell Dam was Brinkmans' Heated Dock. Oscar Brinkman began his career with Union Electric at the dam in 1933. When he retired, he built this heated fishing dock just one mile upstream from the dam at the end of Lake Road 54-26. Today, Spinnacker's Condominiums occupy the shoreline to which this dock was once cabled. (Photo courtesy of Sylvia Brinkman.)

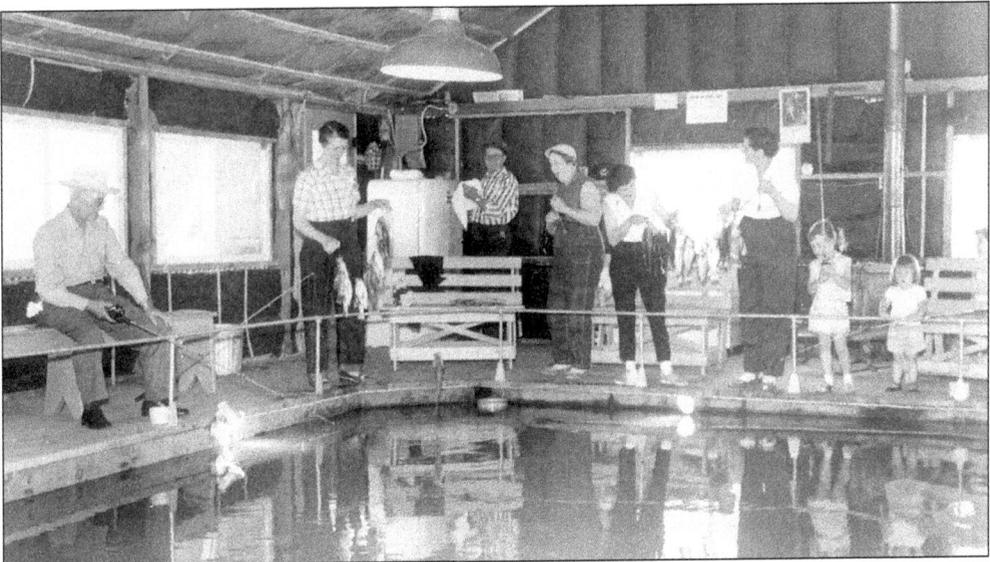

The beauty of Brinkman's Heated Dock was that it made lake fishing pleasant even in the dead of winter. When the Brinkman's chose this site, Lake Road 54-26 didn't exist. They paid for its construction. "People could fish at our dock for $1 a day," said Sylvia Brinkman. "We sometimes took in $100 a day. We sold all kinds of fishing tackle. We had soft drinks, and a gas pump out on the corner of the dock." (Photo courtesy of Sylvia Brinkman.)

41

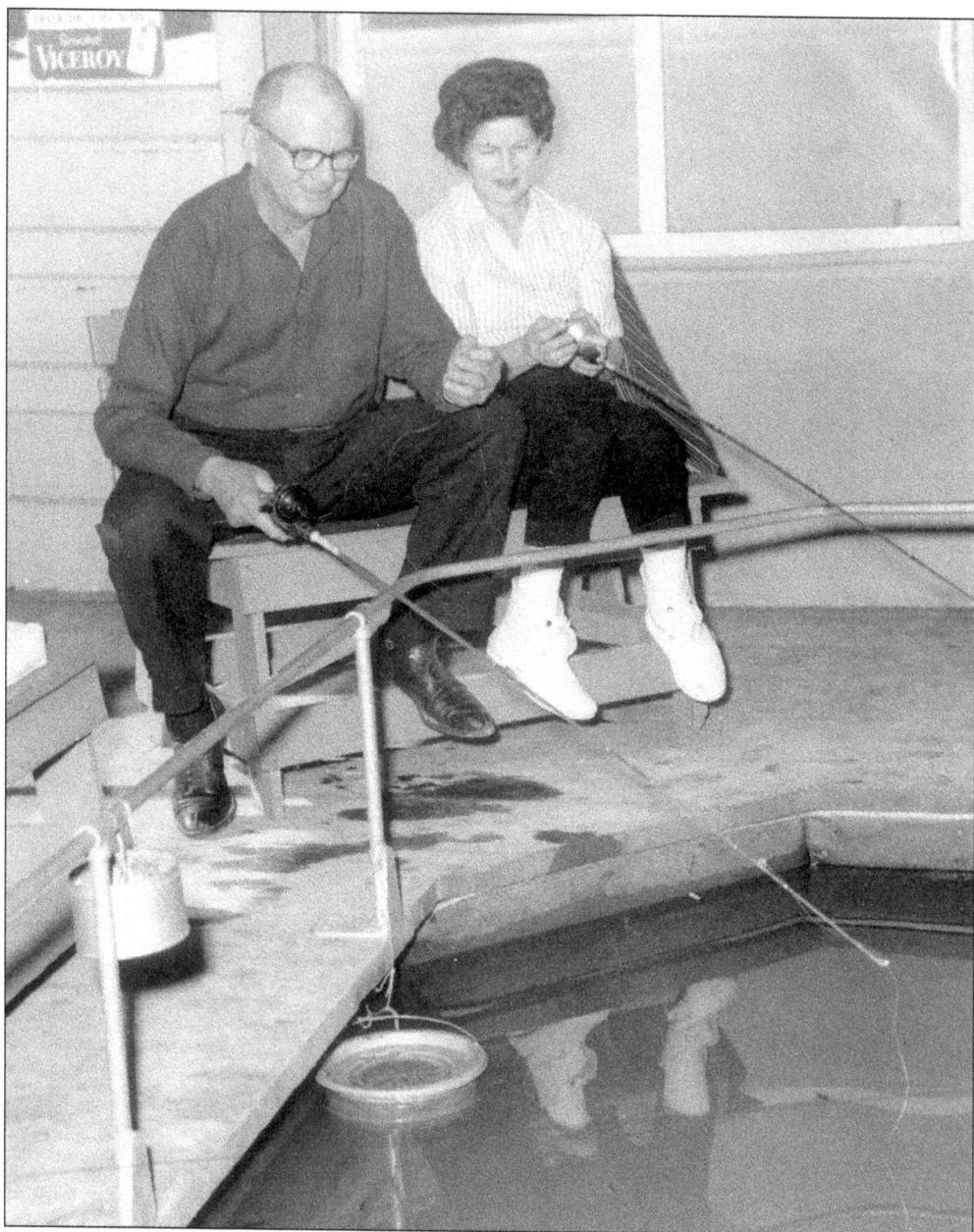

Oscar Brinkman, now deceased, and his wife, Sylvia, now in her late 80s, are seen here enjoying their own fishing dock soon after it was built. "We sold bait, mostly minnows," Sylvia said. "We almost kept the bait man east of Eldon in business. In the winter, the potbellied stoves kept the dock room pretty warm. It had lots of windows to open in the summer and there was almost always a breeze." A wind storm eventually tore up the heated dock and the Brinkman's did not rebuild. Bagnell Dam is in Miller County, and Sylvia Brinkman has lived in Miller County all of her life. One of the sad features of today's development at the lake is that so few of the pioneer businesses and business people of the lake have been forgotten because they have not been remembered in the place names of the lake. The name Brinkman's Point, as it was originally called, has vanished. (Photo courtesy of Sylvia Brinkman.)

Grandview Camp, about one-quarter mile from the northeast end of Bagnell Dam on Hwy. 54, was built in the 1940s. The original cabins were log, but as business improved and the years passed, the cabins were continually upgraded. Today, nothing remains to even show where these cabins might once have stood.

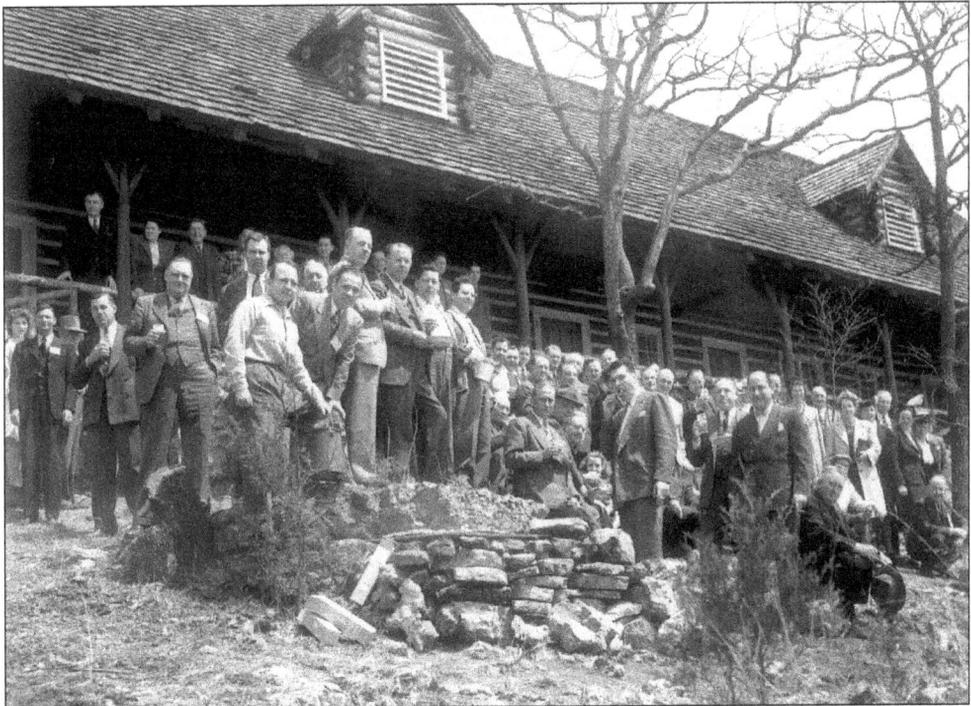

Willmore Lodge, just north of the dam and still within the boundaries of Lakeside, was built by the Union Electric Land and Development Company in 1930 to serve as an administrative and entertainment center during the dam's construction. It has always been a favorite site for convention activities, like this one during the 1950s. The Lodge now houses the Lake Area Chamber Visitor Center and Museum. (Photo by Massie; courtesy of the Missouri State Archives.)

The Lakeside Casino Restaurant, no longer in existence, was built by Union Electric Land and Development Company and offered good meals and fountain service at affordable prices during the Depression years. The screened-in pavilion had a unique canvas floor designed for dancing. The west end of the dam was the gathering place for the greatest number of visitors in the early days, and the location of the Casino made it a very profitable business. (Photo courtesy of AmerenUE.)

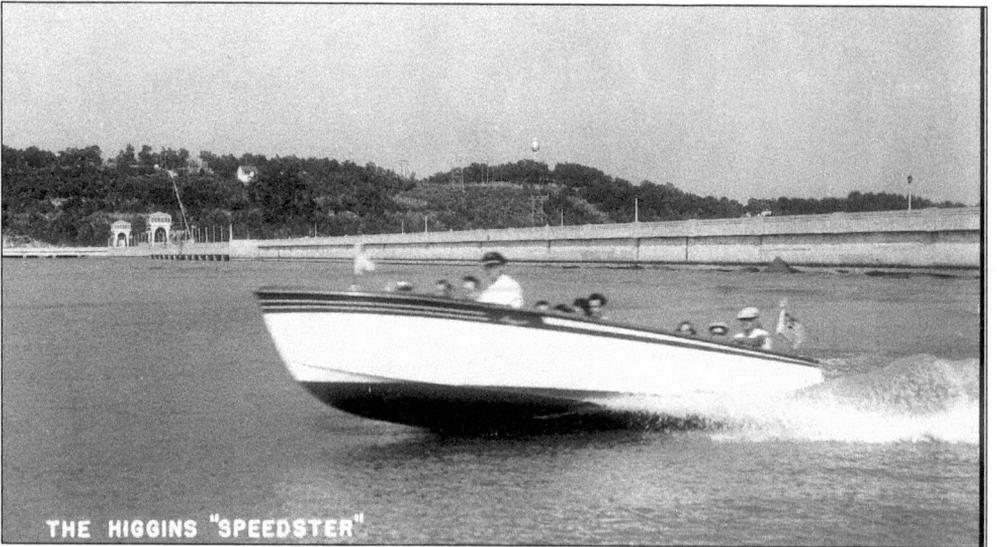

THE HIGGINS "SPEEDSTER"

The first boat dock and excursion boat business at the west end of the dam was built and operated by the Union Electric Land and Development Company. Later, the site, under private ownership, became known as Loc-Wood Dock. Loc-Wood continued the excursion and speedboat business. Here, the Higgins Speedster gives visitors to the lake a fast ride in the late 1940s.

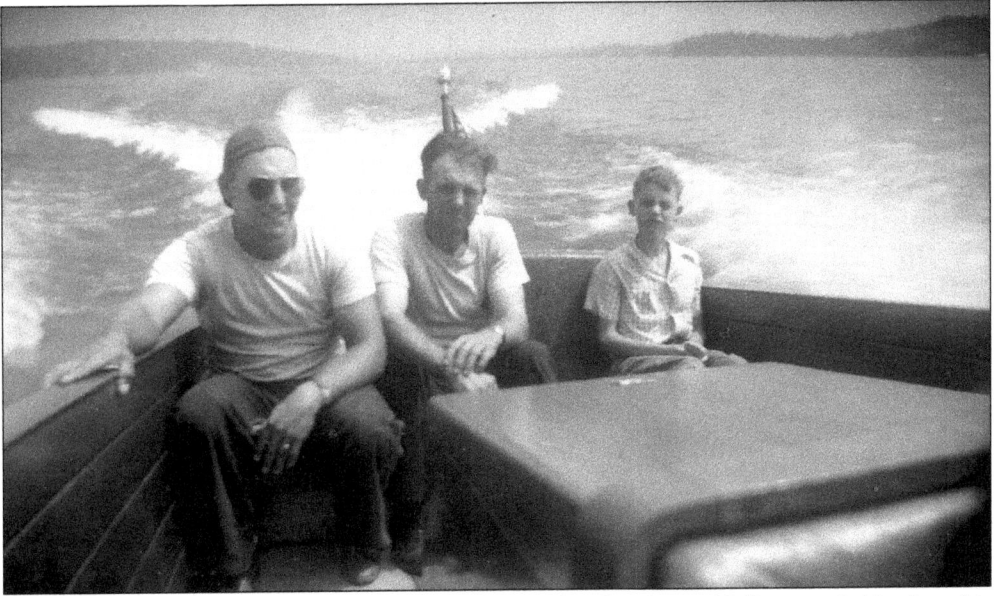

The author became acquainted with the Lake of the Ozarks in 1949 as a child when his parents began going to the lake to fish. Sometimes they enjoyed the recreation provided by the excursion boats and speedboats at Loc-Wood Dock. Here, the author, at the age of 11, sits in the back of the Higgins Speedster with two unidentified men. His father took the photo.

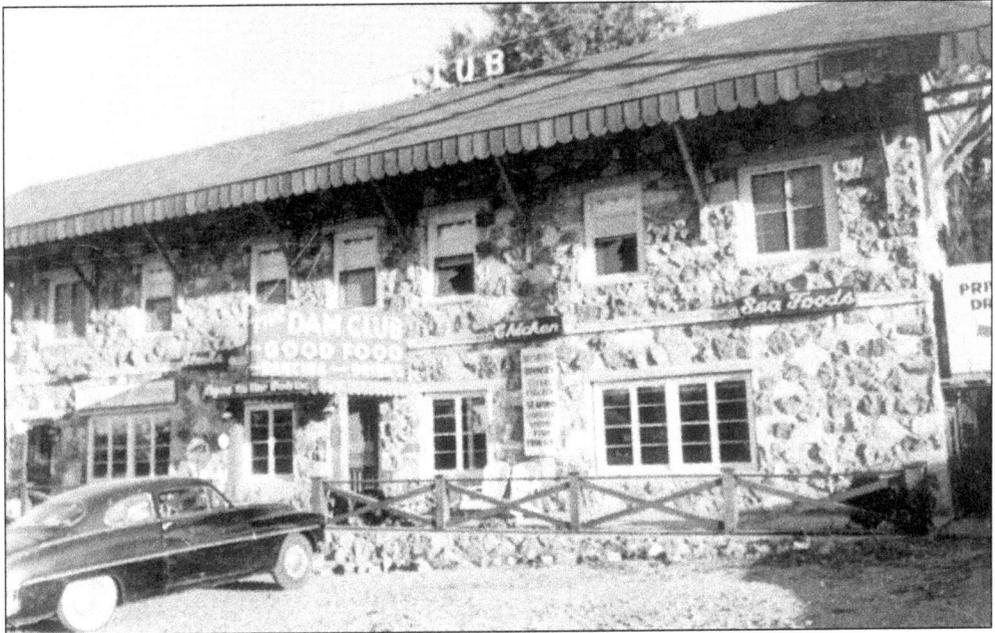

This native rock building on the Lake Ozark strip, built in the 1930s by Joe and Frances Hennessy, still stands virtually unchanged. In Hennessy's day, the second floor was used for a dancehall and the ground floor for the Katydid Gift Shop. People patronizing the dancehall stepped to the lively music of The Yachtsmen. The "dancehall image" of the Lake Ozark Strip was a phenomena of the 1930s and 40s. By the 1950s, the Strip had acquired a "family entertainment" image.

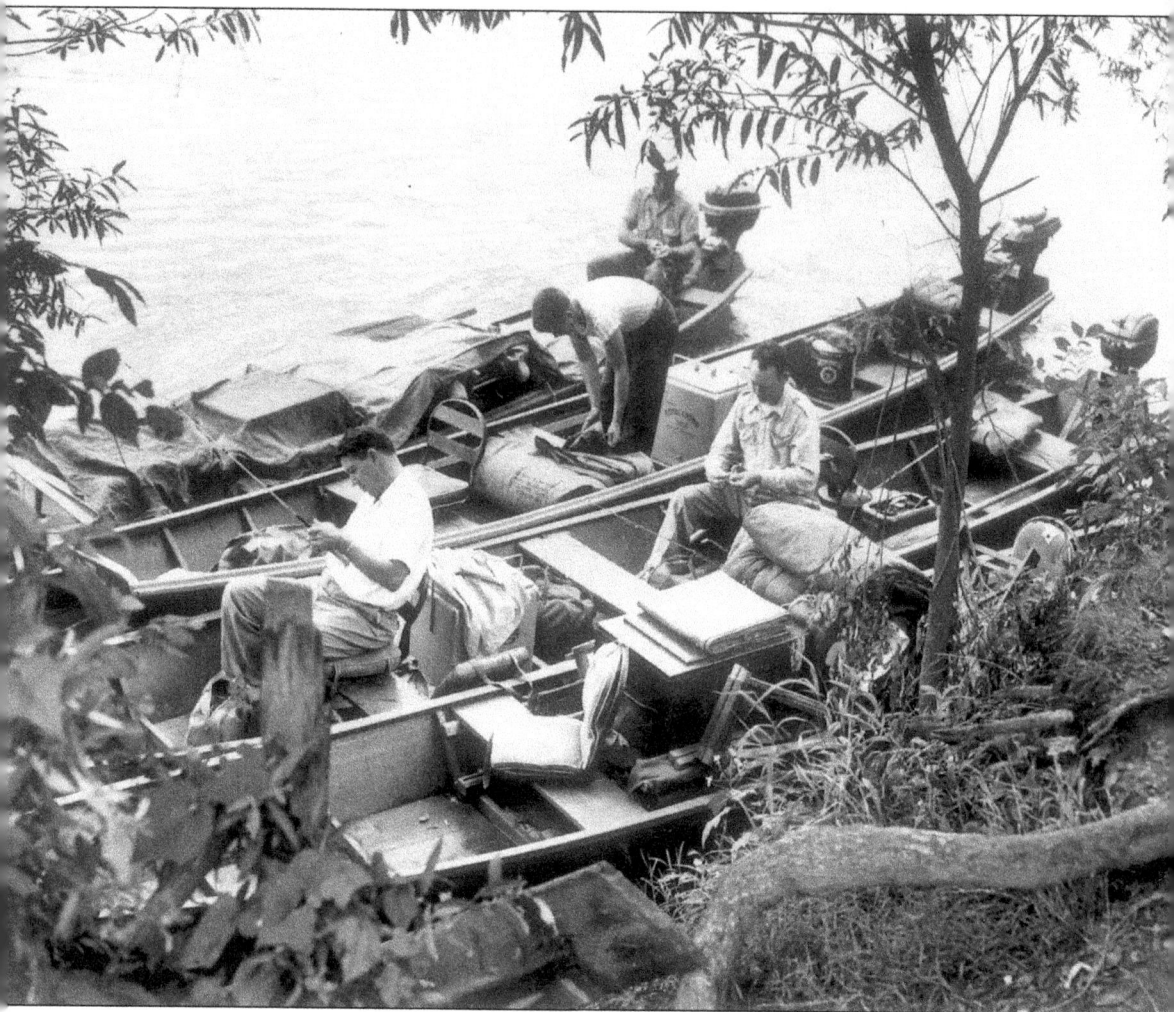

Float-fishing is a sport that originated on the clear, spring-fed streams of the Missouri Ozarks. Sportsmen began coming to Lake of the Ozarks to float-fish in the 1930s and 40s. Several arms of the lake are almost entirely spring fed, such as the Niangua Arm, which has Bennett Springs at its headwaters. There were a number of native residents of the area who turned their fishing savvy into a paying occupation after the creation of the lake by becoming fishing guides. The Ozark johnboat was the preferred choice, even in the 1950s when this photo was taken by Massie as a group of float fishermen prepare themselves for a weekend of great fishing on the lake. The boats carried camping gear, as well as fishing gear, so they could camp overnight during which the fishing guide would prepare chow. The guide received a daily fee for his work. (Photo courtesy of the Missouri State Archives.)

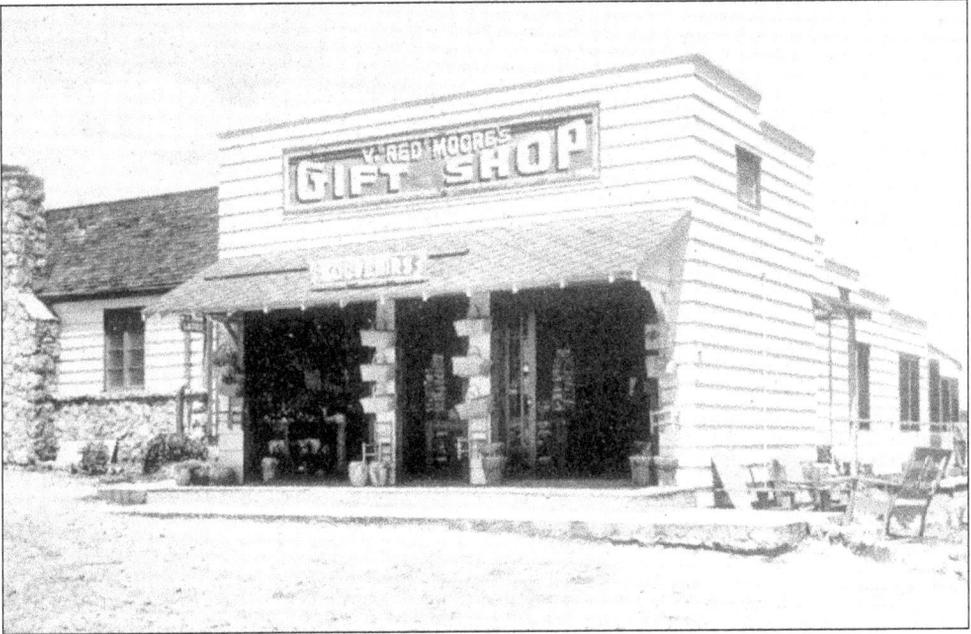

V (Red) Moore and his wife, Carrie, established themselves in Lake Ozark in 1930 and during their 23 years of business, operated two restaurants, a hotel, and a gift shop. The Union Lunch Shop was their first business on the Lake Ozark "Strip." After the Lunch Shop burned in 1939, they built the above gift shop. Gift shops like these were a form of recreation for the wives of men who went fishing on the lake and didn't take them along.

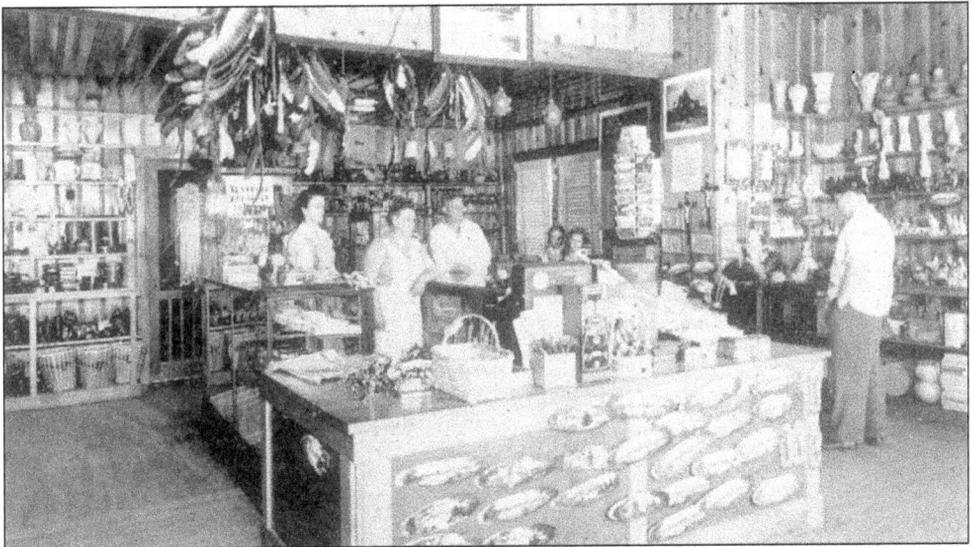

The Moores operated their gift shop until 1949, then sold it to Paul Wolff. The Moores retired in 1953. The interior of the gift shop was knotty pine and many of the souvenirs were made of native red cedar. The tree slices hanging along the front counter had painted lake scenery on them and were very popular. Cedar novelties have been popular in the Ozarks since the 1930s and are still sold in gifts shops around the lake.

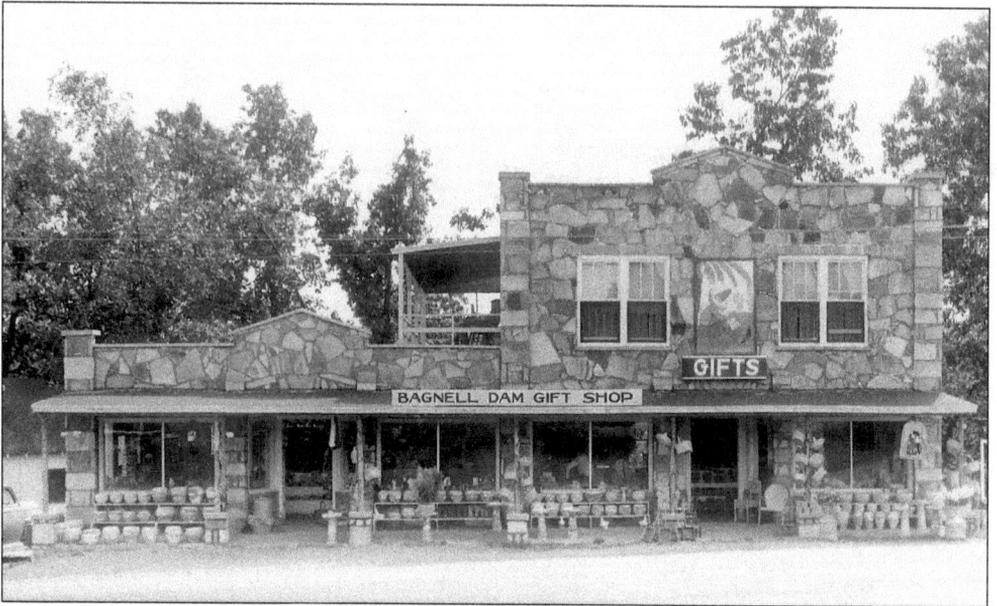

The Bagnell Dam Gift Shop building, constructed in the early days by E.R. Wiseman, still stands on the Lake Ozark Strip. The Wisemans lived on the second floor. Only the rockwork and roofline help identify this building today, as a new front has been added. It is currently owned by Lisa and Steve Dalton, who use the business name, Frick & Frack.

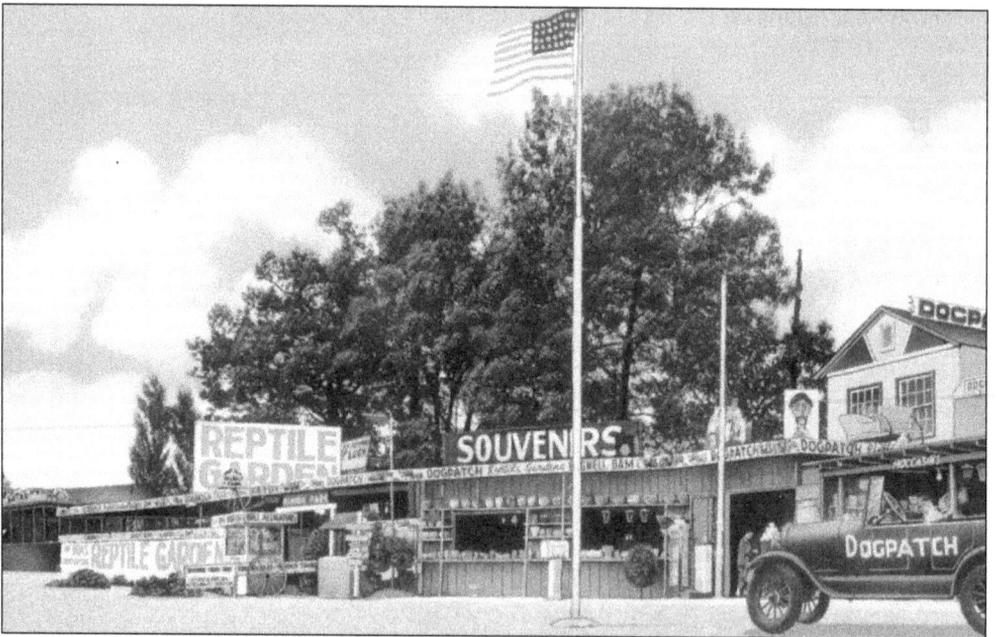

In 1932, American cartoonist Al Capp created the cartoon strip *Li'l Abner*, which featured Li'l Abner Yokum, a hillbilly from Dogpatch, U.S.A. In 1946, Walter and Ada Tietmeyer from Nebraska created a roadside attraction on the Lake Ozark Strip called Dogpatch. Behind the reptile gardens and gift shop, they recreated a backwoods village with a humorous touch. Dogpatch still exists on the Strip but not in the form seen in this early postcard view.

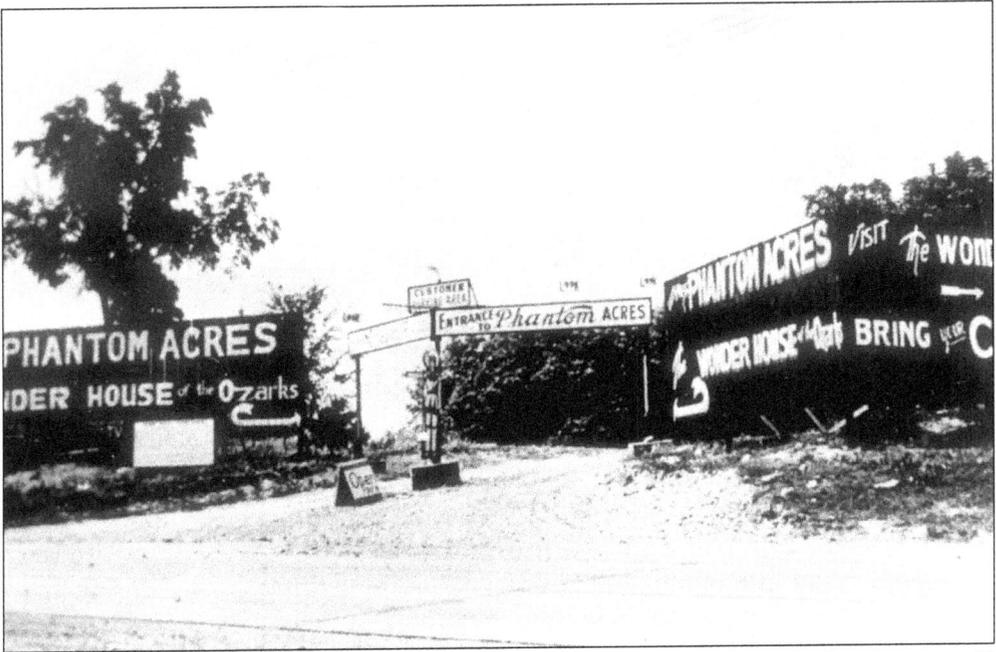

In the 1950s and 60s, after visiting the hillbilly-flavored nonsense at Dogpatch, tourists could go next door to Phantom Acres where absolutely nothing was on the level. Here, there was a "Mystery House," which seemed to exhibit an unusual gravitational anomaly, which made it impossible for anybody to stand up straight in the building and where water, of all things, ran uphill! By the 1970s, Phantom Acres was gone. (Photo courtesy of Danny Lane.)

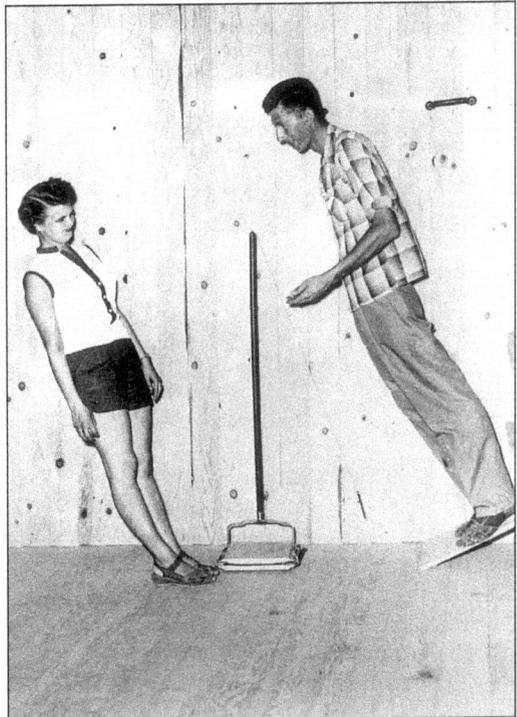

The fact that there were nearly 300 such "mystery houses" throughout the United States in the late 1950s was never mentioned after you paid your fee and struggled to find your way from the entrance to the exit of the Mystery House. Nor did they attempt to explain why such oddities could only be found where tourists seemed to congregate. There was also a hillside "mystery shack" in the Gravois Mills area of the lake.

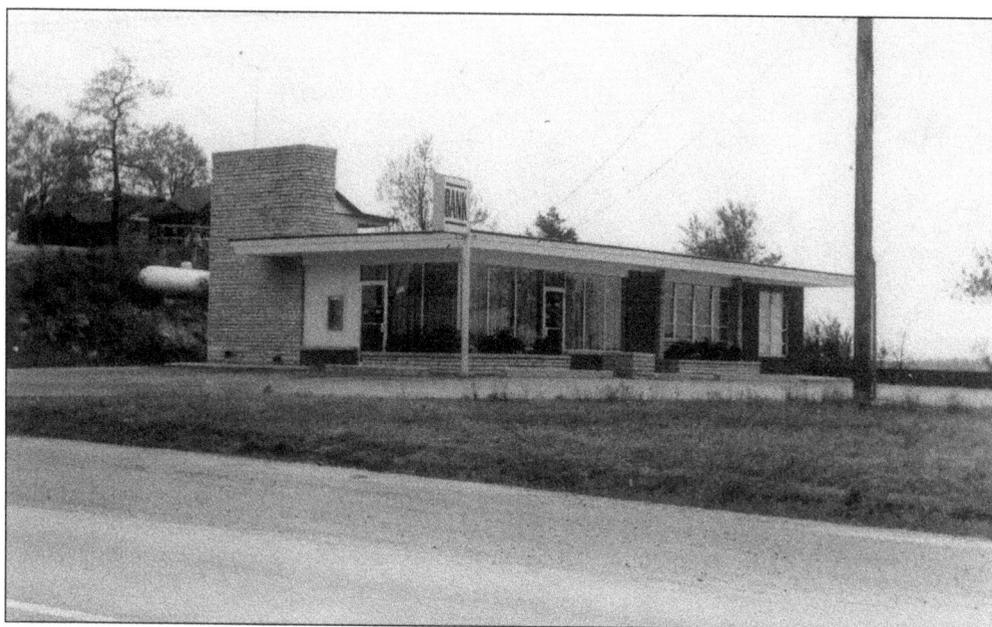

Rising from the charter that was previously the Bank of Brumley, Bank of Lake of the Ozarks opened in 1960 in Lake Ozark along Hwy. 54, adjacent to Mills Cottages overlooking the main channel of the lake. In 1986, it became Central Bank of Lake of the Ozarks. Today, the bank's main facility is located in Osage Beach with branches throughout the lake area. Since it opened, the bank has been the financial backbone of much of the lake's growth and development.

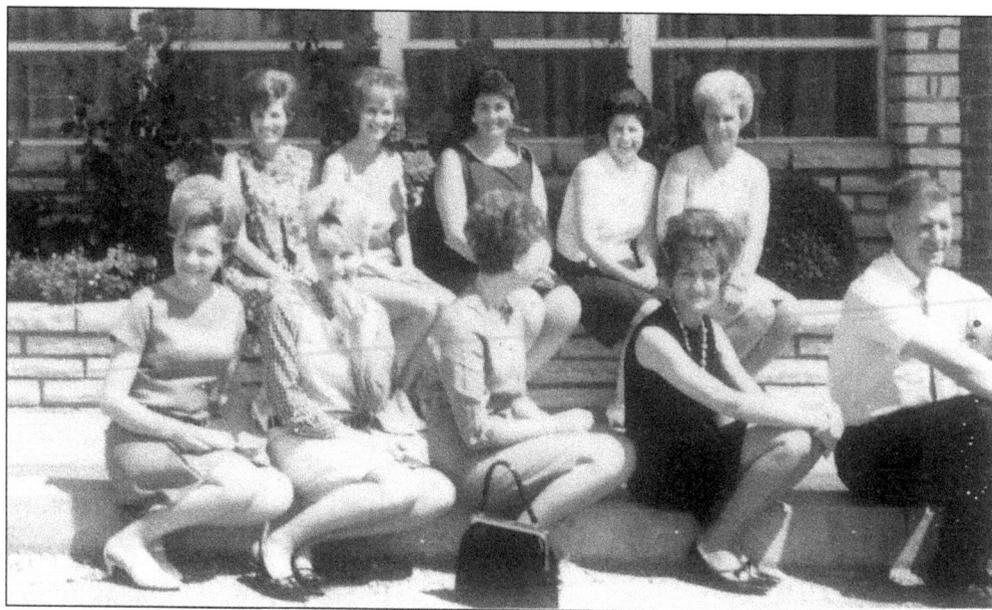

This 1960s photo shows most of the original employees of Bank of Lake of the Ozarks, from left to right, as follows: (front row) Wilma Davis, Carol Stith, Carol Hudson, Jerry Thompson, and James Franklin Sr., president of Bank of Lake of the Ozarks from 1960 to 1986; (back row) Mary Lou Rohls, Edwina Stone, Donna Swadley, Rosie Weaver, and Bonnie Chase.

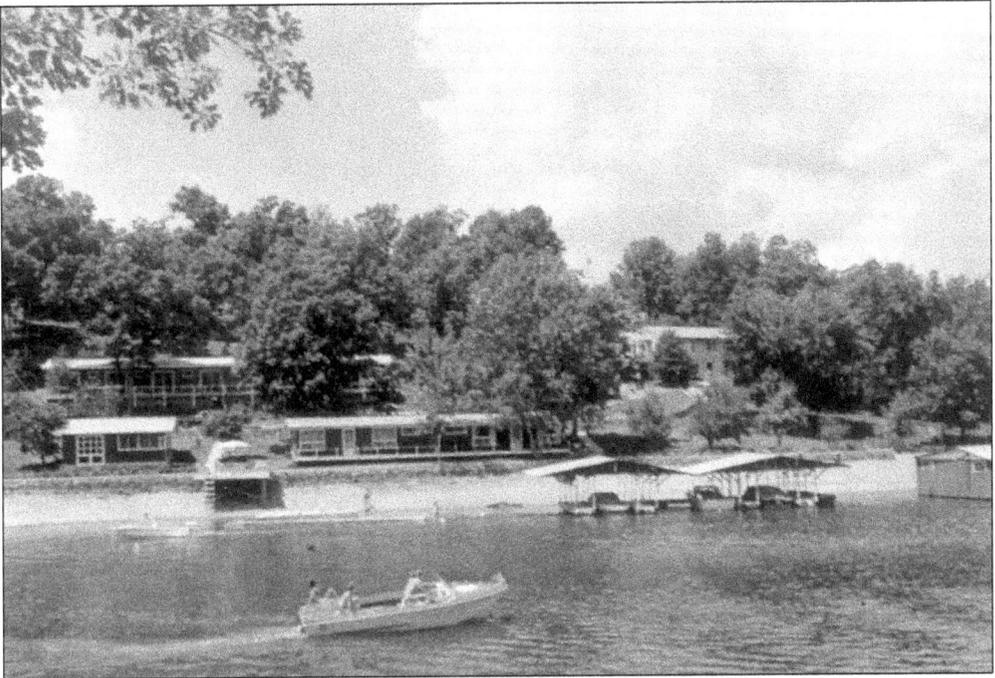

Thompson's Cottages was located on Lake Road 54-9 with some cottages only 15 feet from the water's edge. It was here that Hadley Thompson and his wife, Icel, opened one of the first water ski schools at Lake of the Ozarks. The school had fully licensed instructors. Hadley generally drove the speedboat that pulled the skiers, especially when public performances were given.

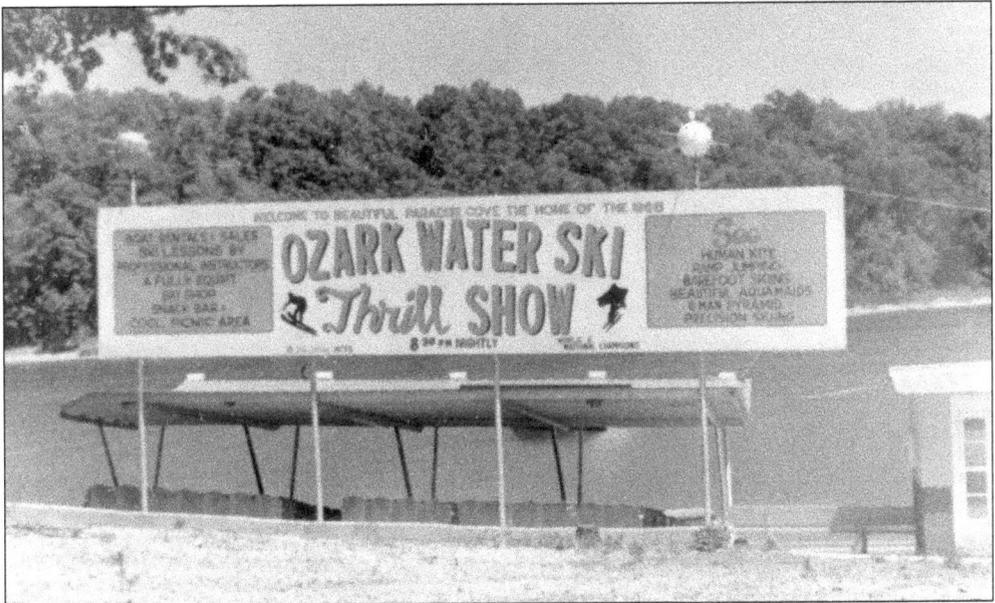

Performance water skiing began in the 1950s in Paradise Cove, a short distance up-lake from Bagnell Dam on the south side. The first show was called "The Ozark Water Ski Pageant." The business later sold to Tex Bemis who changed its name to the "Ozark Water Ski Thrill Show." In the mid-1960s, the Bagnell Dam area was also host to the "Oak Royal Water Ski Show."

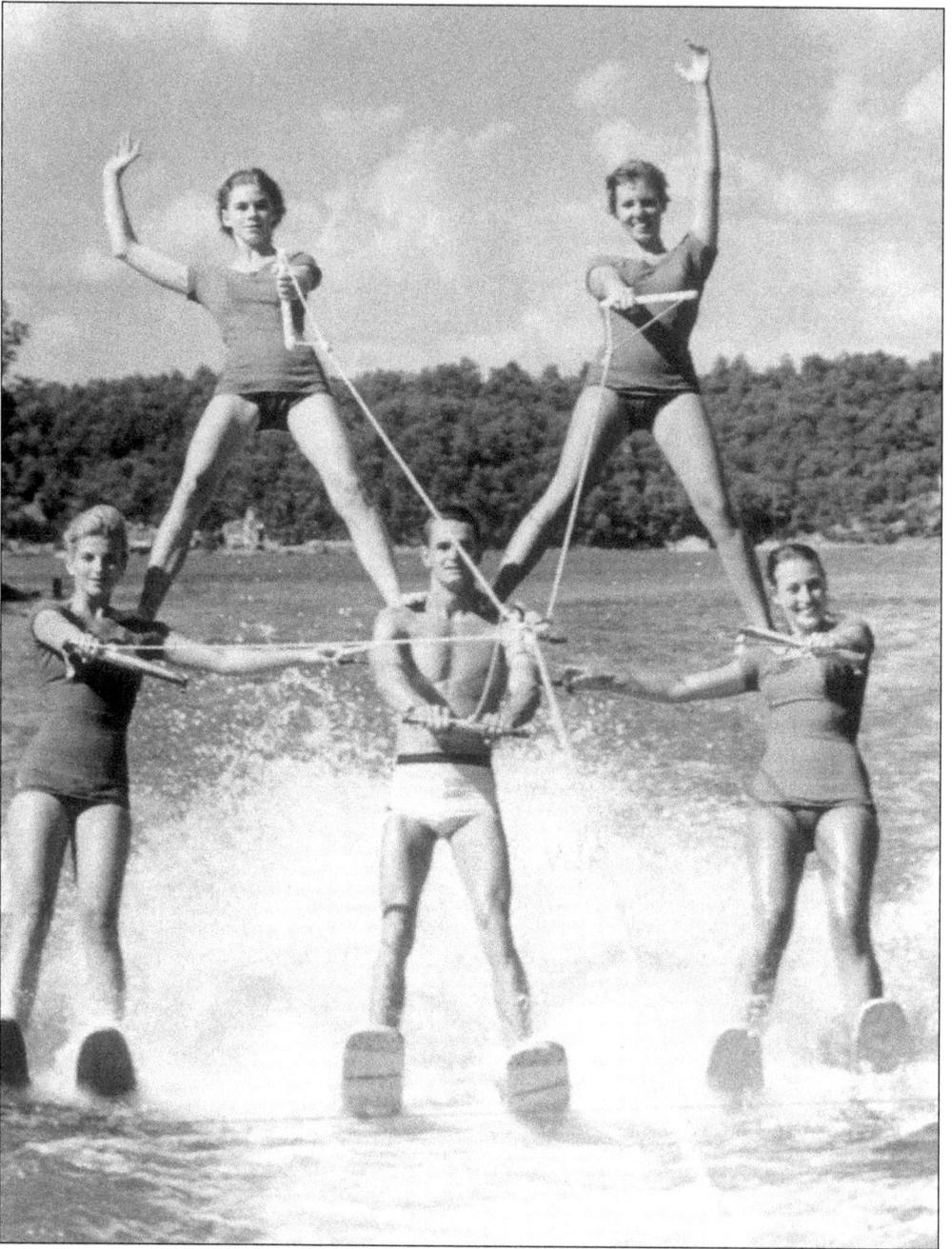

The Ozark Water Ski Pageant featured this skilled group of water-skiing local young people. In the bottom row, left to right, is Cookie Clayton, Larry Fry, and Sharon Sutton. Standing on their shoulders, left to right, is Ruth (Skeeter) Payne and Jane Fry. In the background, between the knees of Ruth Payne, is Lighthouse Lodge on the north shore and to its right between the knees of Jane Fry is the Brinkman's Heated Dock. Ruth Payne is the daughter of Oscar and Sylvia Brinkman, who owned and operated Brinkman's Heated Dock. Sharon Sutton is the daughter of Leonard and Flo Sutton, the former owners of the Sutton Motel, north of Bagnell Dam. Both businesses are featured in this chapter. (Photo courtesy of Sylvia Brinkman.)

Country music is native to the Ozark region. Today, Branson, Missouri, about 130 miles south of Lake of the Ozarks, is world renowned for its theaters and popular country music entertainers. It is often called the Nashville of the Ozarks. But Lake of the Ozarks captured the country music theme years before Branson did. Austin's Nashville Opry was a popular attraction along Hwy. 54 in Lake Ozark in the early and mid-1960s.

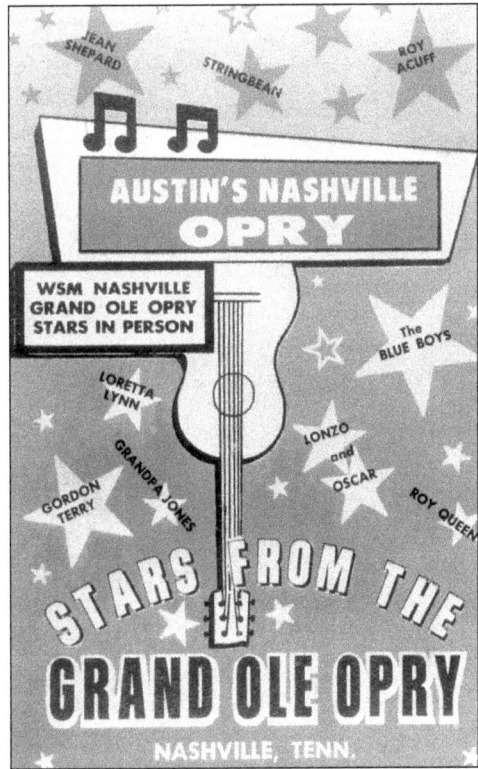

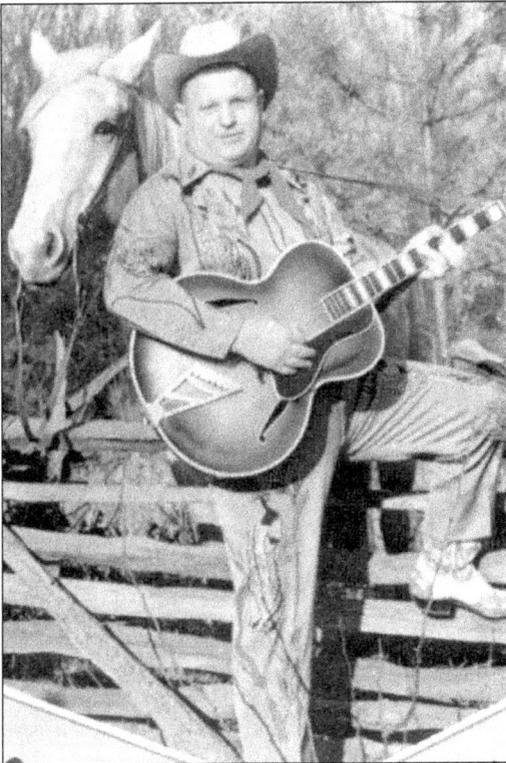

Austin Wood, the show's promoter, was a local country music singer. What made him unique was the fact that he was blind. His Nashville connections made it possible for him to get stars from the Grand Ole Opry to perform on his stage. The show had its difficulties and, unfortunately, did not survive the 1960s, but his building still stands and today houses Inland Marine, a company that sells boats.

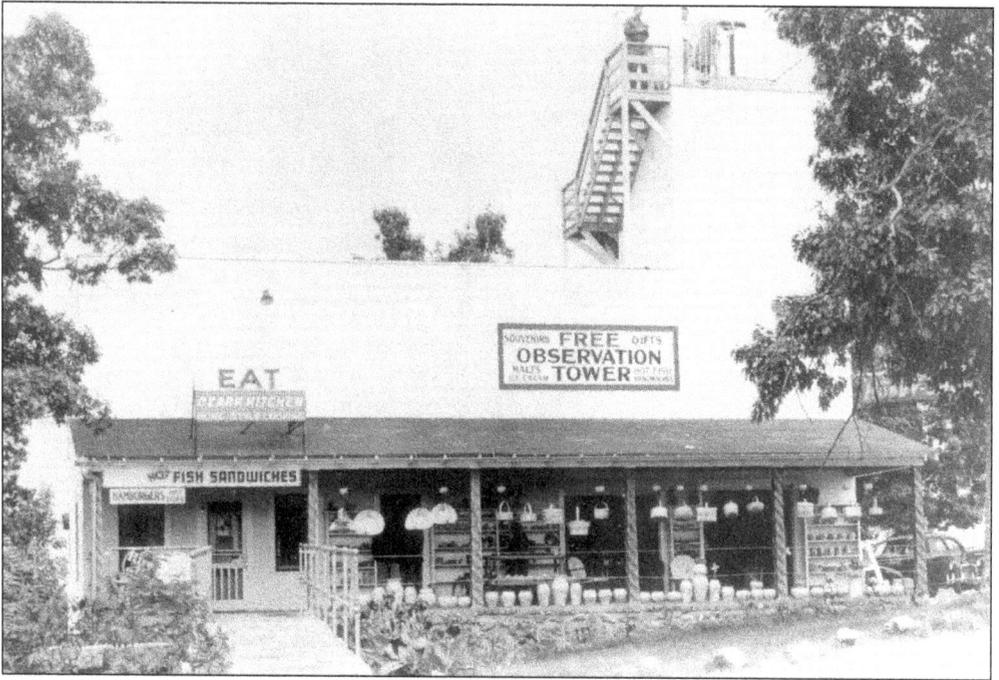

The Tower Hobby Shop and Café, once a landmark south of Bagnell Dam near what is today the junction of Hwys. 54 and Bus. 54, no longer exists. The business was originally owned and operated by Fred and Mable Smith. A roof was eventually built over the top of the observation tower. There was no charge to visit the tower, but just about everyone who made the climb managed to spend some money on the telescopes.

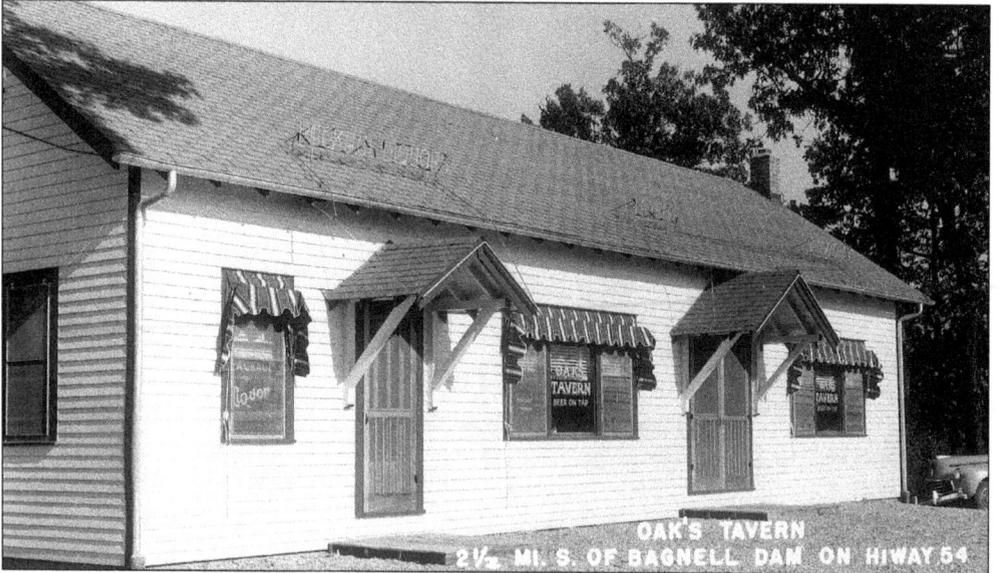

Oak's Tavern was one of the popular "watering holes" along Hwy. 54 in the Lake Ozark area in the 1940s, 50s, and 60s. It was noted for beer on tap in frosted mugs and its "Blue Room." Each new owner made changes to the building. This vintage structure is long gone. Today, this site is occupied by Maggie Mae's Gourmet Grill and Bar.

Four

OSAGE BEACH

Until 1969, a traveler had to pass through Lake Ozark to reach Osage Beach coming from the north. For three decades, the area around the dam was the most prominent focal point of attention for vacationers during the summer months. Then, the dam area was by-passed by new highway construction and Lake Ozark found itself on Bus. 54. The two highways rejoin 6 miles west of the dam near the Miller-Camden County line and the adjoining boundaries of Lake Ozark and Osage Beach.

Development in the Osage Beach area had been slow until the highway change. First time visitors to the area often let the highway funnel them directly into Osage Beach because they are unfamiliar with the layout of the communities. It is then necessary, in a sense, for them to backtrack to get to Bagnell Dam. At first, this caused some consternation in the Lake Ozark business community. It didn't help when Osage Beach advertised that they had "the largest and most of the finest resorts, motels, restaurants, and cocktail lounges...in the center of the family entertainment area of the lake."

Osage Beach has experienced a building boom and growth that hasn't stopped yet, while Lake Ozark has suffered over the past several decades. A new bridge across the lake in Lake Ozark to the southwest side, has helped, and efforts are now underway to upgrade the Lake Ozark Strip to draw more vacationers back to the place where it all began more than 70 years ago.

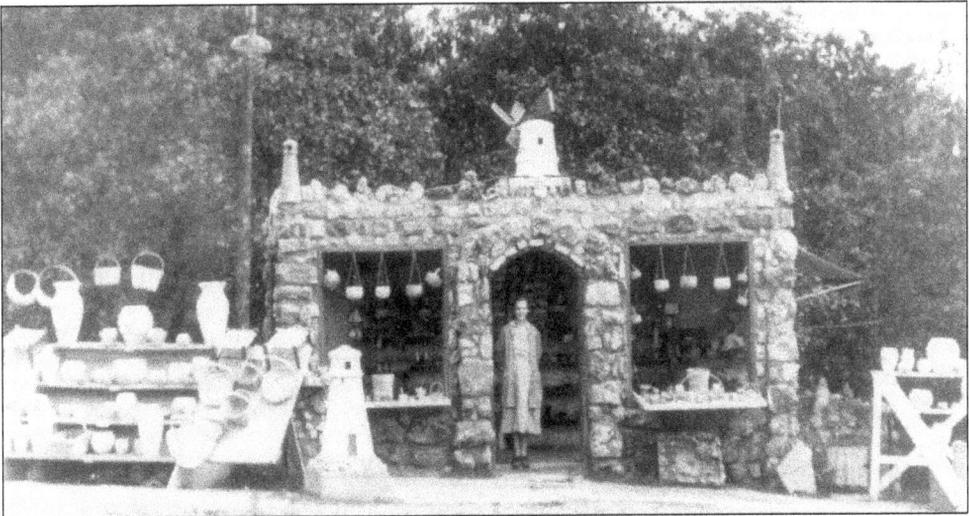

Cromer's Osage Beach Pottery Shop was built in Osage Beach in the mid-1930s along Hwy. 54. Francis Cromer stands in the arched doorway of the unusual Ozark rock masonry structure. The shop was adjacent to Harry Frack's Acre. Many buildings and retaining walls of the area were built of native rock in the 1930s, 40s, and 50s. Most of these structures, including this one, are gone. (Photo courtesy of the City of Osage Beach.)

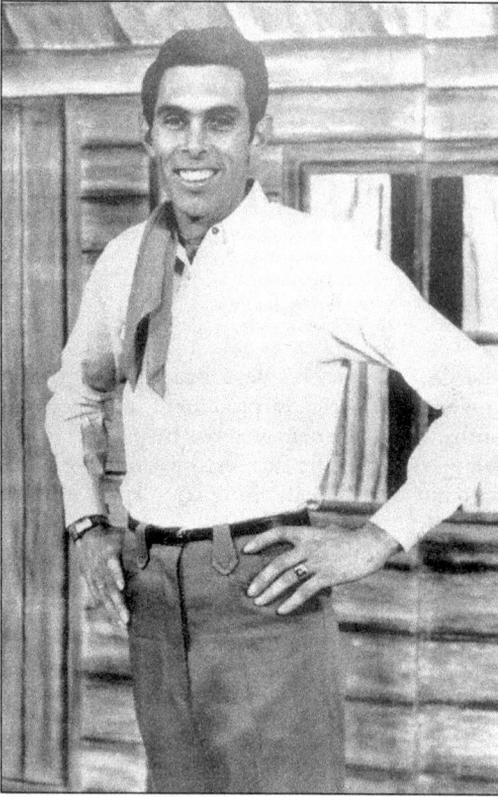

The late Lee Mace is the country music legend of the Lake of the Ozarks and the area's earliest country music ambassador. Born on a farm near Brumley, 10 miles east of Osage Beach on Hwy. 42, he practically grew up with a guitar in his hands playing for dances and picnics. He got into square dancing in the late 1940s and married his partner, Joyce Williams of Linn Creek, in 1951. Together, they created the Ozark Opry in 1953.

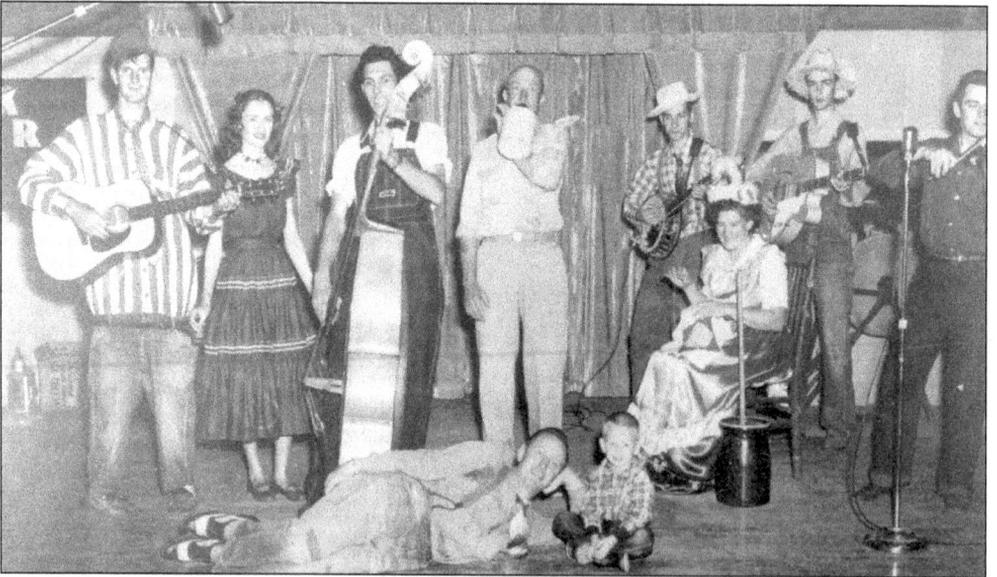

They rented a building next to Bagnell Dam for their show. It held about 200 people and it was not uncommon for people to bring their own chair because seats were at a minimum. Lee Mace, playing base, is shown here with his first group of performers, all of them local talent. They began with two shows a week and by the second season, were filling the house and having to perform more often to meet public demand. The show, you could say, was an instant success.

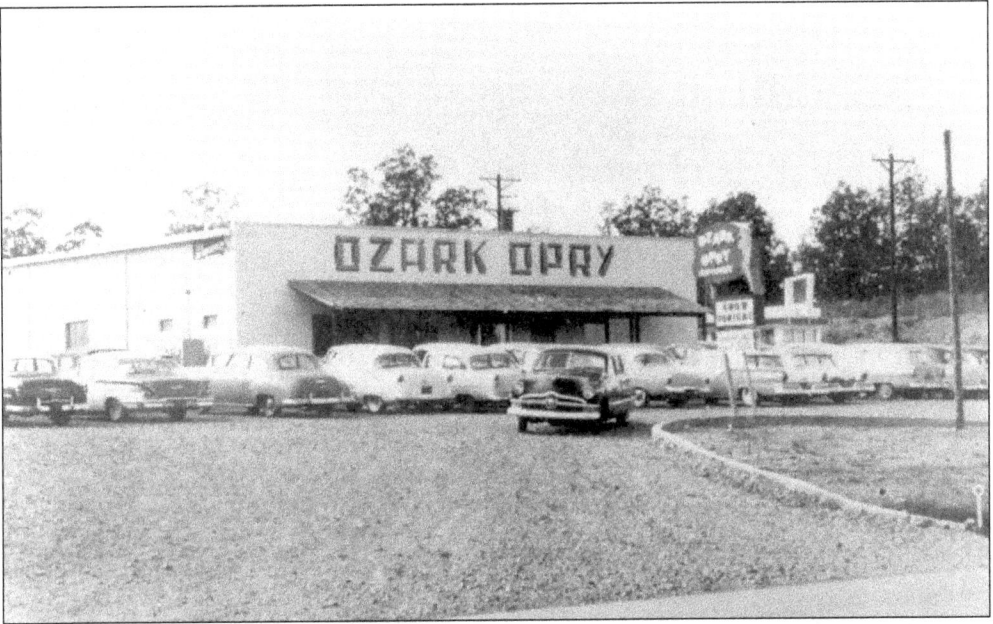

In 1957, the Maces built their Ozark Opry building in Osage Beach and the building is still in use. Success brought several renovations and the building now seats more than 1,100 people. But even before this building was erected, the show was appearing live on KRCG-TV at Jefferson City, and KMOS-TV in Sedalia, Missouri. Their Neilson ratings put them in the top ten.

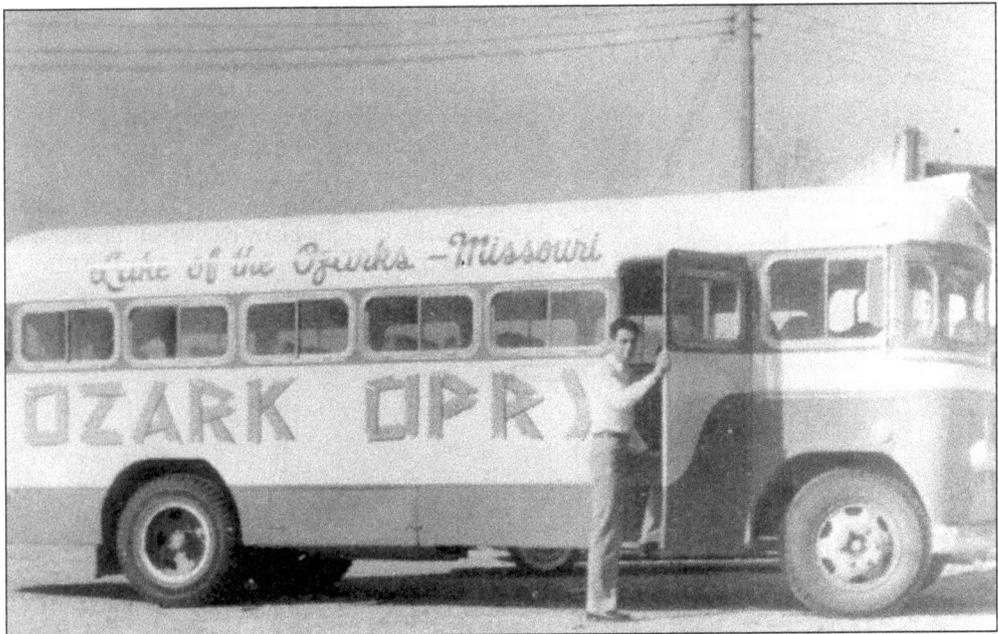

Lee Mace also took his show on the road throughout the Midwest in the off-season at the lake. As his fame spread, greater and greater numbers of people came to Lake of the Ozarks to see his show and vacation. Lee Mace was more than just an ambassador of country music: he played a significant role in the promotion and development of Lake of the Ozarks as the state's finest family vacation paradise. Lee Mace died in a plane crash in 1985, but his show and his legend live on.

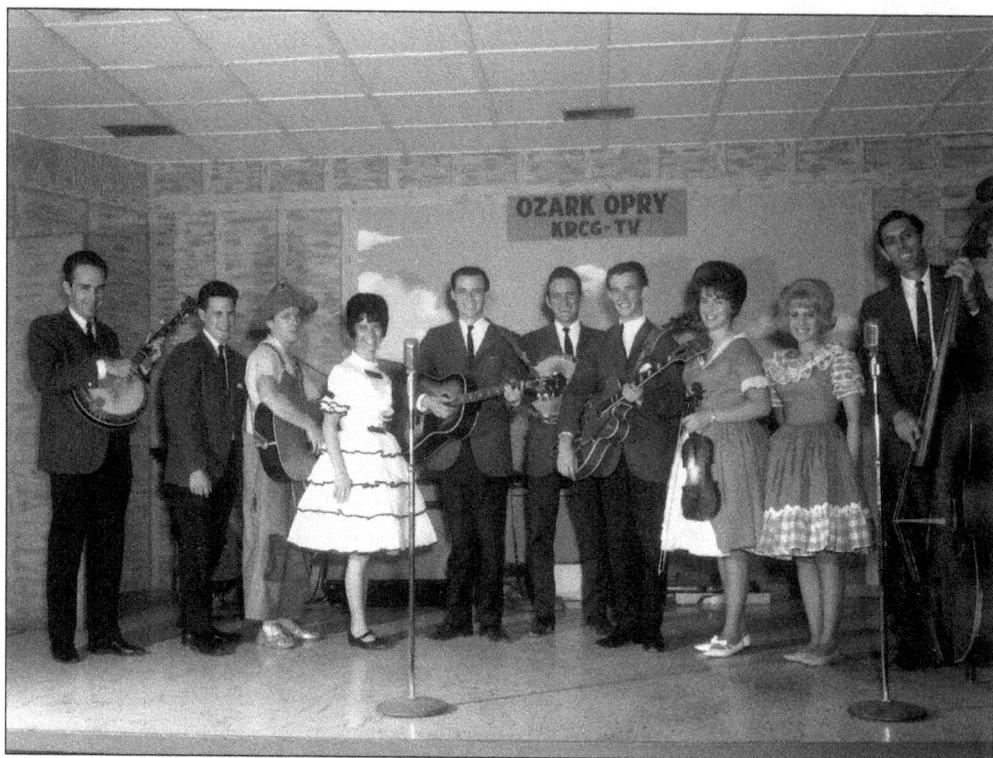

Many young talented country musicians had their start on the Lee Mace Ozark Opry. The above group composed his troop of performers in the 1960s. Among them, third from the left, is Bill (Goofer) Atterberry, who was the show's comedian for more than three decades. In his role, he achieved nearly as much fame as Lee Mace, and his popularity brought many people to the show, as well as to the lake. (Photo courtesy of the Missouri State Archives.)

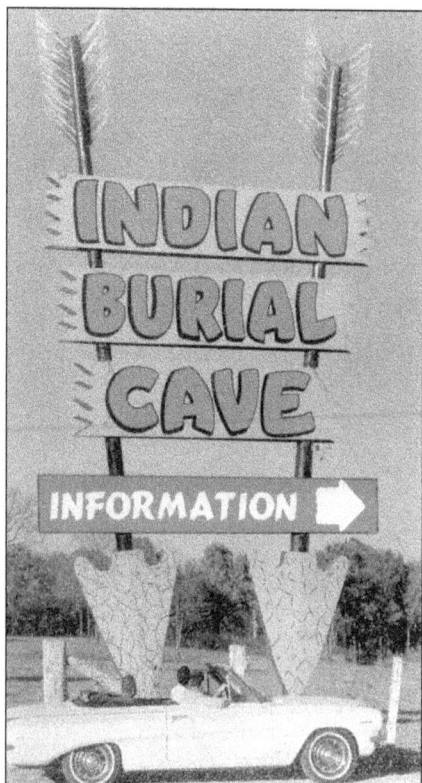

Caves have been both a draw and a given in lake area entertainment since the lake's inception. Surveys taken in the 1960s indicated that nearly 10 percent of the 2.5 million people then visiting the Lake of the Ozarks each year had at least one visit to a show cave on their entertainment agenda. In the 1960s, Lee Mace teamed up with Al Lechnir, and leased Indian Burial Cave off D Road in the Osage Beach area. At left, is one of the attraction's unique road signs.

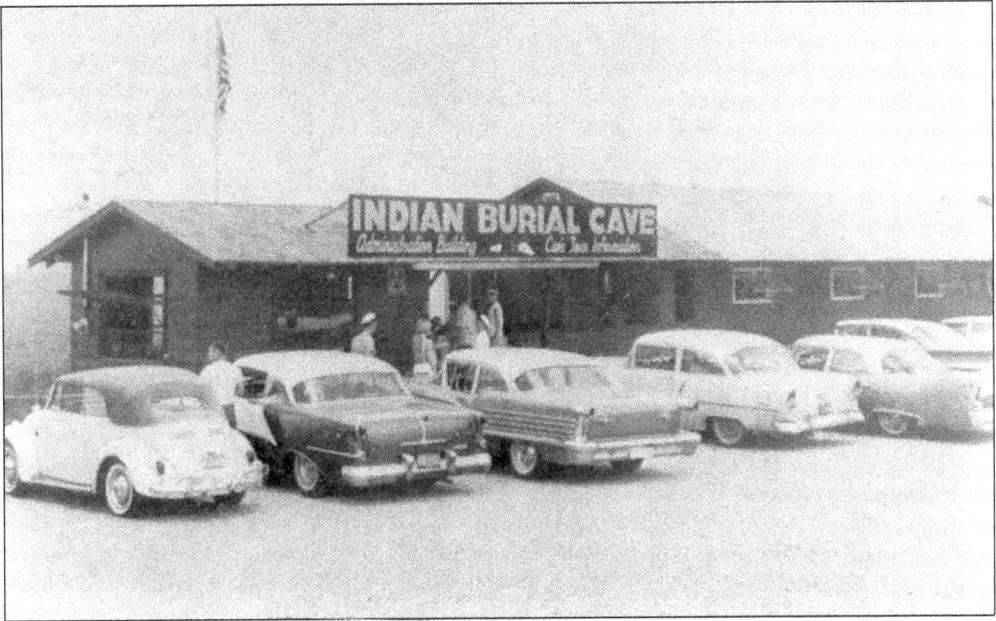

Indian Burial Cave was newly opened but not doing well. Lee Mace, with his captive audience at the Ozark Opry, turned the business around and made it one of the most popular attractions in the lake area for several decades. It featured Indian burials, boat and tram rides, and had a commanding view of the Osage River valley. The cave is no longer open to the public.

The Colonial Restaurant was built in the 1940s and operated by Frank and Tony. "Tony played the piano and Frank waited tables," said Victoria Hubbell in her 1998 book, *A Town Of Two Rivers*, which is a history of Osage Beach. The building was later remodeled and called The Fountains. It is now gone and a church stands in its place. (Photo courtesy of the City of Osage Beach.)

Idlewild Cabins & Court was built in the 1940s in Osage Beach near the junction of Lake Road 54-24. Its log structure was architecturally unusual, having the appearance of an old fort. An enclosed courtyard existed behind the building. To its right was the Osage Beach Post Office which later became Minder's Grocery. Today, Beabout's Bait & Tackle Shop has replaced Minder's building. Idlewild Court is no more, but the rock wall survives.

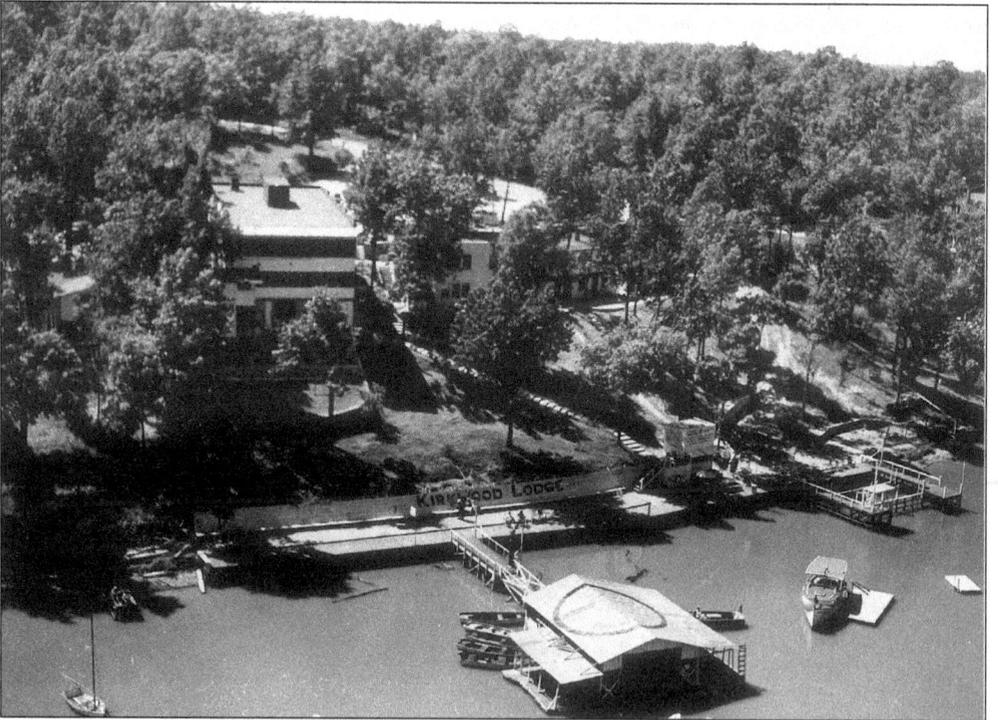

Among the resorts in the Osage Beach area in the 1950s and '60s, one stands out from all of the rest because of its promotional zeal and success: Kirkwood Lodge on Lake Road 54-24. Built in the early 1940s and operated as the Pope Hotel, the resort was purchased in the late 1940s by two Army colonels, Kirkman and Woodmancy, and its name changed to Kirkwood Lodge. In the 1950s, it was purchased by Bill Hagadorn and family. (Photo courtesy of the Les Gotcher Collection.)

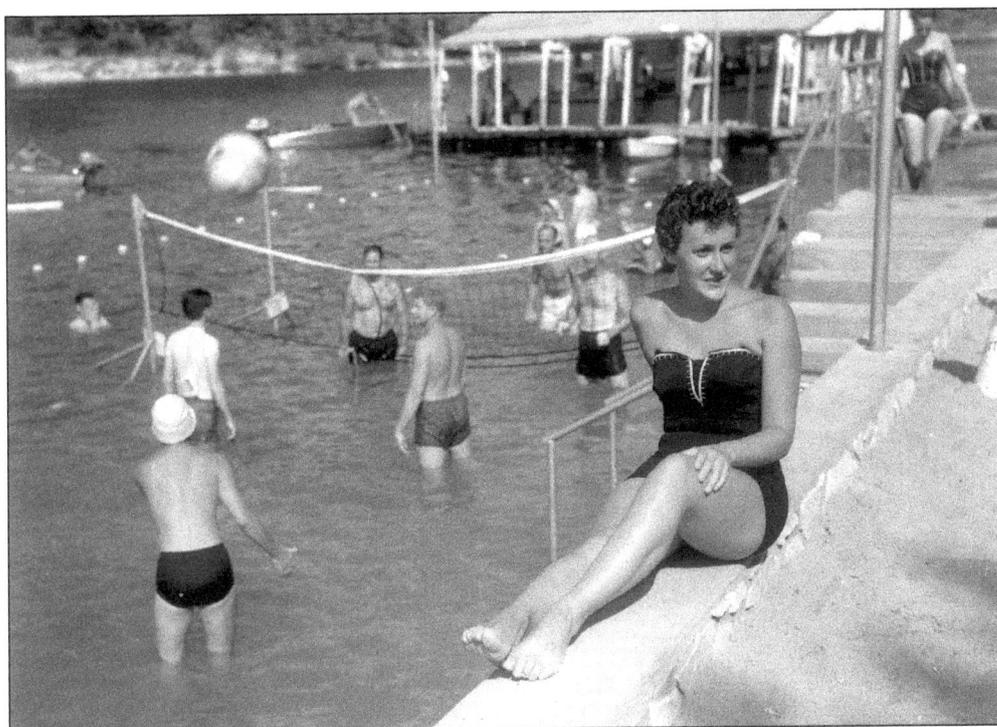

In the blue waters of its quiet cove, the sprawling resort had a lively recreation area along its shoreline. This photo by Gerald Massie from about 1960, shows some of the summer activities. In the background is Drasky's Boat Dock. The Drasky operation was separate but serviced the people who stayed at Kirkwood Lodge. (Photo courtesy of the Missouri State Archives.)

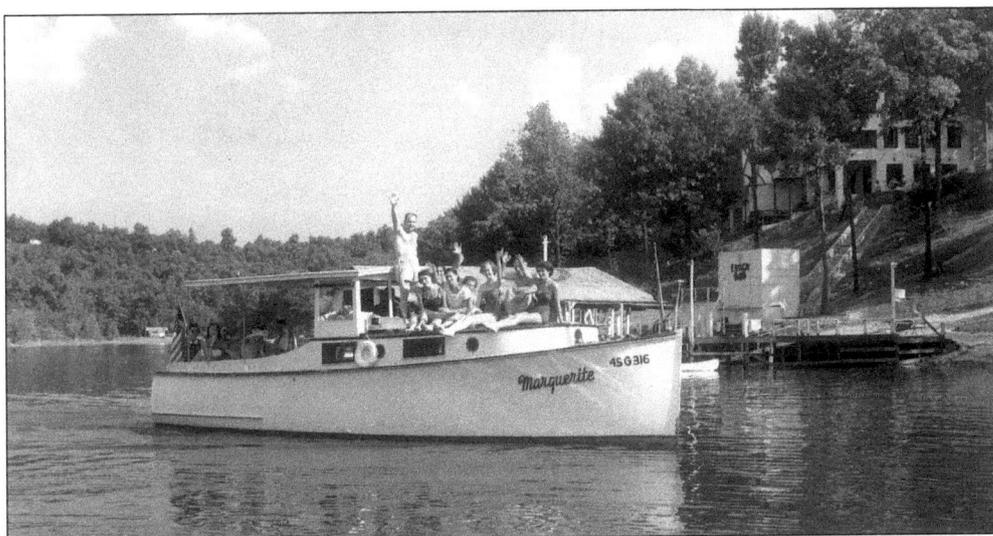

Kazimir and Marguerite Drasky had commercial boats, sailboats, and a cruiser, which "Kas" named after his wife. When it was cruise time, Kas would blow the horn and collect people from Kirkwood and other resorts in the cove. The Draskys eventually sold their boat dock to Kirkwood Lodge and opened a bait and tackle shop in Osage Beach. (Photo courtesy of the Missouri State Archives.)

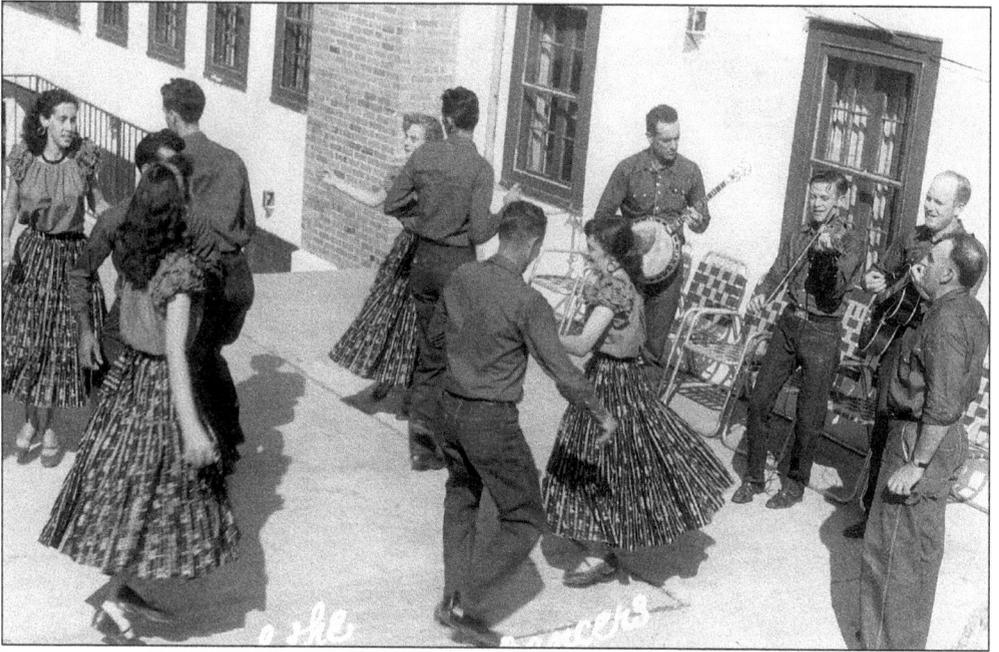

Square-dancing has a long history at the lake. In 1946, Buford Foster of Lake Park put together the first square-dance group in the area, naming them the Lake of the Ozarks Square-Dancers. They performed on Ted Mack's Amateur Hour in 1953, the same year that the Hagadons of Kirkwood Lodge organized a square-dance institute at their resort under the direction of famous square-dance caller Les Gotcher from Buena Park, California. (Photo courtesy of the Les Gotcher Collection.)

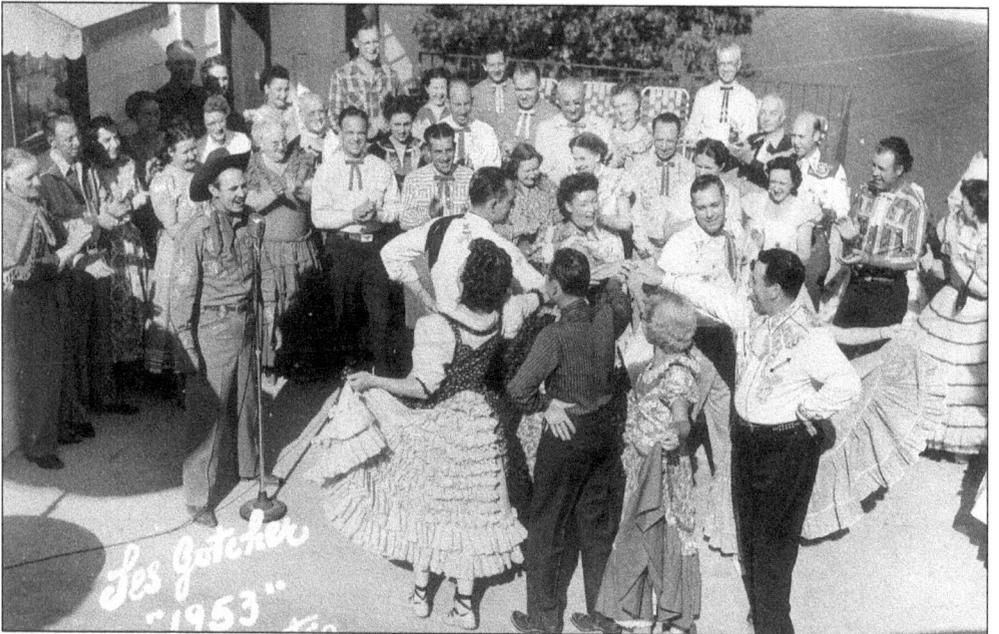

Les Gotcher is seen here teaching square-dancing at the first Square Dance Institute at Kirkwood Lodge in 1953. Kirkwood Lodge still entertains square-dance groups in the spring of the year. (Photo courtesy of the Le Gotcher Collection.)

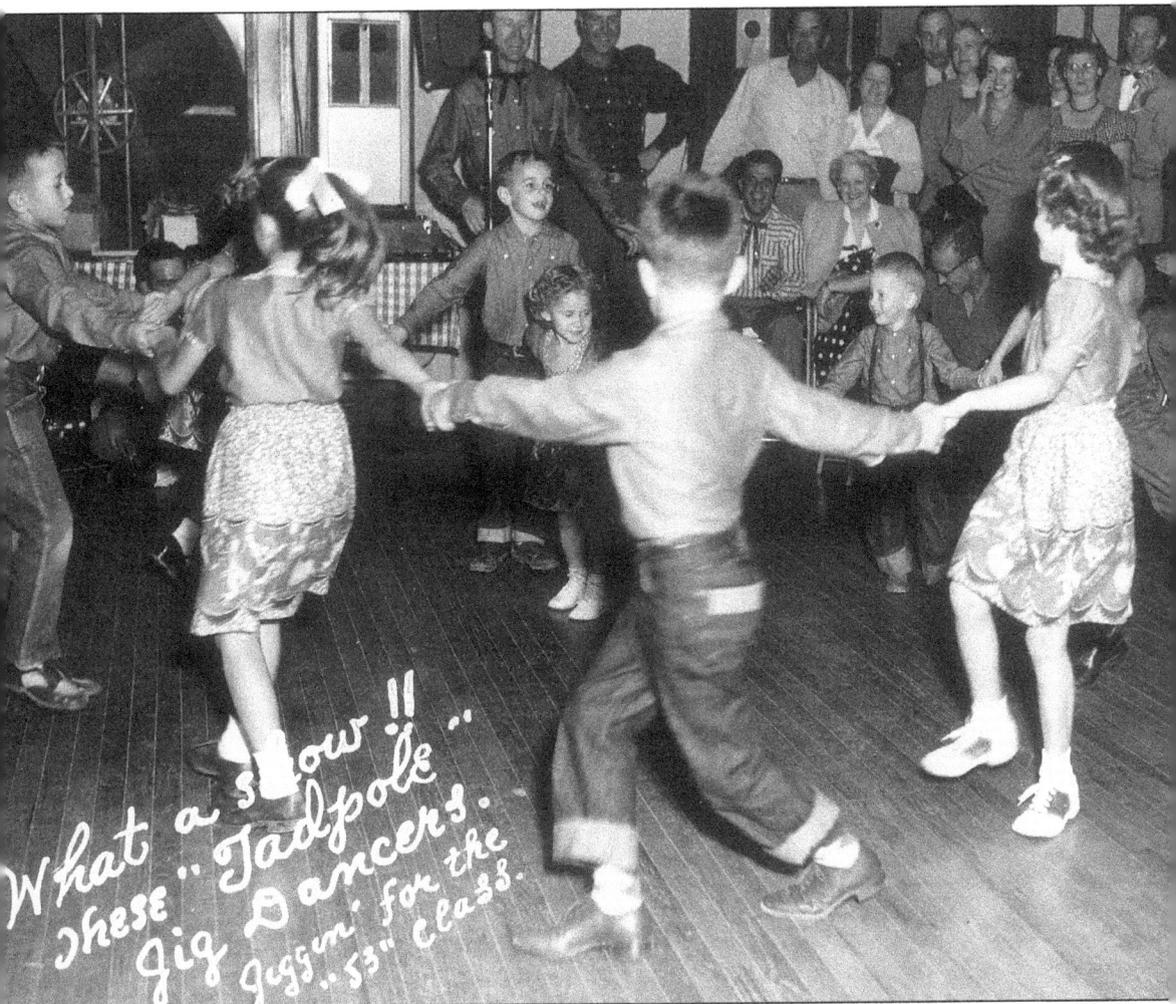

What a show!!
These "Tadpole"
Jig Dancers.
Juggin' for the
"53" Class.

Square-dancing and jig-dancing ("clog-dancing" as it is called today) were also popular with local children. In the above photo, a children's group known as the "Lake of the Ozarks Tadpoles," organized by Buford Foster of Camdenton in the early 1950s, perform at Kirkwood Lodge in 1953. Buford can be seen in this photo next to the microphone. Les Gotcher, (calling the square-dance on the opposite page), was famous for his square-dance calling and his Hollywood connections. He taught dancing to dozens of famous movie stars of the day including Ceasar Romero, George Burns and Gracie Allen, Jack Benny, Dinah Shore, Hopalong Cassidy, and the Walt Disneys. The first institute of Kirkwood Lodge graduated 120 attendees who came from throughout the United States to participate. The publicity generated by the institute brought prominence to the Lake of the Ozarks, as well as to the Hagadorns and Kirkwood Lodge. (Photo courtesy of the Les Gotcher Collection.)

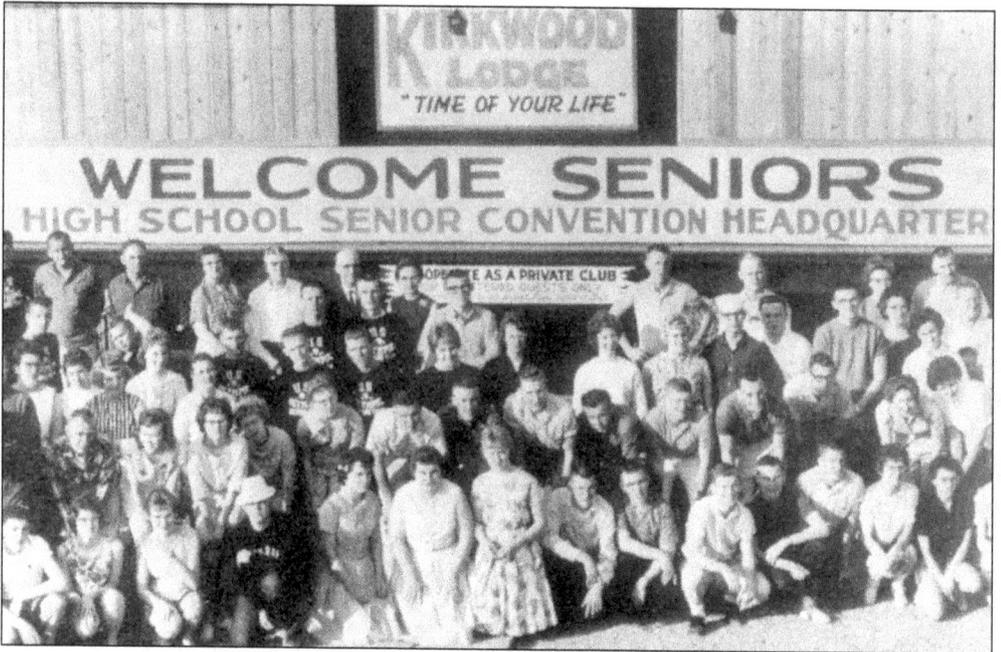

During the 1950s and '60s, the lake was the spring destination for many graduating high school classes. Kirkwood Lodge was one of the resorts that offered them an entertainment package. The students thus became unpaid promoters of the lake and its future vacationers. Changing laws regarding the use of school buses, increased costs, and insurance problems have reduced the number of senior groups that now come to the lake. (Photo courtesy of Kirkwood Lodge.)

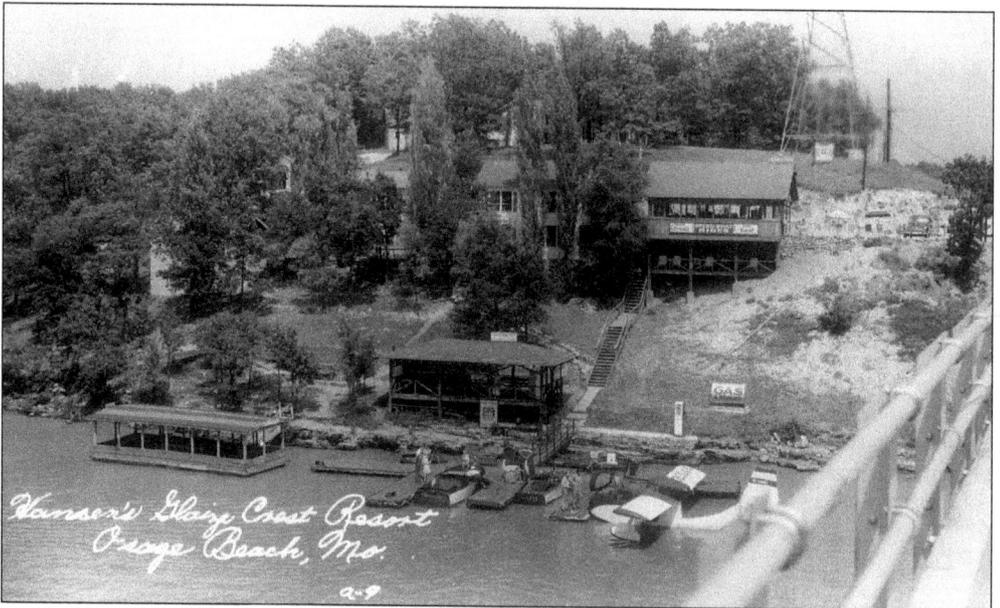

During the 1950s and '60s, there were businesses close to the highway on either side of the east and west ends of the Grand Glaize Bridge. Hansen's Glaize Crest Resort was on the north side at the east end of the bridge, and Chet's Anchor Inn was on the south side. Today, due to highway and bridge improvements, there are no businesses close to the bridge at the east end.

64

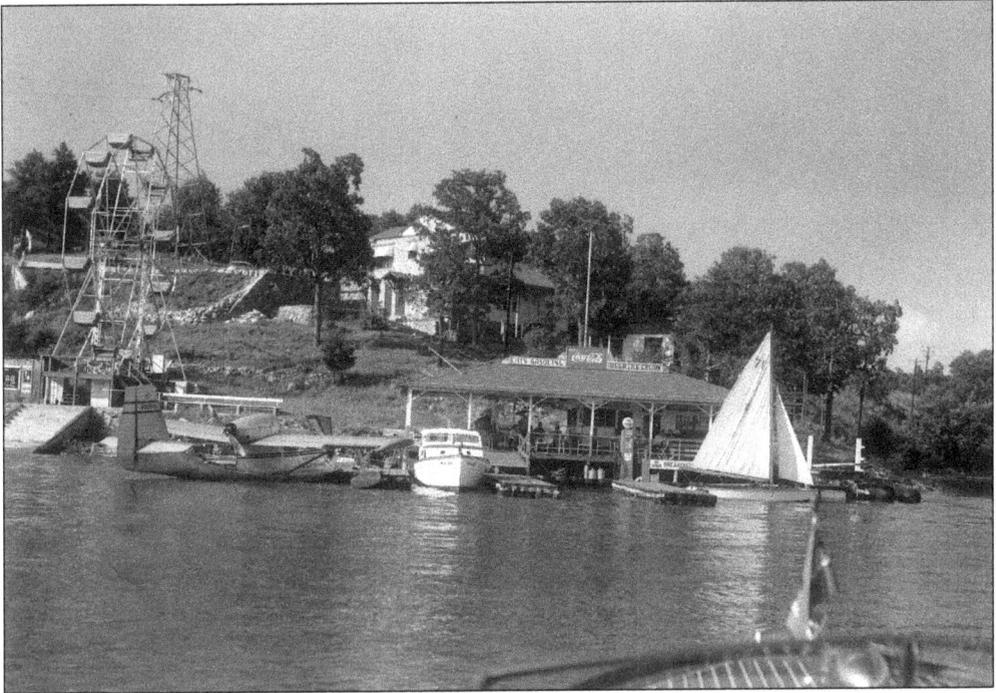

Chet's Anchor Inn was owned and operated by Chester Mason "Chet" Hymes. It grew into an elaborate center for recreational opportunities. You could buy souvenirs, find food and lodging, take a boat ride, a plane ride, or a carnival ride all at one location. In 1953, Hymes sold to Fred Link of Wichita. (Photo courtesy of the Missouri State Archives.)

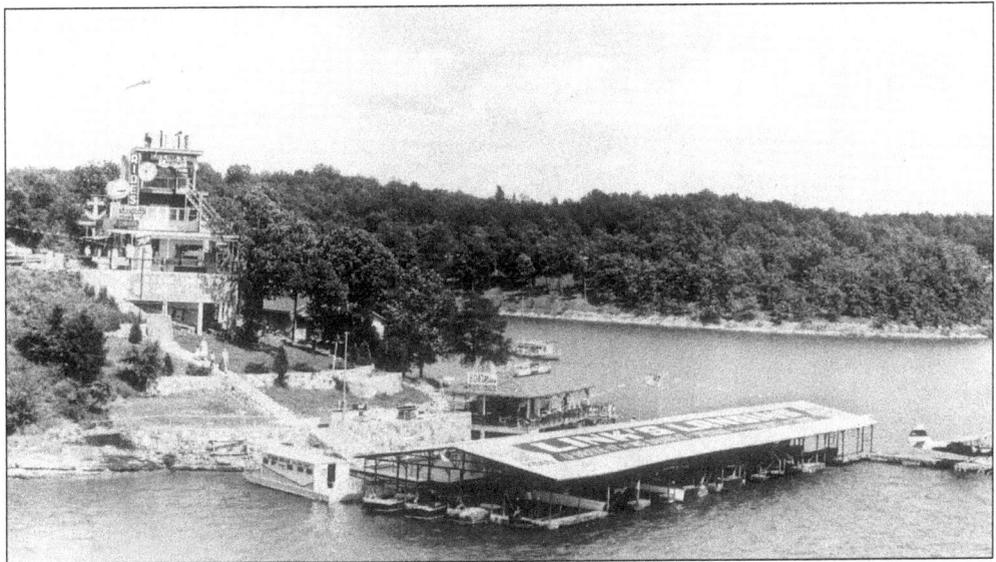

Chet's Anchor Inn became Link's Landing and by the beginning of the 1960s, the Links had given the site a whole new look. Their operation grew and prospered. In the late 1970s, word came that the highway department was planning new twin bridges to replace the original 2-lane Grand Glaize Bridge, which was also known as the Upside Down Bridge. Construction began a decade later and by 1996, a new Grand Glaize Bridge was built and Link's Landing was no more.

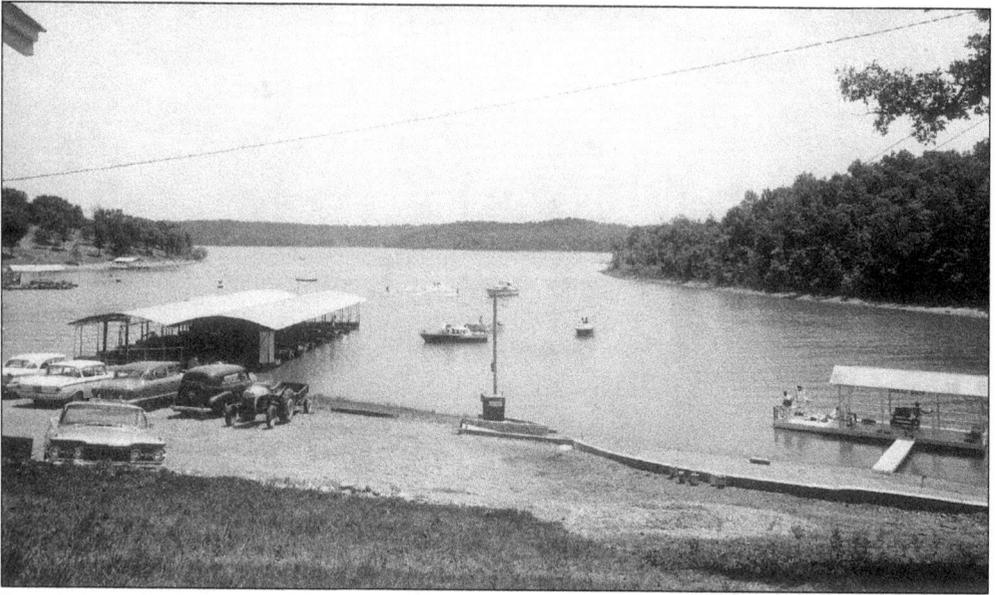

Pictured is a vintage view of the lakefront and beach at Temple Resort & Marina, one mile west of the Grand Glaize Bridge. It was owned and operated by Temple and Eunice Hamner when this photo was taken. This beach, and other sand beaches for which Osage Beach was named, were all man-made because the shoreline of the lake at an elevation of 660 feet is generally nothing but bare dolomite bedrock.

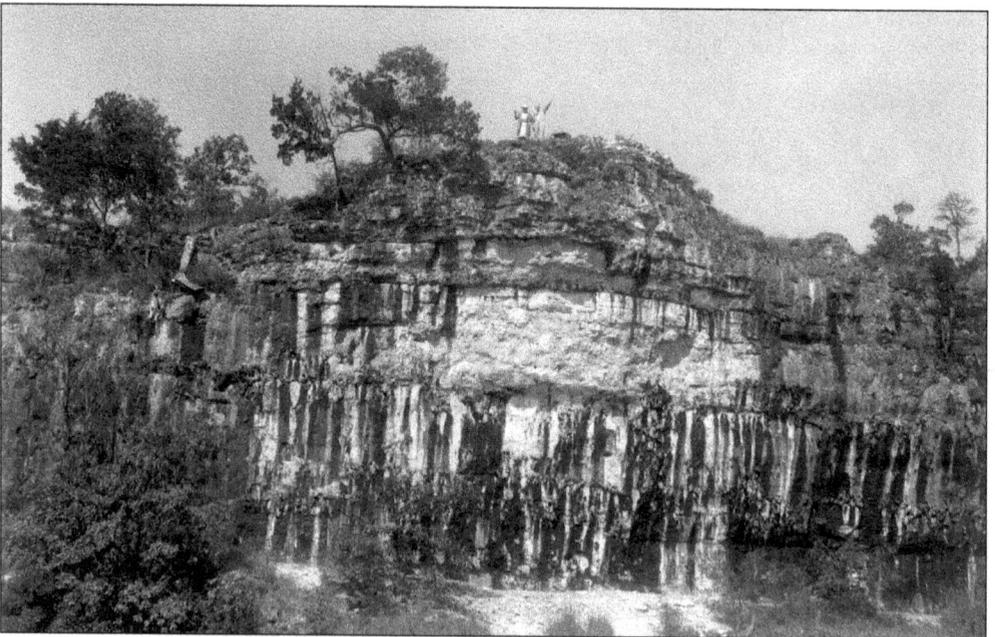

This majestic bluff is along the lake shore near the confluence of the Grand Glaize Arm of the Lake and the Osage. A town named Zebra was near here in pre-lake days. Zebra was later annexed by Osage Beach. The little town of Zebra got its name in the early days when steamboat pilots said that this bluff looked like the hide of a Zebra. (Photo courtesy of the Missouri State Archives.)

Five

KAISER AND BRUMLEY

"Old" Kaiser, about two miles east of the junction of Hwys. 54 and 42 in Osage Beach, is one-half-mile off Hwy. 42. The settlement dates to 1904. It was once the location of a prominent grist mill, blacksmith shop, general merchandise store, post office, and several dwellings. Old Kaiser saw a lot of activity in the 1930s when the Civilian Conservation Corps built Lake of the Ozarks State Park, which all but surrounds the old town site. The state park covers 17,296 acres. "New" Kaiser, a town of new businesses along Hwy. 42, is one-half-mile west.

Brumley is located about 10 miles east of Osage Beach on Hwy. 42, and about 2 miles north of the upper reaches of the Grand Glaize Arm of the Lake of the Ozarks. The Brumley post office was established in 1863 and the town was platted in 1877. It was once a very prosperous community having a steam-powered mill, churches, general merchandise stores, a Masonic Lodge, school, and bank. While Brumley is still home to people who make their living farming or working in tourism, the town is no longer the thriving center of commerce that it was in pre-Lake days and is fading away. However, it bequeathed the Lake area something extremely valuable—its bank. In 1959, the stock of the Bank of Brumley was sold and in July 1960, became Bank of Lake of the Ozarks, now Central Bank of Lake of the Ozarks.

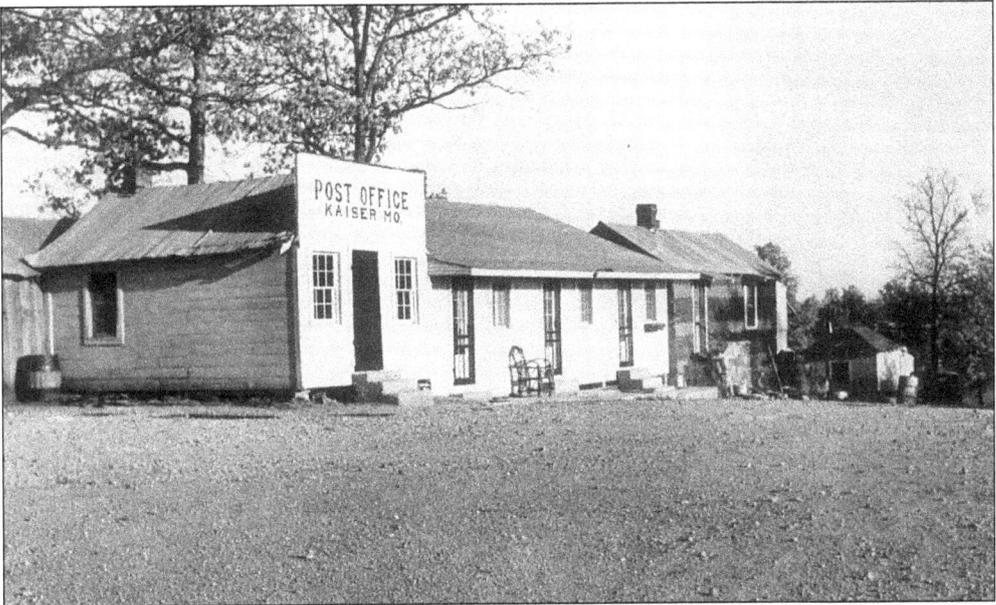

A visit to Old Kaiser is a trip back in time. This 1936 photo was taken when the Civilian Conservation Core was building facilities for the new Lake of the Ozarks State Park nearby. The post office building and its attached structure with rental units are almost unchanged to this day, although the post office was discontinued in 1971. The buildings at the far end are now gone.

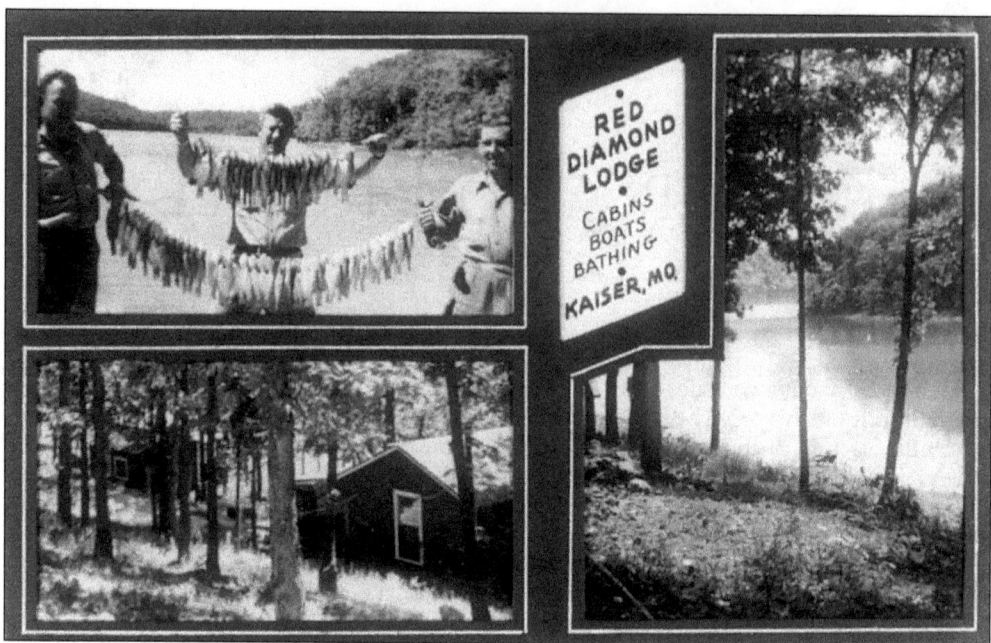

Red Diamond Lodge was a fishing camp on the Grand Glaize Arm of the lake in the Kaiser area in the 1940s. The proprietor was H.N. "Red" Jordan. Considering the string of fish these men are showing, it is understandable how the camp could boast of having "the best fishing area" on the upper Grand Glaize.

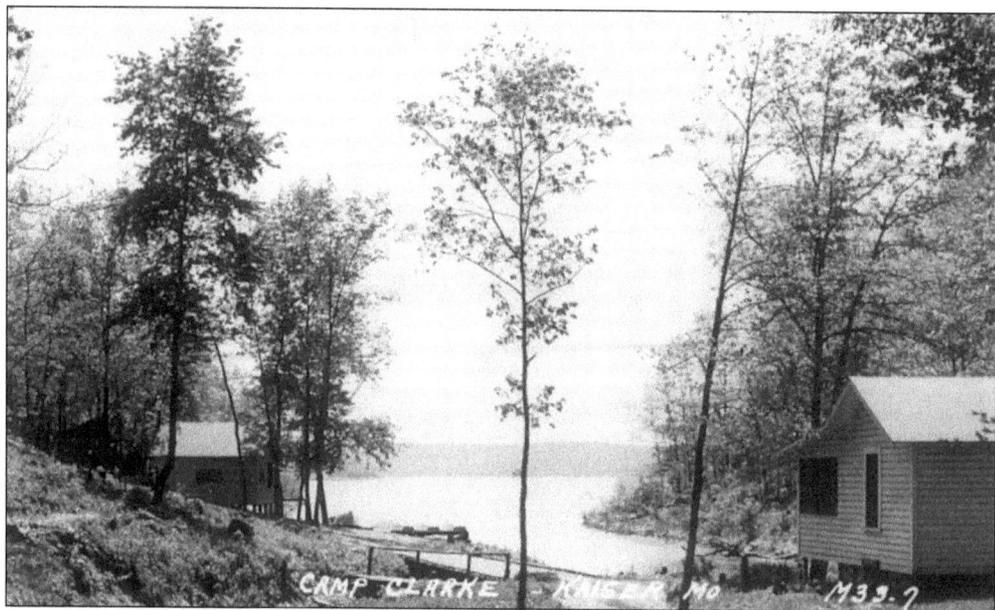

Camp Clarke was another fishing camp in the Kaiser area in the early days. It did very little advertising, relying on word of mouth for its guests. In the 1930s, the fishing camps in this area were often identified with the National Recreation Area, which is what the Lake of the Ozarks State Park area was called until it became a state park in 1946.

Shortly after Lake of the Ozarks State Park was dedicated in 1946, Hope and Victor "Tex" Varner, who were passing through the area, heard that help and horses were needed at the Lake of the Ozarks State Park riding stables. They stayed and went to work at the park's Ozark Homestead Riding Stable, living in a cabin at the Homestead. In 1955, they started producing rodeos in Osage Beach at their Ozark Stampede, which stood where McDonald's is located today.

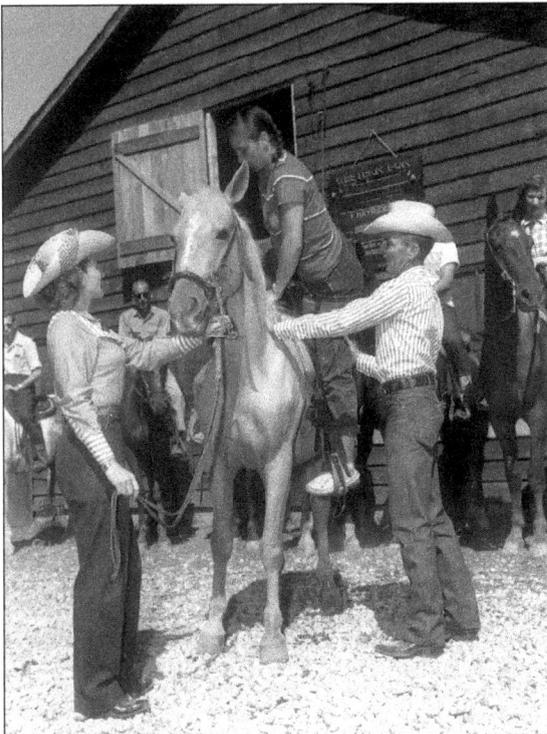

Here, Hope and Tex help a young person get into the saddle for a trail ride at the stables. The park has equestrian trails. Horseback riding, horse-powered hayrides, pony rides, burro rides, covered wagon rides, as well as wiener roasts and campfire singing was the kind of entertainment they provided at the park. Hope, an accomplished musician and singer, was usually the vocal entertainment. Their western themes were popular forms of recreation at the lake in the 1950s, '60s, and '70s. (Photo by Massie; courtesy of the Missouri State Archives.)

69

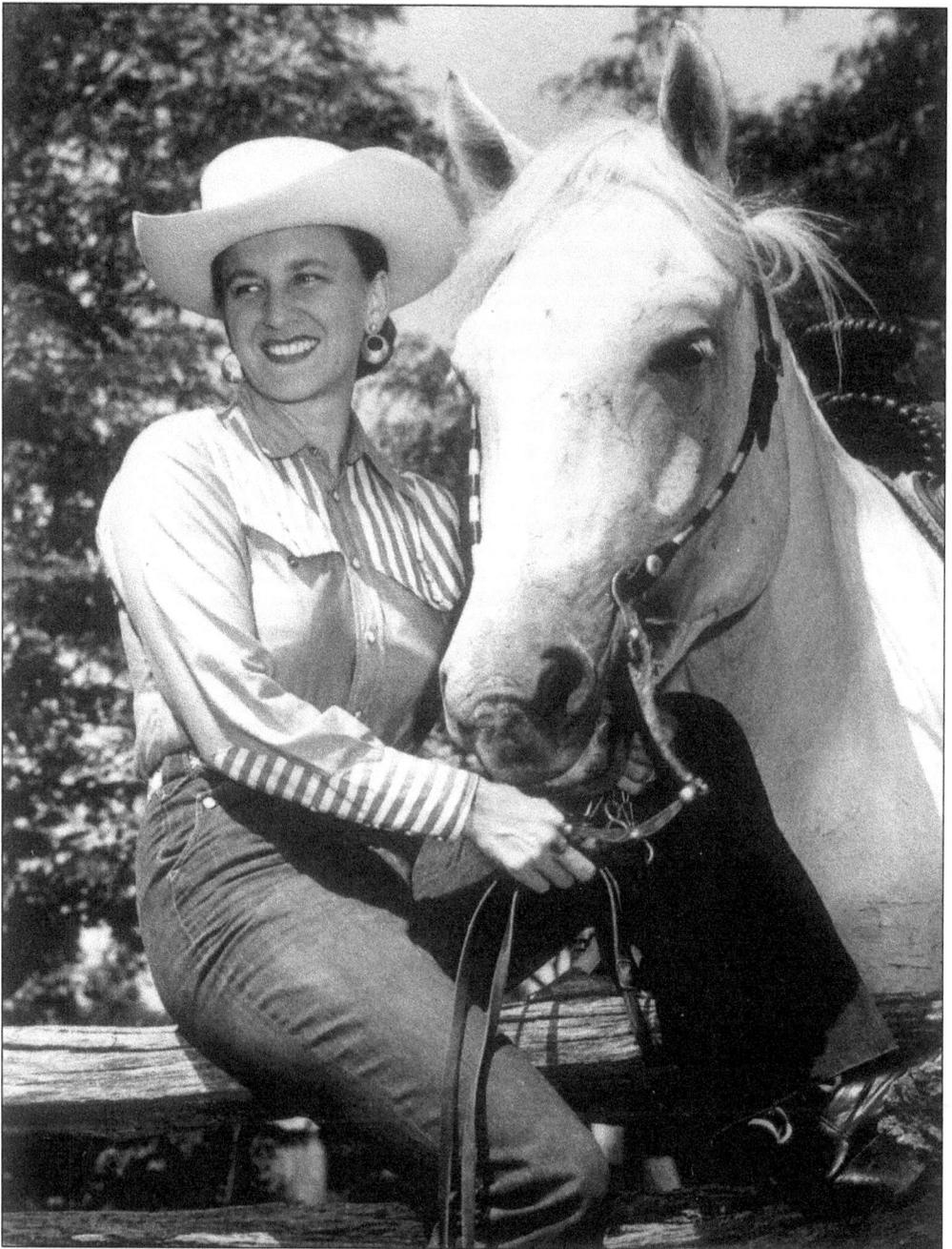

Following the death of her husband, Tex, in 1973, Hope Varner became a local entertainer at various lodges in the Lake of the Ozarks area. She sang, played guitar, keyboard, and accordion. In 1988, at the age of 74, she was inducted in the Cowgirl Hall of Fame. Her display case is in the Annie Oakley Room of the museum. Behind glass are many of her personal items. Hope was noted in the lake area for her eclectic collection of things from all over the world. The legacy of Tex and Hope has not been forgotten in the lake where, every Saturday night during the 1950s and '60s, you could find them in command of bull riding, bareback bronco riding, calf roping, and steer wrestling. (Photo by Massie; courtesy of the Missouri State Archives.)

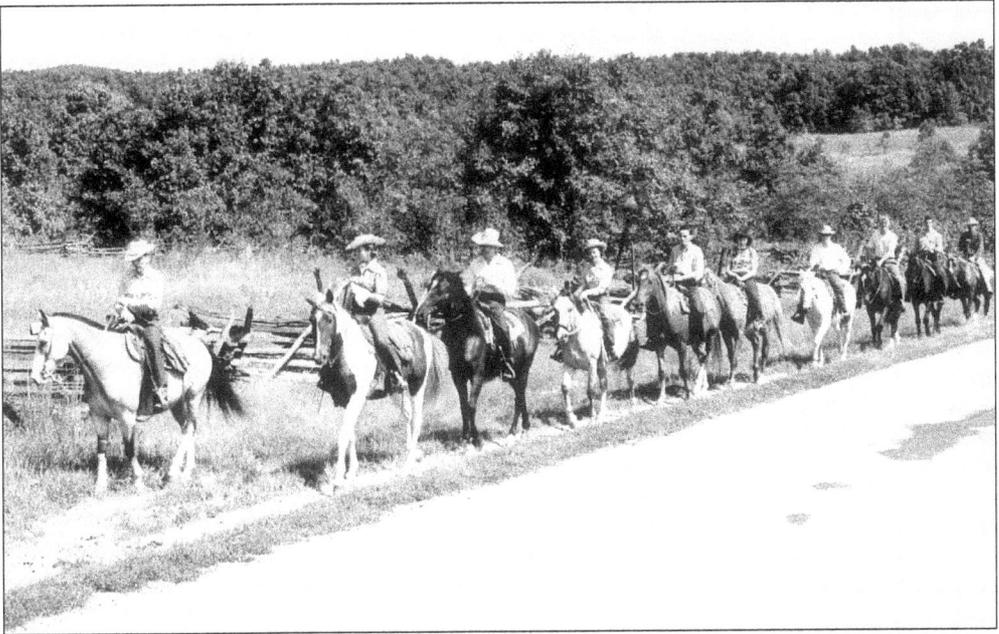

Horseback riding (above, *c*. 1953) is just one of many different kinds of recreational activities that the Lake of the Ozarks State Park has offered vacationers since its establishment in the 1940s. There are two public swimming beaches, campgrounds, hiking trails, natural areas, wildlife areas, caves, springs, and beautiful lake scenery. (Photo courtesy of the Les Gotcher Collection.)

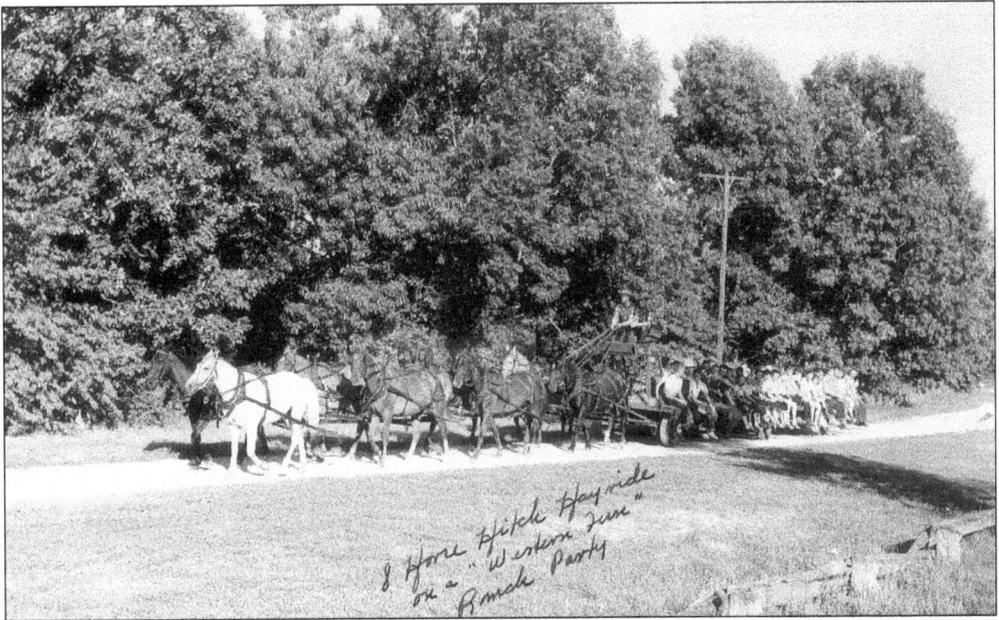

This 1953 photo shows an 8-horse hitch hayride in Lake of the Ozarks State Park during a Western Fun Ranch Party. Lake of the Ozarks State Park has many miles of lake shoreline within its boundaries and some 44.5 miles of hiking trails. There are also excellent fishing accommodations. (Photo courtesy of the Les Gotcher Collection.)

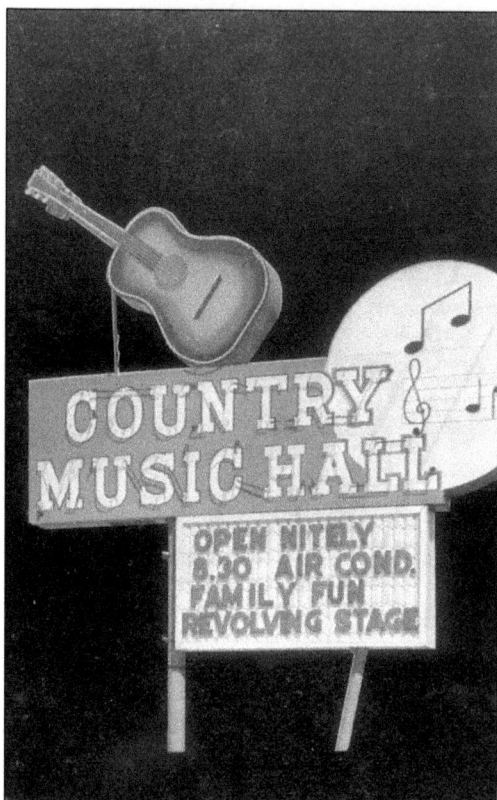

During the 1930s and '40s, fishing, hunting, dining, dancing, and horseback riding were the themes in the promotional literature of the lake. In the 1950s and '60s, roadside attractions and country music shows made their appearance, along with rodeos and miniature golf courses. The area also saw the arrival of an annual Gun Show and large 4th of July fireworks displays sponsored by Chambers of Commerce. On Hwy. 42, a third country music show made its debut in this period: Country Music Hall.

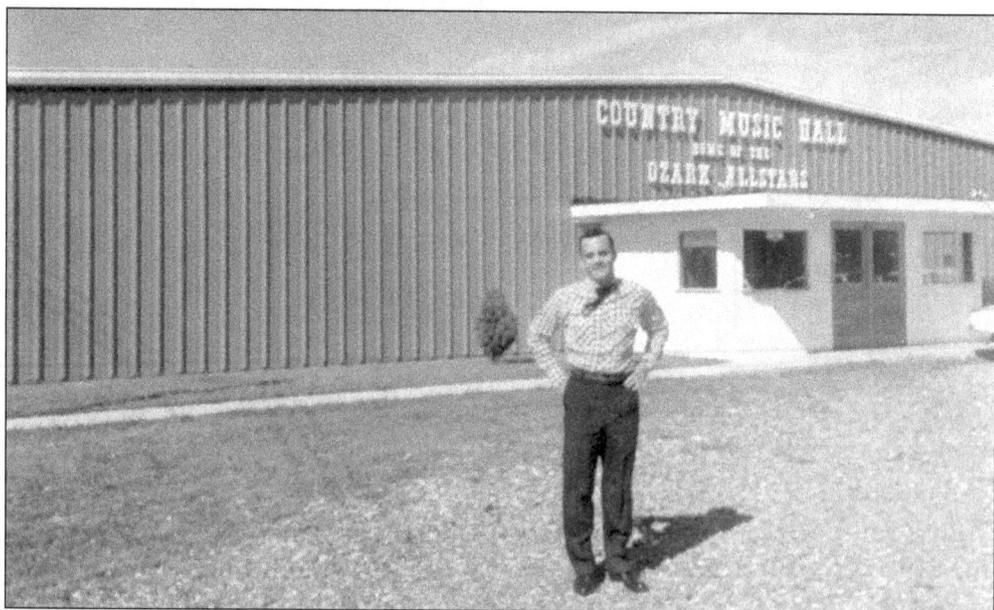

The above photo shows Bob Nolan, the promoter of the Country Music Hall, in front of his building along Hwy. 42 in New Kaiser. Like Lee Mace and Austin Wood, he was a local musician. His show hired local people who enjoyed pickin' and singin' all styles of country, blue grass, and Ozark music. As was true with all of the area shows, comedy was also a big part of the performance.

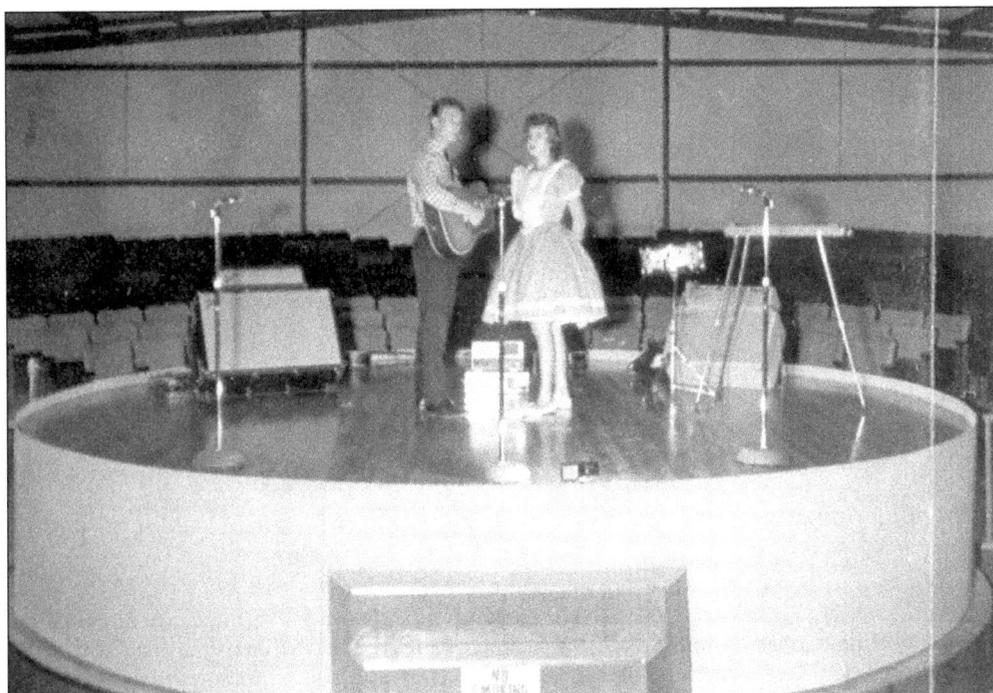

One feature of the Country Music Hall that made its show different was that the performers played on a round stage that revolved slowly "bringing the complete entertainment to everyone." All seats in the audience were within 40 feet of the stage. Early in her career, Barbara Mandrell gave a benefit performance on this Country Music Hall stage. The Country Music Hall show lasted only a few years. Today, the building houses a church.

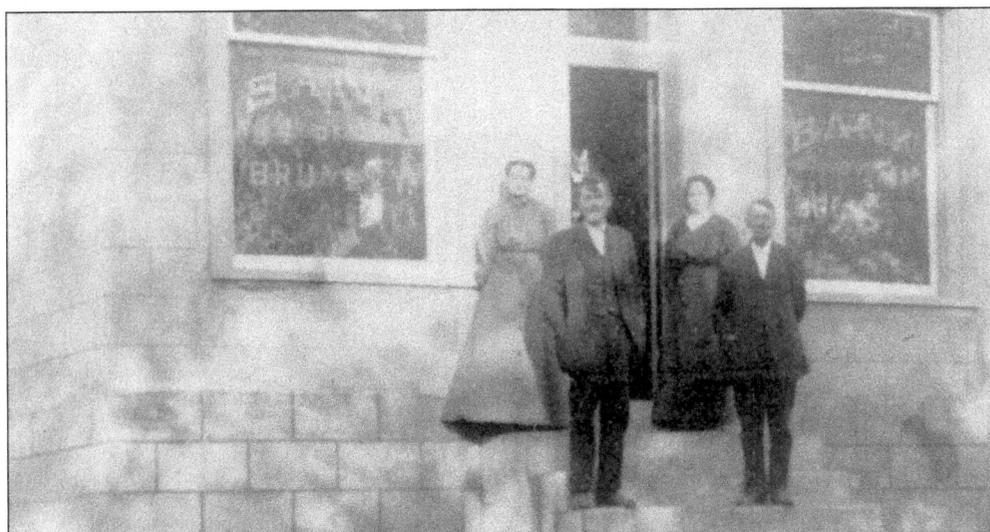

The Bank of Brumley opened for business on Oct. 15, 1906, with 18 original stockholders, pictured in this photo, from left to right, as follows: (front row) James M. Hawkins, the first president (1906–1910) and E.C. Thompson, who served as the second bank president (1910–1914); (back row) Mrs. W.E. Thornsberry and Mrs. Lloyd Pugh. See Bank of Lake of the Ozarks in Chapter Four for more information.

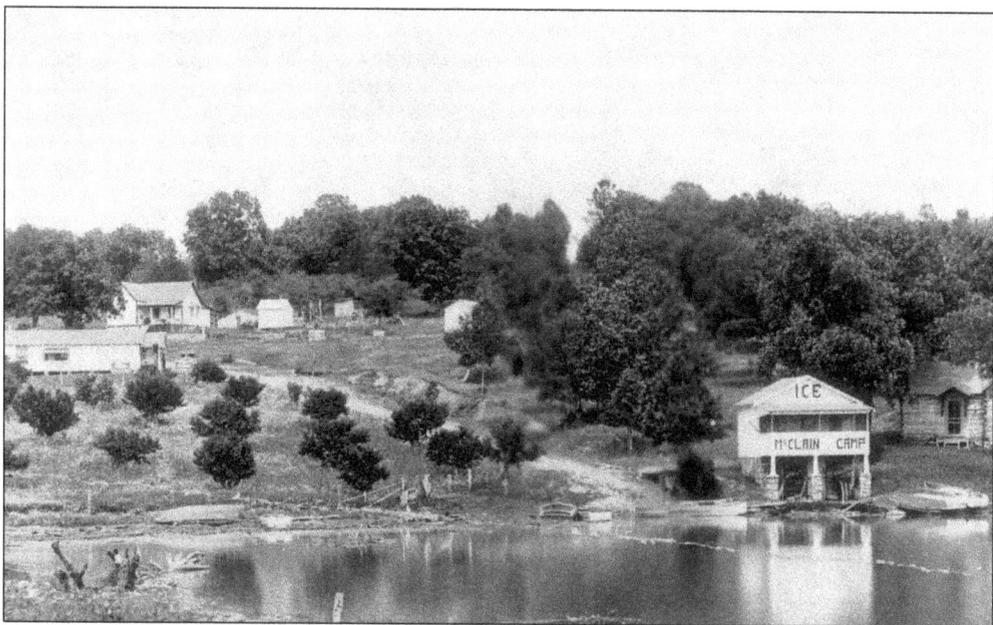

Mc Clain's Camp, near Brumley, is a fishing camp established on the Grand Glaize Arm of the lake in the 1940s. The owner's home can be seen on the hill. Along the shoreline is the camp's store and bait shop. The log house to the right of the shop was a rental unit. Another camp building is further up the hill. (Photo courtesy of Danny Lane.)

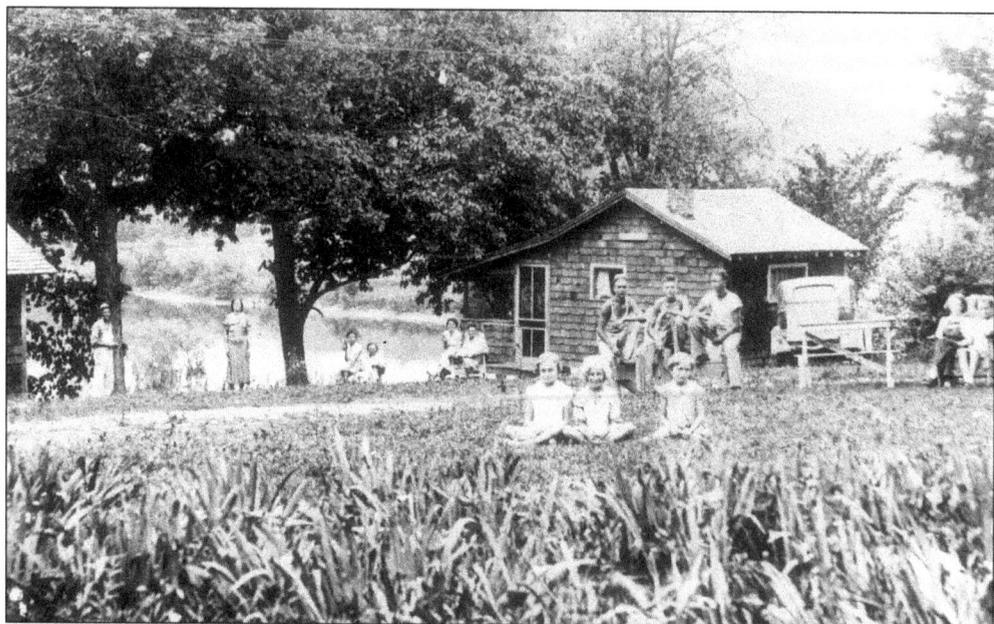

Lacus Lodge, also in the Brumley area in the early days, was established about 1932. The land originally belonged to Judge Clarence H. Wright. He sold the campsite portion to W.C. Payne, who built the Lodge. In 1935, Judge Wright shot Edwin Metcalf to death at the Lodge in an altercation related to business matters. In 1937, Payne leased the Lodge to George T. Withers of Brumley. (Photo courtesy of John Bradbury.)

74

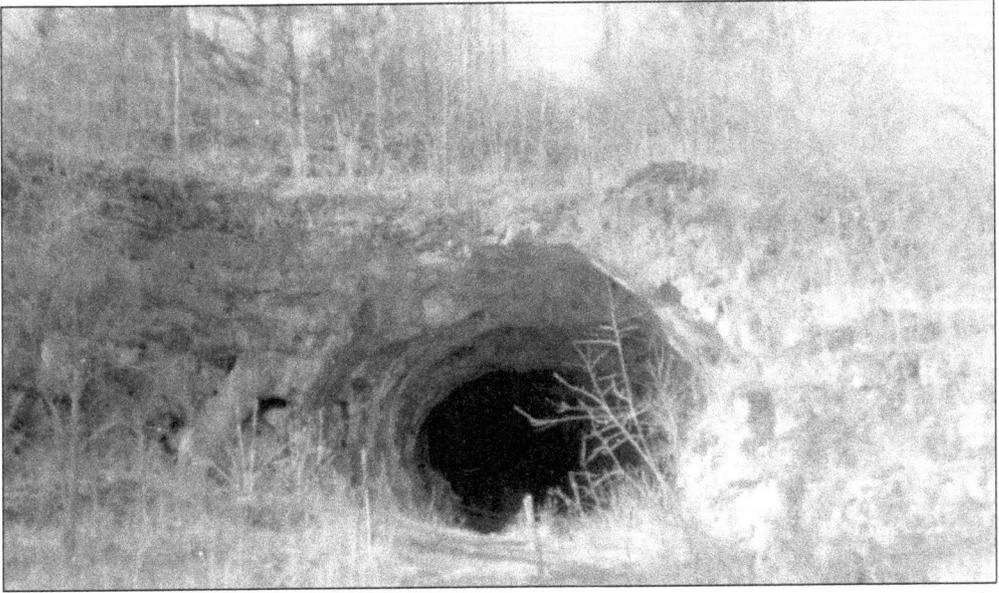

The entrance to Wright Cave is shown here in winter during the 1950s. It is located beside Lake Road 42-10, which is known in the Brumley area as the Swinging Bridges Road. The cave is not very large, but in 1967, it was commercialized by Fred Robinett of Latham, Missouri, and renamed Arrow Point Cave. The cave's history includes its use in pioneer times as a place for social gatherings and church services.

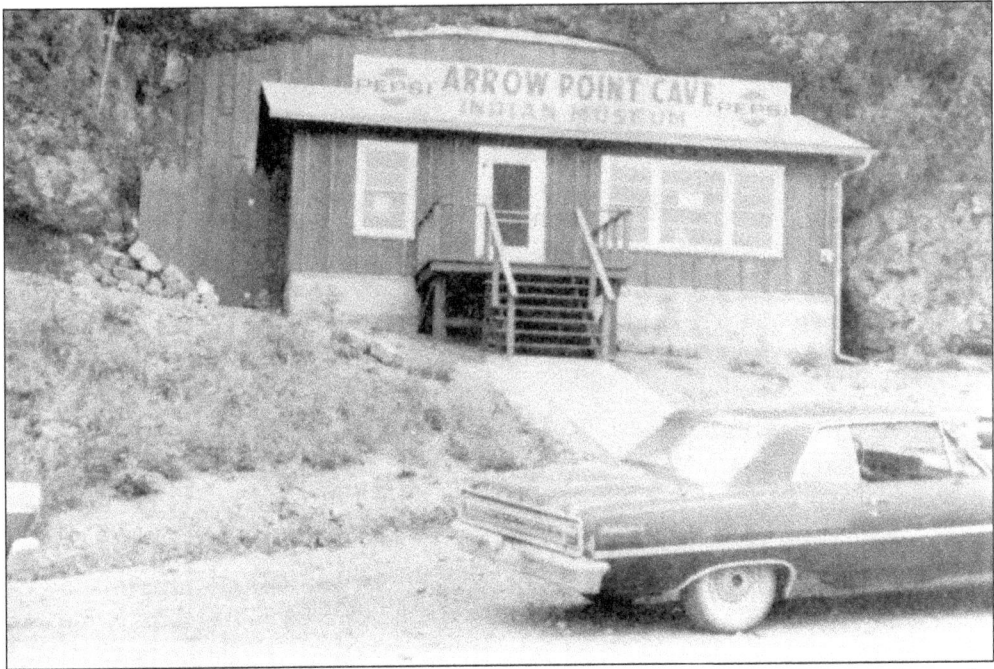

Fred Robinett housed-in the cave opening. In preparing the cave for commercial use, he discovered many Indian artifacts and they became an important display for visitors. The cave was operated for only a few years. The building is now gone, but the wall behind the building covering the entrance is still in place. Visitation is not permitted.

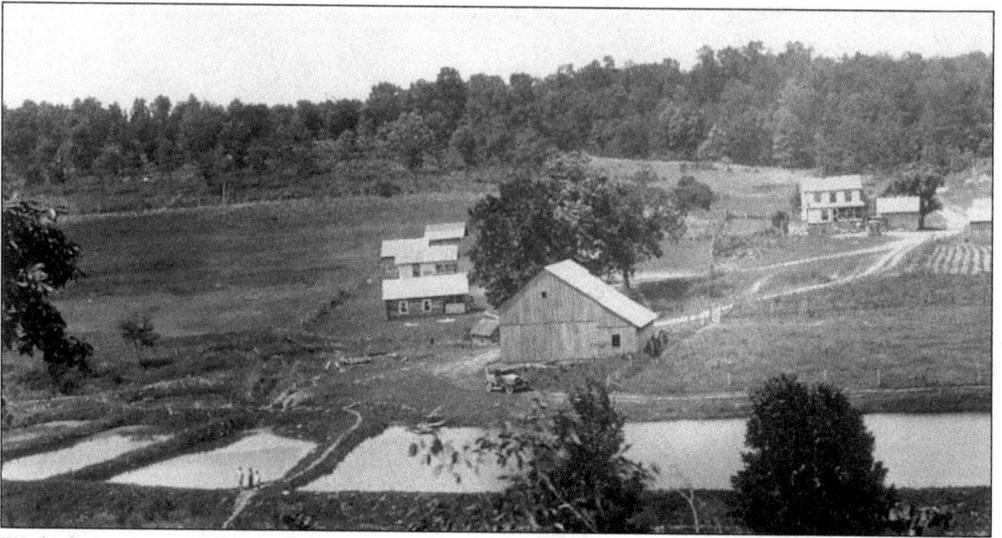

With the creation of Lake of the Ozarks and the huge influx of fisherman that resulted, demand for bait became substantial. Eventually, just about every community around the lake had one or more hatcheries. Plemmons Bait Hatchery & Resort, owned by Roy Plemmons, was in the Brumley area. It was located on the Swinging Bridges Road.

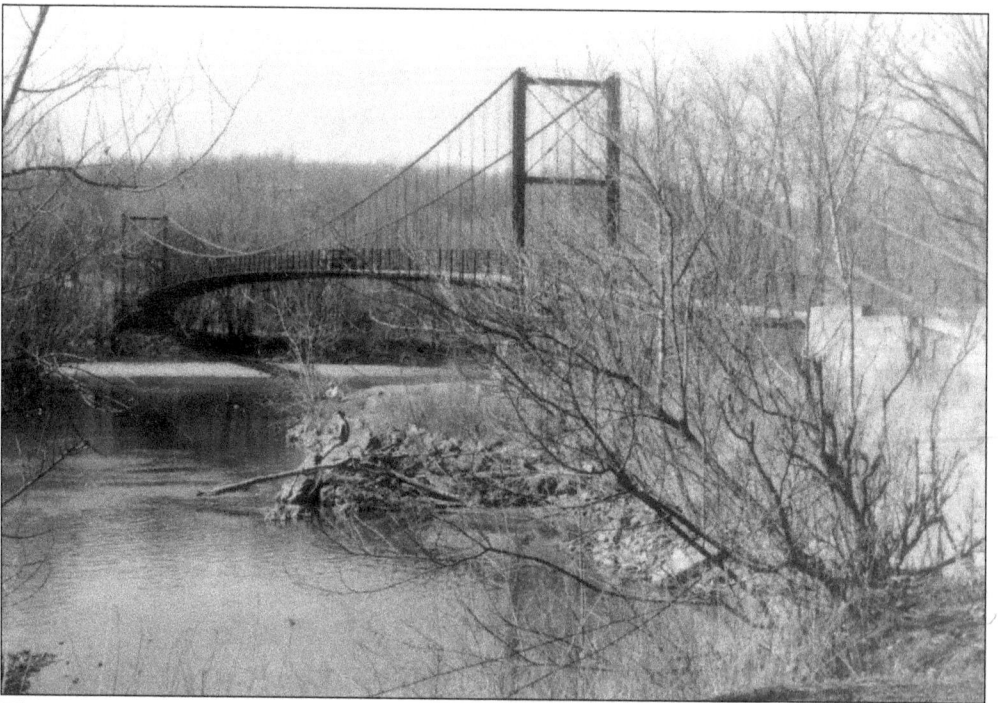

There are two swinging bridges on Lake Road 42-10, near Brumley: a small bridge that crosses a creek just northwest of this bridge; and this larger suspension bridge built by Joe Dice in 1930 at the same time as the construction of Bagnell Dam. Dice built many such bridges over the Osage River and its tributaries between 1890 and 1930. This is probably the only one still in use and it crosses the Glaize Arm of the lake at its headwaters. (Photo c. 1950.)

Six

LINN CREEK AND CAMDENTON

The history of Camdenton, today's "New" Linn Creek, and old Linn Creek are intertwined because, in a sense, both Camdenton and New Linn Creek rose from the ashes of old Linn Creek in 1931. However, New Linn Creek had a head start because there was a small settlement at the head of the valley called Easterville and its population was greatly expanded as old Linn Creek citizens relocated. Camdenton, on the other hand, rose from farm fields and the vision of its founders at the junction of Hwys. 54 and 5.

Camdenton is the county seat of Camden County. The county was first settled by Reuben Berry and William Pogue in 1827. It was named Kinderhook County in 1841, but the name was changed to Camden County in 1843 in honor of Charles Pratt, Earl of Camden, because of his sympathetic stand on the question of "taxation without representation."

Just southwest of Camdenton is the Niangua Arm of Lake of the Ozarks. Zebulon M. Pike, who explored the Osage River in 1806, recorded that "the Yunger (or Ne-hem-gar)," as the Niangua was then called, was so named by the Indians because of the many springs at its source. The stream was famous for the bear in the vicinity, which, Pike says, were hunted not only by the French, but by the Osage and Creek Indians. And it is here, on a spring branch feeding into the Niangua River, that Ha Ha Tonka State Park is located.

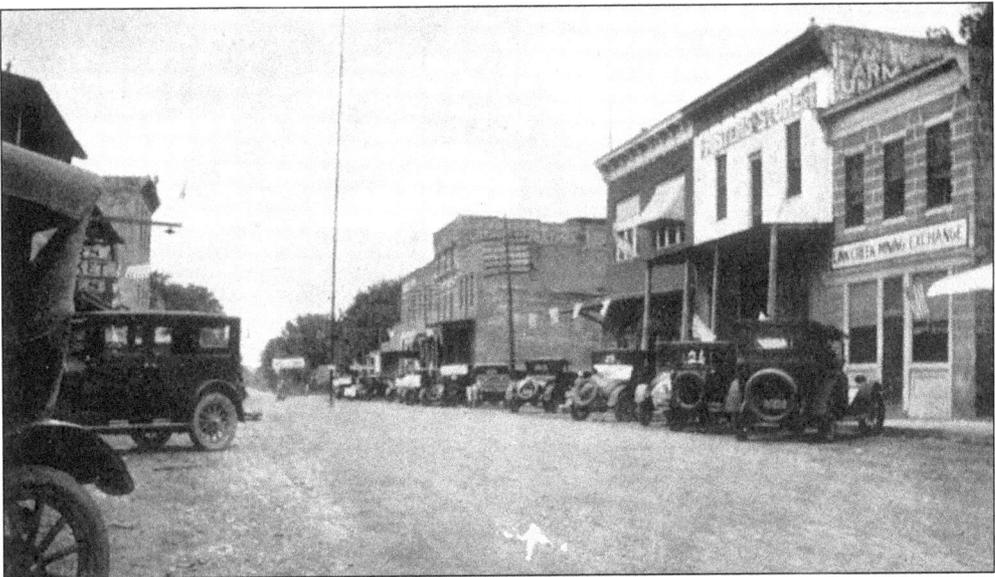

Linn Creek was a quiet county seat town in a seemingly remote location along the Osage River before the construction of Bagnell Dam began. By the time this photo was taken in 1928 or 1929, the nature of things had changed, and it was busy every day of the week as people prepared for the town's imminent destruction and coming inundation.

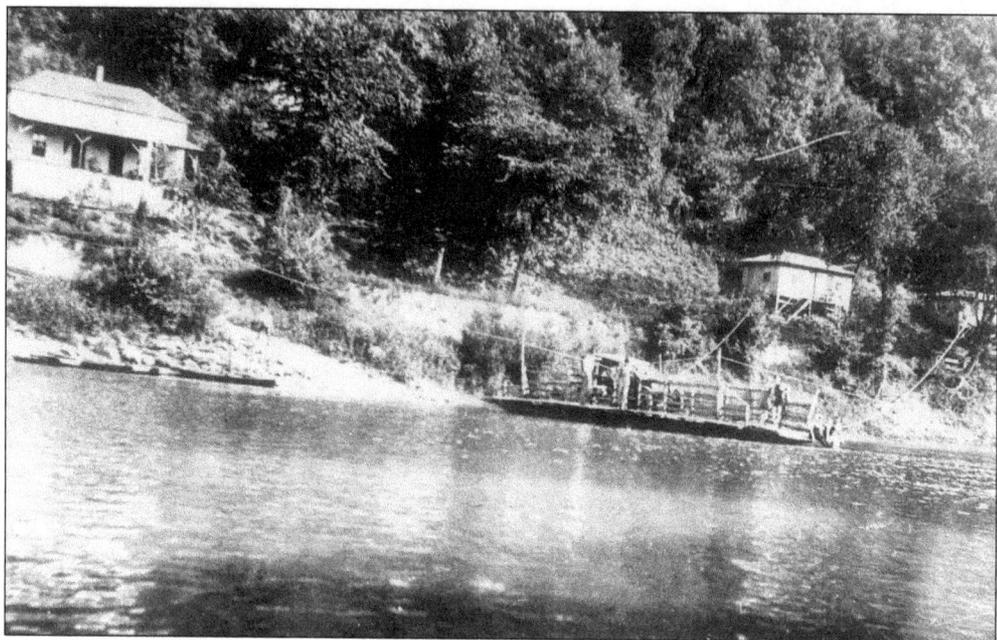

Linn Creek was located a short distance up Linn Creek valley from the confluence of the Osage River and the Big Niangua River. A ferry was established here across the mouth of the Niangua and operated continuously from 1841 to 1931. Harvey (Harv) Kiplinger was the contractor when this photo of the ferry was taken in about 1928. The Kiplinger home can be seen in the upper left. (Photo courtesy of Danny Lane.)

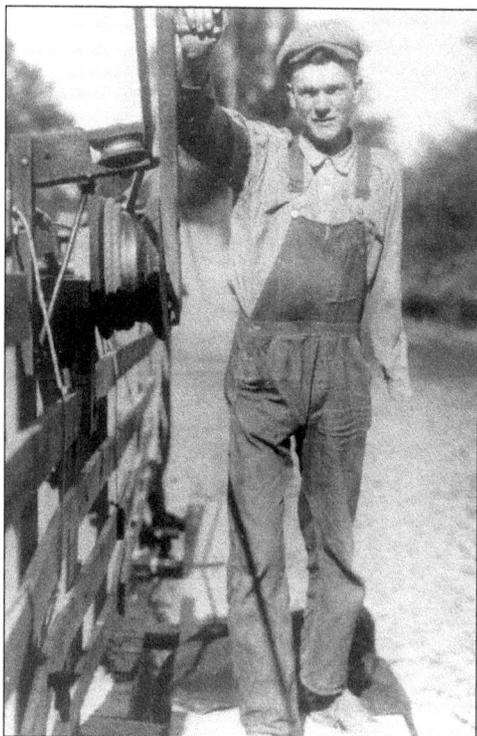

Most ferry operations were family-operated. In this photo, Raymond Kiplinger uses the windless that pulled the ferry along a cable from one side of the river to the other. The windless was a circular, tube-like device about a foot in diameter with a handle that enabled him to turn it. There were numerous hazards associated with the operation of a ferry but the most costly were sinking, ice, and flooding. (Photo courtesy of the City of Osage Beach/ Camden County Historical Society.)

This 1909 photo of John McGowan, a famous early-day fishing guide on the Osage River, shows him with his catch. John was considered the "champion Waltonite" of the valley. By the time Linn Creek met its fate, he was 80 years old and reluctant to sell his home and move. "They'll have to rope me and pull me to get me off this place," he said. His son was also a fishing guide. (Photo courtesy of the City of Osage Beach/ Camden County Historical Society.)

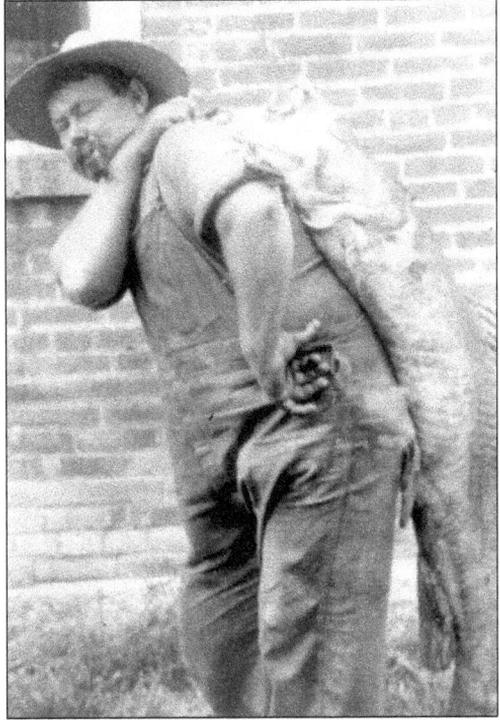

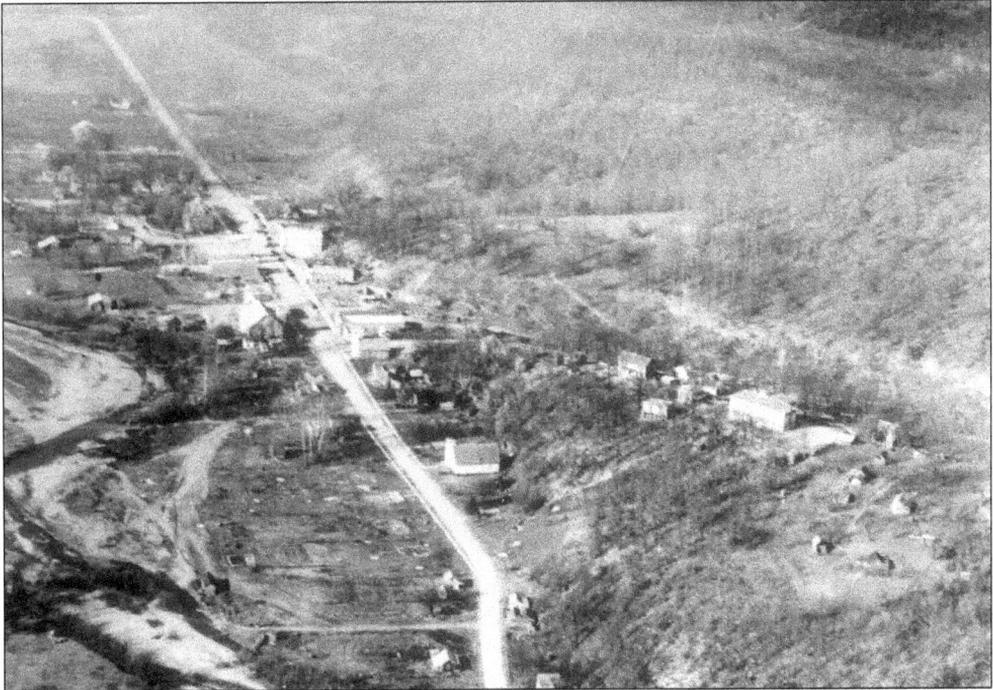

Old Linn Creek was often called the "Town of Three Hills": Cemetery Hill, Indian Hill, and School House Hill. In this aerial photo of the demolition of old Linn Creek, the school house can be seen on the hill to the right. A new school had to be built because the lake created an island out of School House Hill, isolating the structure. (Photo courtesy of AmerenUE.)

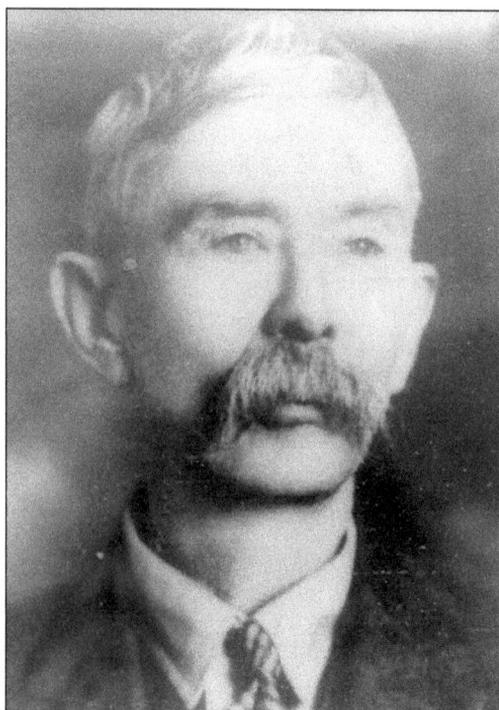

J.W. Vincent was one of the best known citizens of old Linn Creek. His father founded *The Reveille* newspaper in Linn Creek in 1879, and a year later, J.W. bought it from his father. He was a no-nonsense man and outspoken. He fiercely opposed the construction of Bagnell Dam. He was also a Representative for Camden County for three terms and served terms as Village Trustee and mayor of old Linn Creek. He died March 26, 1933, at the age of 73. (Photo courtesy of the Camden County Historical Society.)

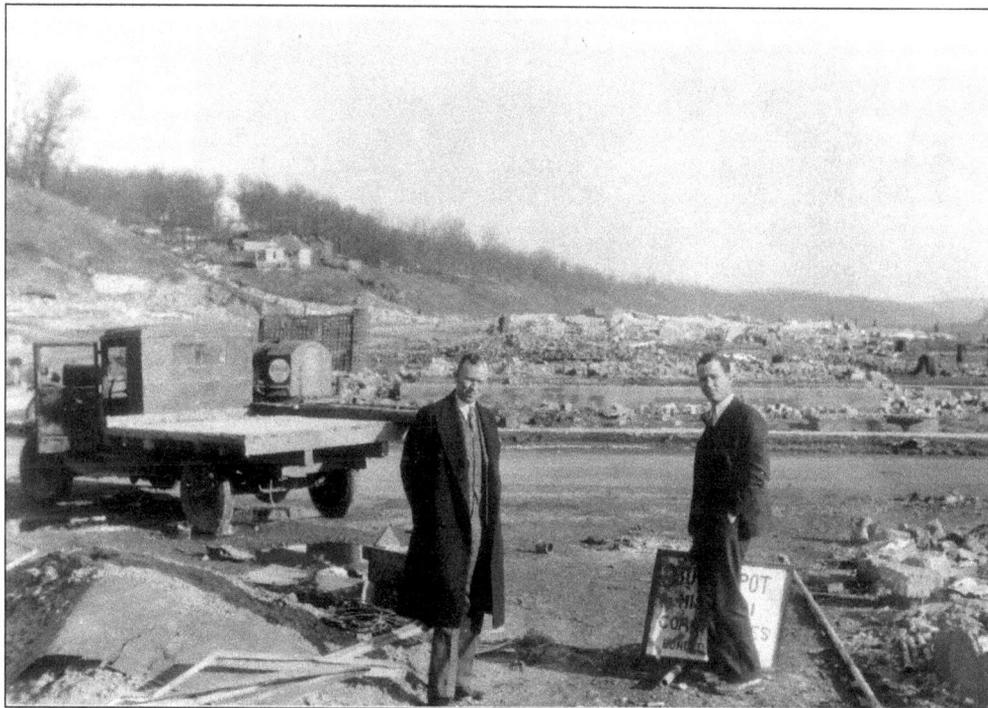

Cemetery Hill is on the left in this photo, which shows Carl Crocker and T. Victor Jefferies collecting souvenirs. Jefferies (on the left), was born in old Linn Creek, became a lawyer, and worked for Union Electric during the dam's construction. His 1974 book, *Before the Dam Water*, tells the story of old Linn Creek. (Photo courtesy of AmerenUE.)

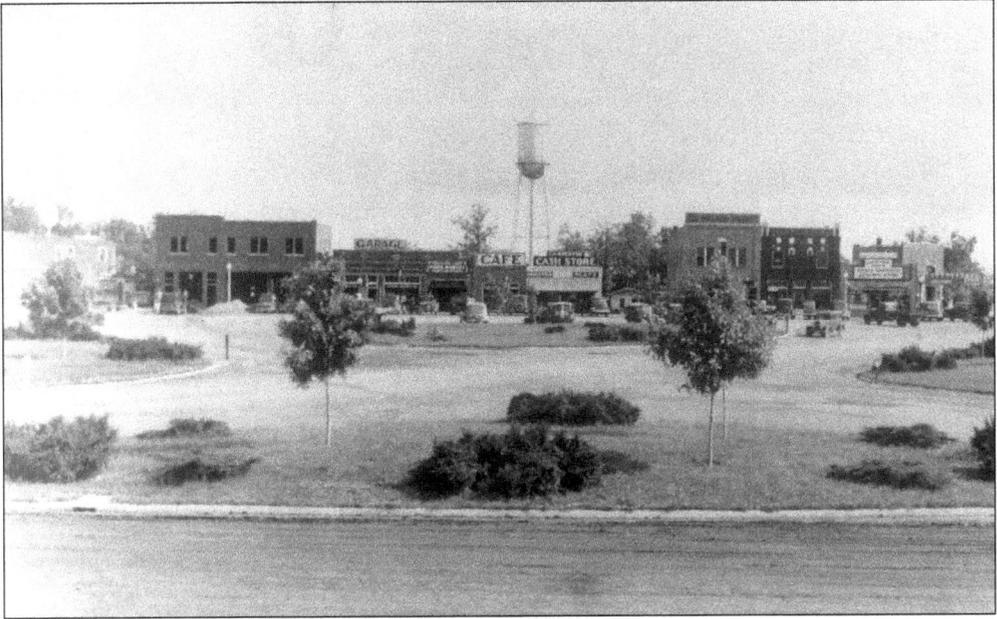

Most of the people of old Linn Creek relocated further up the valley where "New" Linn Creek is today, or at the junction of Hwys. 54 and 5 (seen in this photo), which became the new town of Camdenton. Union Electric, builders of the dam, replaced the county's government buildings, erecting the public school in Linn Creek and the courthouse in Camdenton.

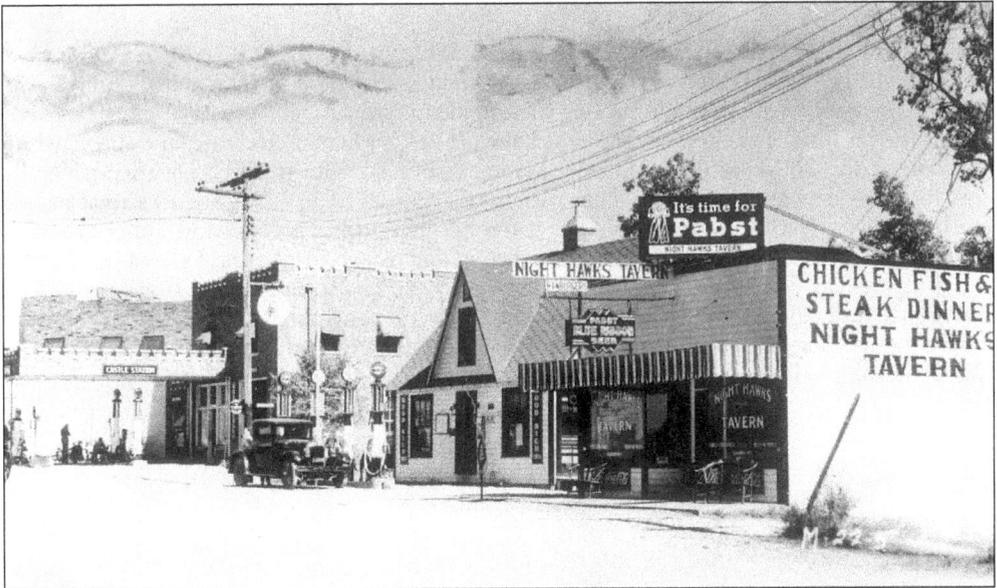

The Night Hawks "Tavern" Café is one of the best-known former businesses in Camdenton. The original building, dating to 1932, burned in 1933 and was replaced with this structure by Jack and Toots Stotler. They sold to Buford and Anna May Foster in 1945. The Fosters changed the word "tavern" to "café" and operated it until 1986. The Ozbun-Rains Service Station next to it was in business until about 1980.

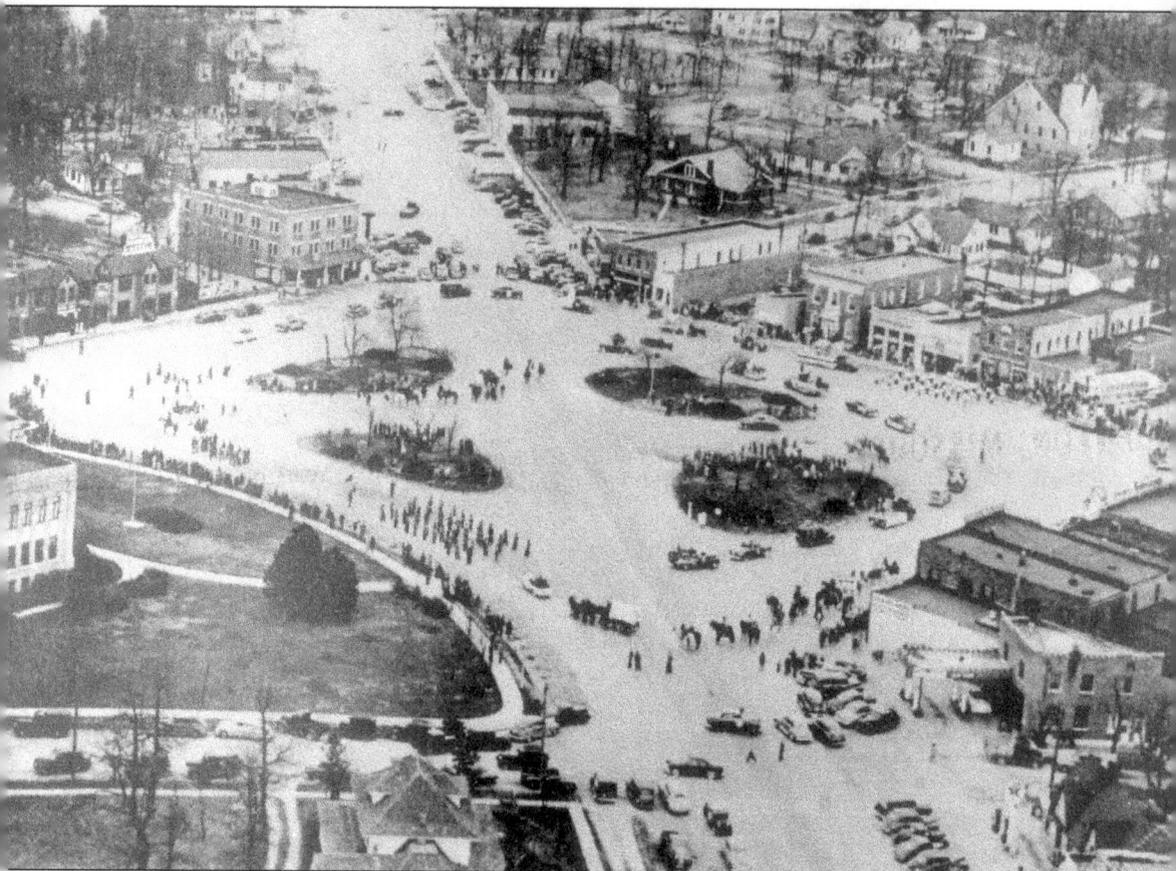

The Dogwood Festival is an annual spring event held in Camdenton. The above photo shows the first Dogwood Festival parade circling the Camdenton square on April 20, 1950. The event signals the opening of the tourist season at Lake of the Ozarks and celebrates the snowy white blossoms of the flowering dogwood tree, Missouri's official state tree. The festival generally lasts for three days and includes a wide variety of events. The first Dogwood Festival parade was led by Hope Varner (featured in chapter five) on her mare, Painted Lady. Other events at the first festival included a buffalo barbecue, a coon dog race, boat races on Lake of the Ozarks, and a square-dance exhibition. A Miss Dogwood Queen and a Junior Miss Dogwood Queen contest are always highlights of the festival. The Dogwood Festival has done a great deal toward promoting the lake area and bringing it media and public attention. (Photo courtesy of the Camden County Historical Society.)

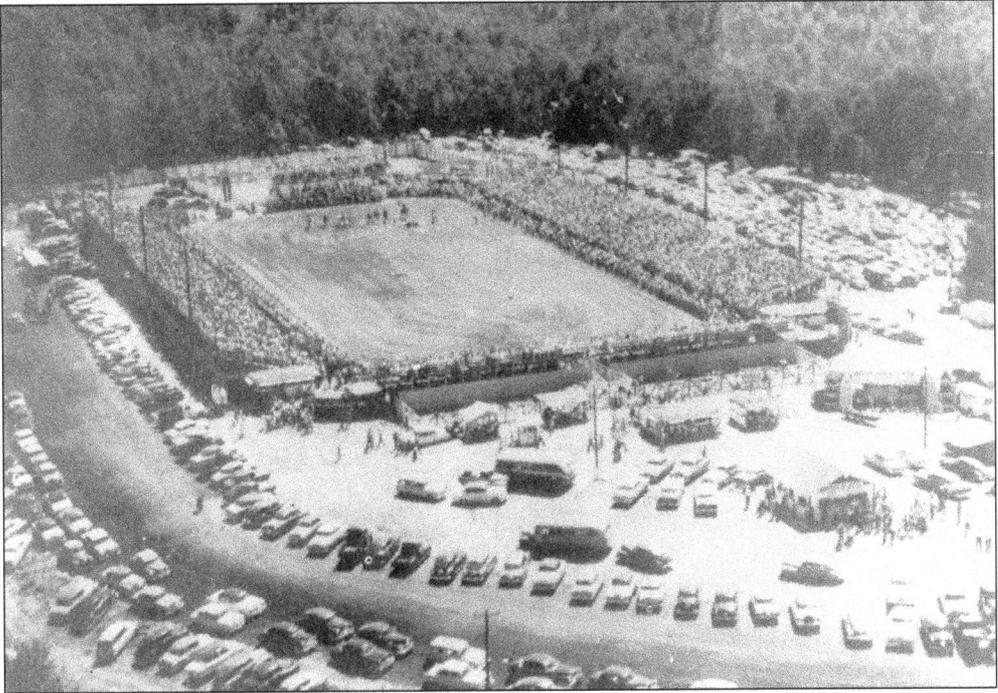

The J-Bar-H Rodeo, established in 1952 by Harry B. Nelson, put Camdenton on the map in the 1950s and '60s. Peak attendance came in the '60s when crowds for the annual 9-day event exceeded 100,000 people. Many famous Hollywood personalities appeared at the arena. Today, the J-Bar-H Rodeo is only a memory and the stadium site is now the location of a new public library and other city buildings.

At the right is the cover of the J-Bar-H Rodeo program for July 7–12, 1958. The program cover features Rex Allen, who made an appearance at the show. Rex Allen was the last of the Hollywood singing cowboys that came along in the late 1940s and early 1950s. Allen was actually a cowboy and enjoyed appearing at rodeo events. Over the next decade the J-Bar-H Rodeo featured many western, country, and Hollywood stars and helped popularize Lake of the Ozarks.

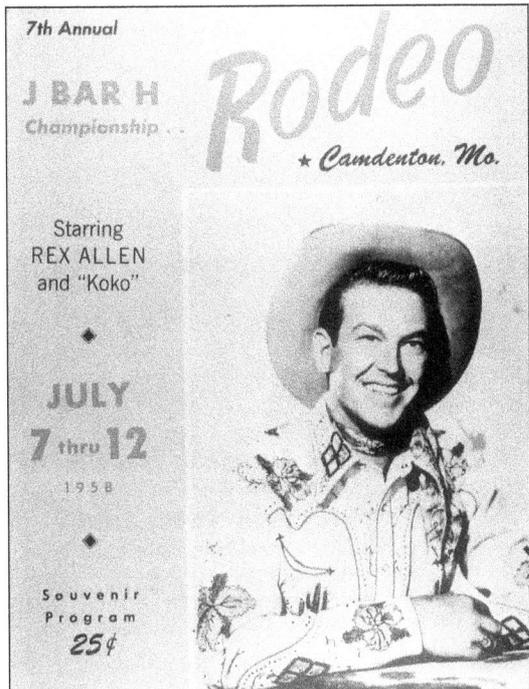

7th Annual

J BAR H
Championship . .

Rodeo
★ Camdenton, Mo.

Starring
REX ALLEN
and "Koko"

◆

JULY
7 thru 12
1958

◆

Souvenir
Program
25¢

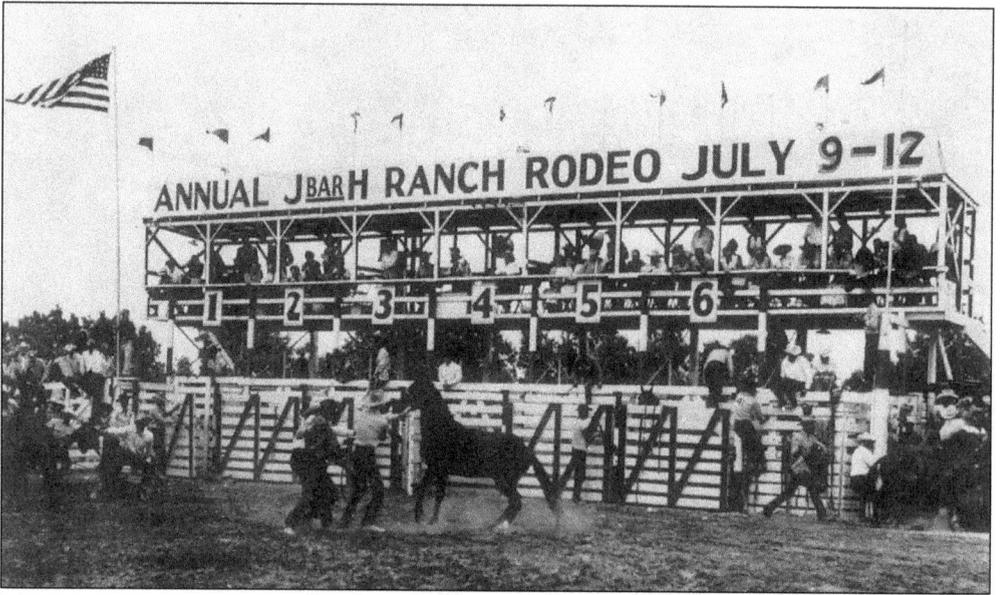

The J-Bar-H Rodeo was operated by Harry B. Nelson from 1952 to 1965. The rodeo brought the lake wide publicity with its outstanding performances and by bringing to the area each year the top cowboys of the nation. The J-Bar-H Rodeo became a household name among rodeo fans. Harry Nelson was formerly a professional boxer and had a brief career as a baseball player with the Chicago Cubs. He died in 1980.

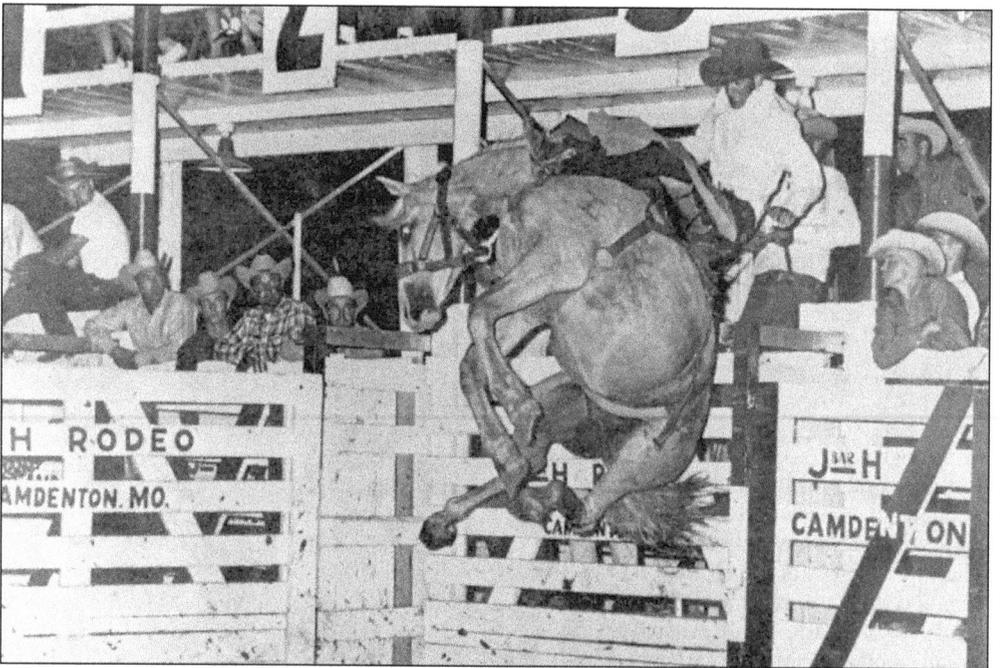

The J-Bar-H Rodeo died with Harry Nelson. All attempts to revive it by later operators failed, but the memory of the rodeo lives on throughout the area. Here, a cowboy finds himself on one very powerful and ornery bucking bronc who, no doubt, surprised everyone at just how high it could get off the ground. Saddle-bronc riding is one of the most important contests in a rodeo.

In the 1940s and '50s, the Missouri Conservation Commission built many fire towers throughout the Missouri Ozarks. It was from the small building atop the towers that forest rangers monitored the area for wildfire. The towers built in the Lake of the Ozarks area were quickly discovered by vacationers. They rise to heights of 100 feet and from them, lake views are spectacular. Today, the towers are being dismantled, but several popular ones still stand in the lake area. The one in Camdenton at the Missouri Department of Conservation's Lake Ozark Headquarters site is very popular and is climbed by thousands of visitors every year. The tower in this 1950s photo by Gerald Massie is typical of the early ones. The Camdenton tower now has an observation platform in place of the enclosed building seen on this tower. (Photo courtesy of the Missouri State Archives.)

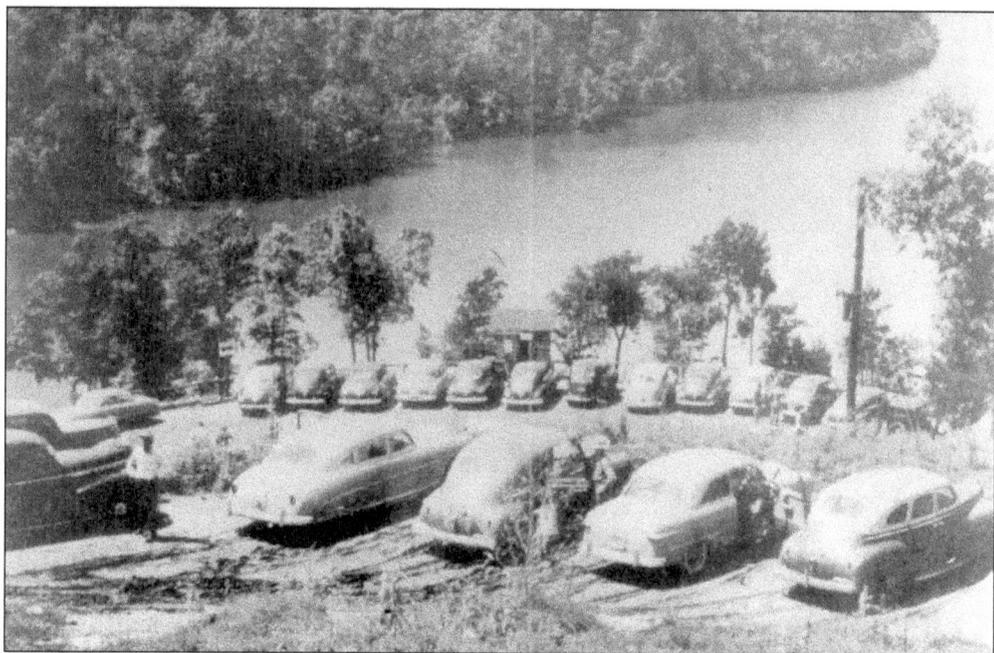

There are few show caves in America with a more scenic location than Bridal Cave at Lake of the Ozarks. It penetrates the flanks of Thunder Mountain about 40 feet above the 660 foot elevation of the Lake of the Ozarks. The cave has been known since the early 1800s and a legend tells of an Indian wedding in the cave. A portion of the cave was developed for public touring in 1948. The above photo shows visitor cars on the parking lot, c. early 1950s.

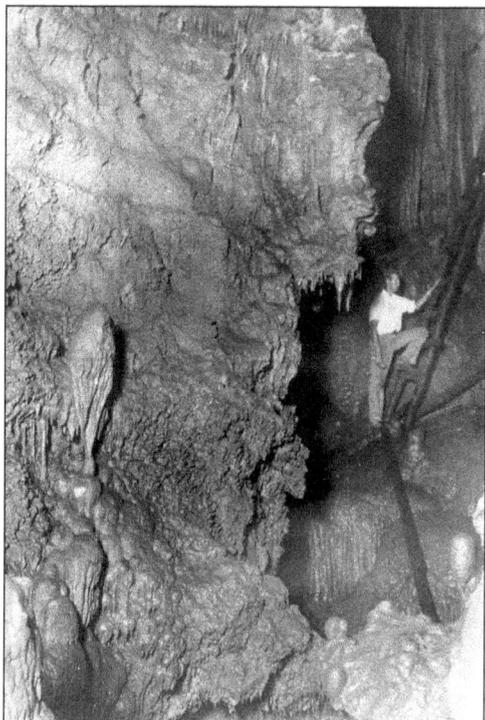

This rare photo shows a 1920s explorer in Bridal Cave at the base of the Frozen Niagara formation. The cave property was originally owned by Robert M. Snyder who owned Ha Ha Tonka a few miles upstream on the Niangua Arm of Lake of the Ozarks. When the lake basin was being surveyed and cleared for the lake, some of the surveyors explored the cave out of curiosity. Note the rugged floor area in the foreground.

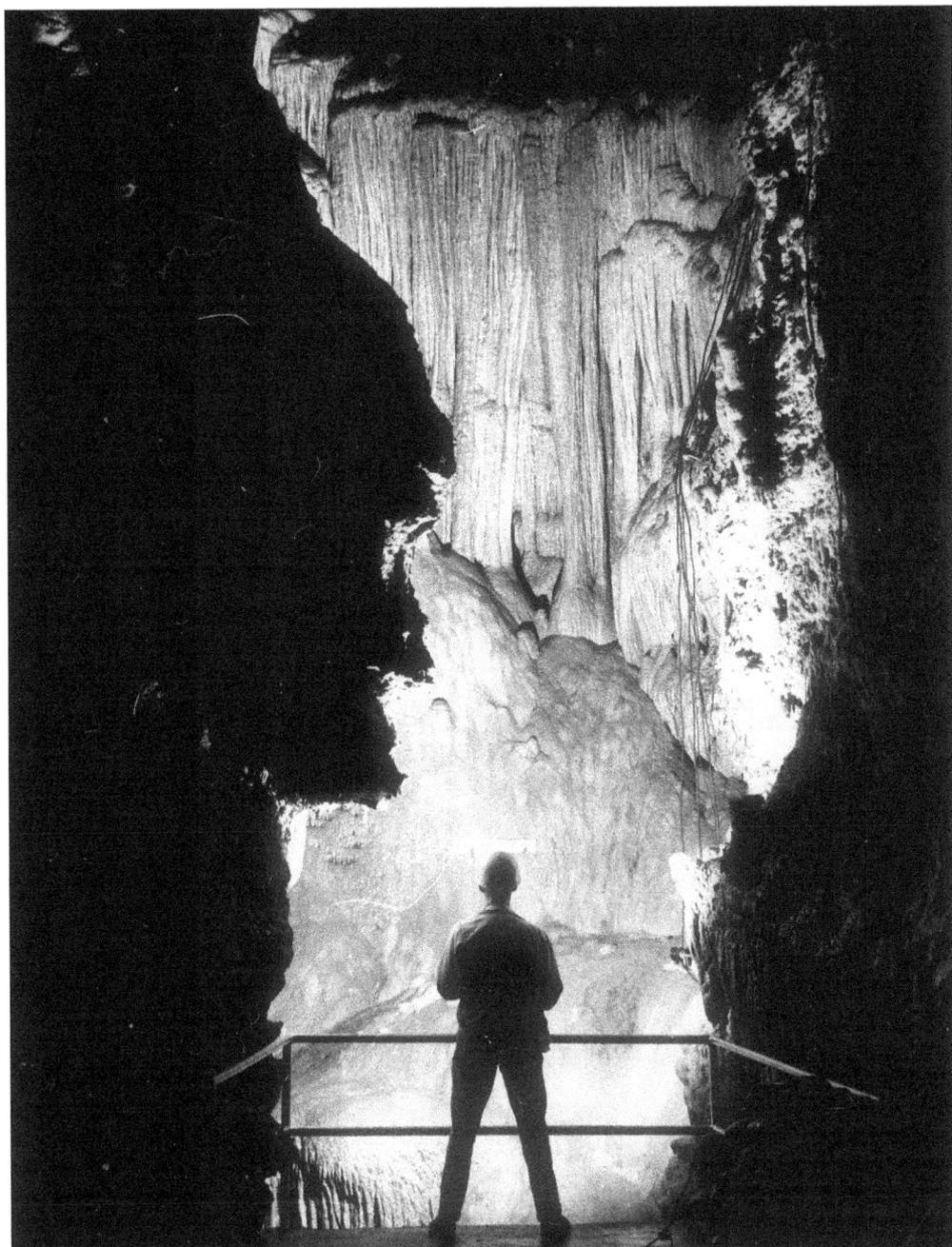

This photo was taken in the 1960s by Paul A. Johnson from very nearly the same spot as the lower photo on the opposite page. This one however, shows the Frozen Niagara illuminated with floodlights and the platform and trail that now covers the rugged floor crevasse seen in the opposite photo. The author is the person in the photo. For more than four decades, the Frozen Niagara marked the end of the commercial trail in Bridal Cave. In the 1990s, the formation was bypassed with a man-made tunnel to permit the opening of another beautiful part of the cave to the public. The tour now ends at a large crevasse-like canyon with a lake in the bottom, but there is an even larger lake and more spectacular chambers beyond the present commercial section.

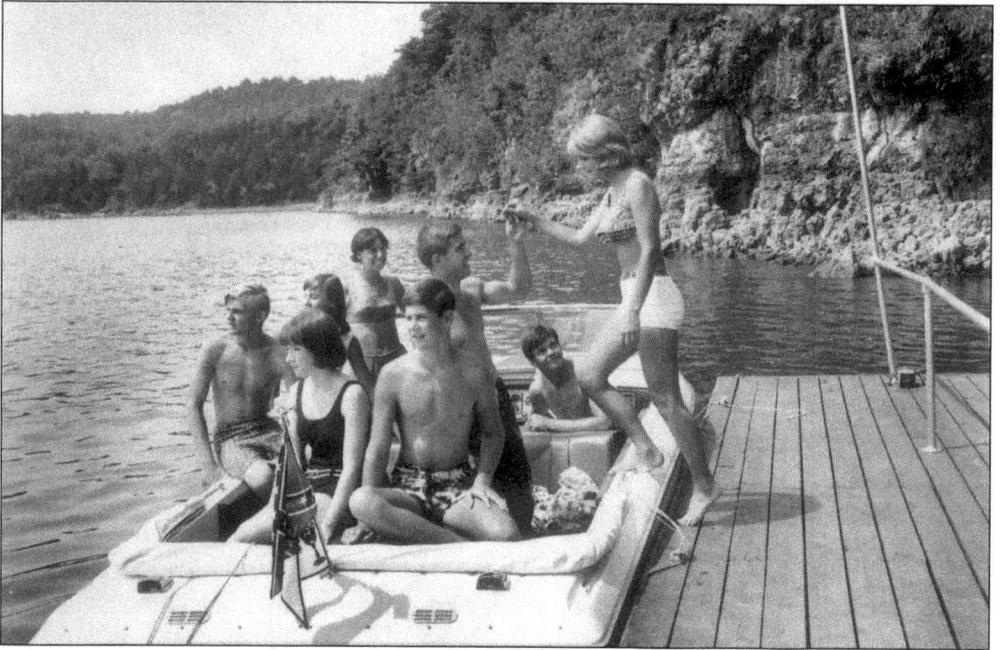

This photo by Massie, c. 1960, was taken on the Bridal Cave boat dock. In the summer, the cave has many visitors that come by water. The shoreline beyond the boaters is still pristine. A small cave called Bluff Cave, penetrates the rock just to the right of the girl boarding the boat. At the far end of this shoreline, bald eagles roost in the winter. (Photo courtesy of the Missouri State Archives.)

There is only one show cave in the Lake of the Ozarks area that presents a natural entrance to the visiting public: Ozark Caverns. This photo shows the entrance restored to its pre-1950 appearance. The restoration was undertaken after the cave was bought by the state in 1978. To restore the entrance, it was necessary to remove former commercial building and earth-fill that clogged muddy bogs (fens) fed by the many springs along the hillside.

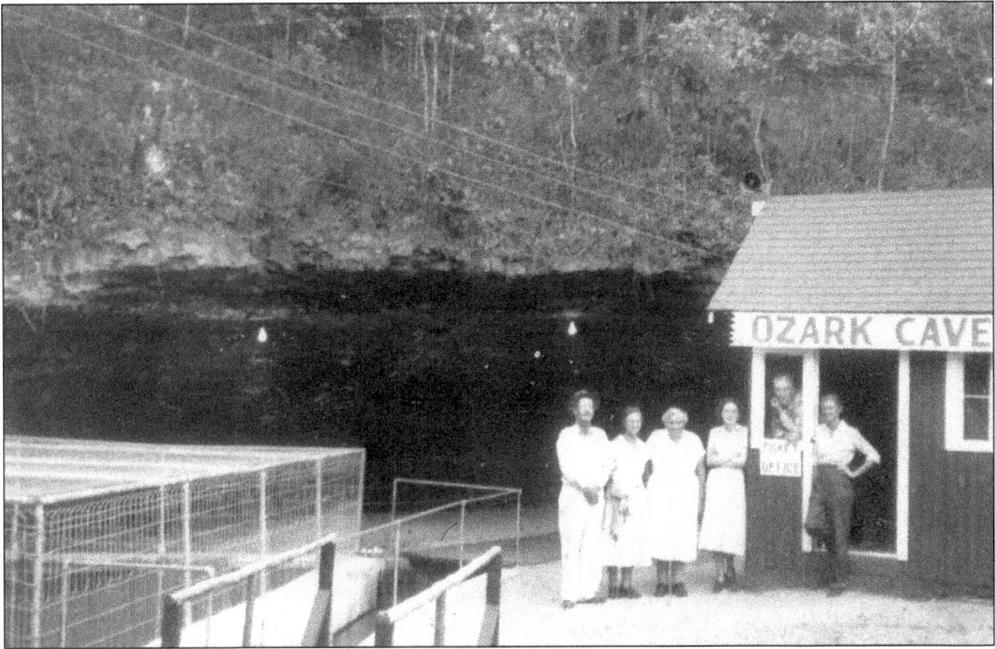

Ozark Caverns was opened to the public in 1951 by Jim Banner, B.F. Krehbiel, and R.L. Wilkerson of the Bridal Cave Development Corporation. This photo shows the first ticket building and a wire hood covering a goldfish pond fed by the cave stream. The cave has a history that pre-dates the Civil War. (Photo courtesy of the Camden County Historical Society.)

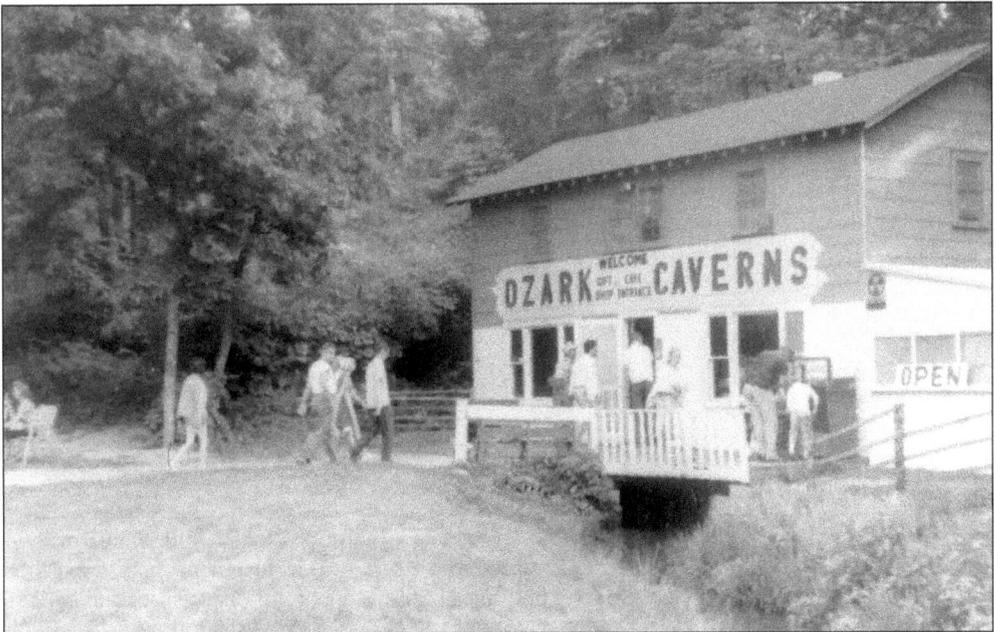

In 1955, this building was erected across the entrance to Ozark Caverns. The second floor provided living quarters for the Logans who managed the cave, and the main floor was used for a gift shop and staging area for tours. This building was removed during the restoration work done by the state in the 1980s. The above picture was taken in 1964.

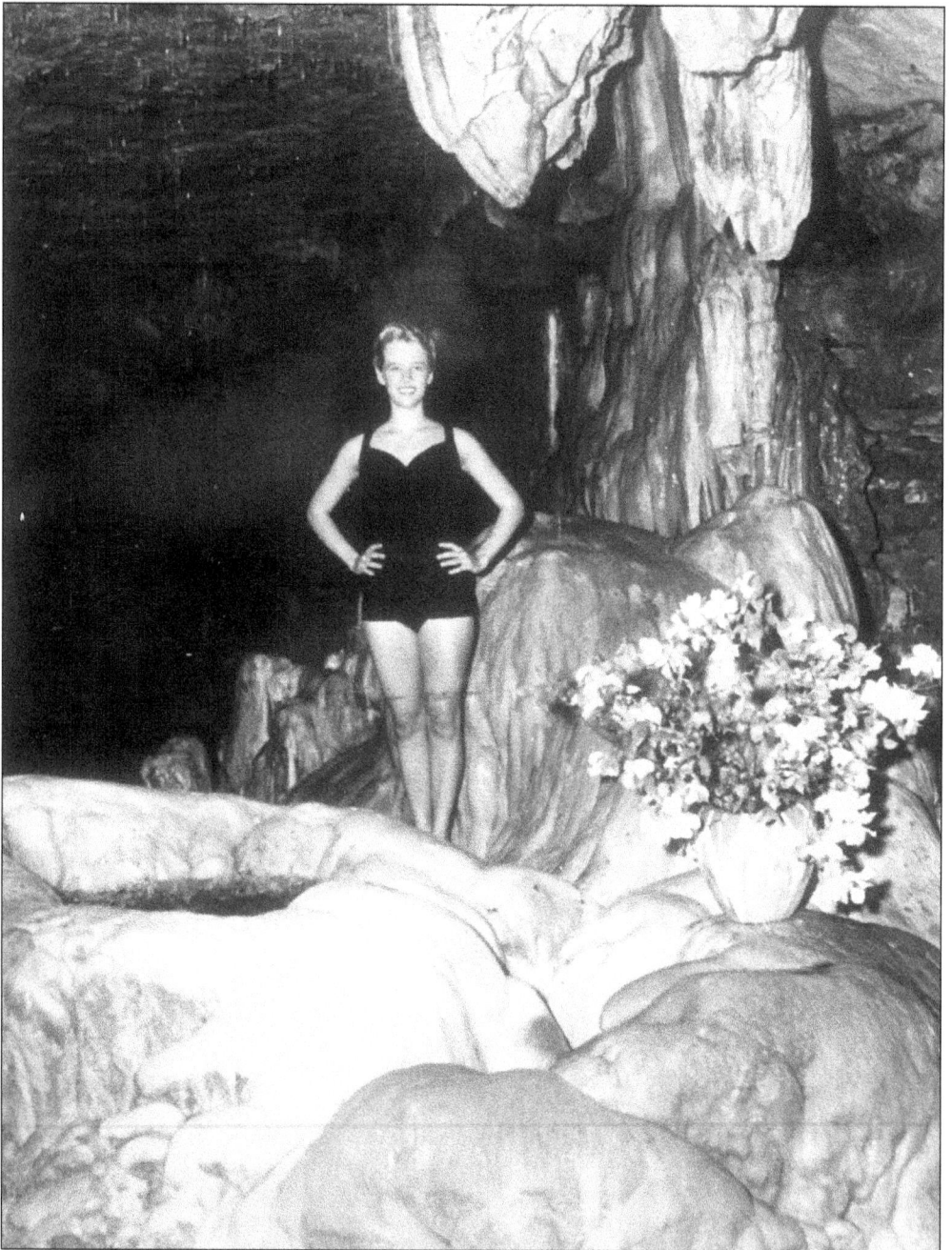

In the mid 1950s, the Bridal Cave Development Corporation sold Ozark Caverns and 400 acres of land to Ralph H. and Mary Ohlson, who had a café in Camdenton. They owned the cave from 1956 to 1978 when the cave became a part of the natural history program at Lake of the Ozarks State Park. Coakley Valley, in which the cave is located, is noted for its springs and natural areas. The most spectacular group of formations in the cave are seen here and the feature is called the Angel's Shower. The Ohlsons were supporters of the Dogwood Festival and a Dogwood Festival Queen is shown here posing behind the Angel's Shower. The cave's electrical lights were removed in 1979 and today's tours are made by hand-held lantern.

Seven

HA HA TONKA

Ha Ha Tonka is unquestionably the premier natural wonder of the Lake of the Ozarks. It has attracted attention since the days of Daniel Boone. Efforts to designate the place a state park began early in the 20th century but were not successful until 1978. Since then, Ha Ha Tonka State Park has become a jewel in the state park system and unashamedly the state's most popular day-use park. Few people who vacation at the lake have not visited it and many people have made it a family tradition to visit the park each year when they vacation at the lake.

There is much to do in the park besides picnic, swim, and fish. There are nature trails to hike, caves to visit, a great spring to see, a giant chasm to marvel at, a natural bridge to walk beneath, glades, sinkholes, and the ruins of a castle. When all of that has been done and seen, one can stand upon the ramparts of the great cliff and look out across the undulating, green forested Ozark hills and capture a look at the sparkling blue waters of the Niangua Arm of Lake of the Ozarks.

Geologists were among the first tourists to become captivated with Ha Ha Tonka. In the year 1900, Missouri State Geologist Jno. A. Gallaher praised it highly in his works and said that it was a place of "unparalleled wonders." One hundred years later, its wonders are still captivating visitors.

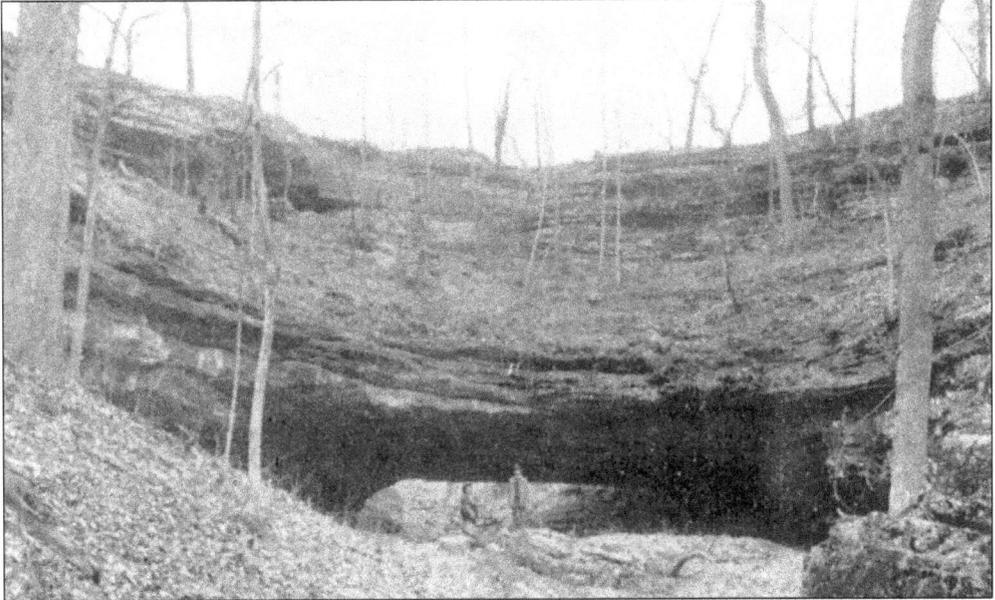

The Ha Ha Tonka Natural Bridge is a span of dolomite and sandstone, and the remains of an ancient cave passage. It is not sway-backed as the angle of this photo, c. 1910, suggests. A road once crossed the bridge leading to the Ha Ha Tonka Castle. About 60 to 70 feet in length, the arch is 45 feet thick and the opening beneath it 9 to13 feet high. A hidden sinkhole dell exists just beyond the distant opening in this photo. (Photo courtesy of Danny Lane.)

This photo of the high north cliff of the Ha Ha Tonka Chasm was taken about the year 1899 and is one of the earliest known photos of the chasm wall. The wall of rock exposes 135 feet of Eminence Dolomite, 20 feet of Gunter Sandstone, and 85 feet of Gasconade Dolomite. It was on top of this bluff that Robert McClure Snyder began the construction of his castle in the year 1904.

Here at the mouth of the Ha Ha Tonka Chasm one can see the rushing spring branch of Ha Ha Tonka Spring emerging from the Trout Glen. The large pitted rocks are the ruins of a cave for the great chasm was once a giant cave passage. The 48 million gallons of cold water that discharge from the Ha Ha Spring flow down the canyon and are then divided by Onyx Cave Island into two streams. (Photo courtesy of the Camden County Historical Society.)

92

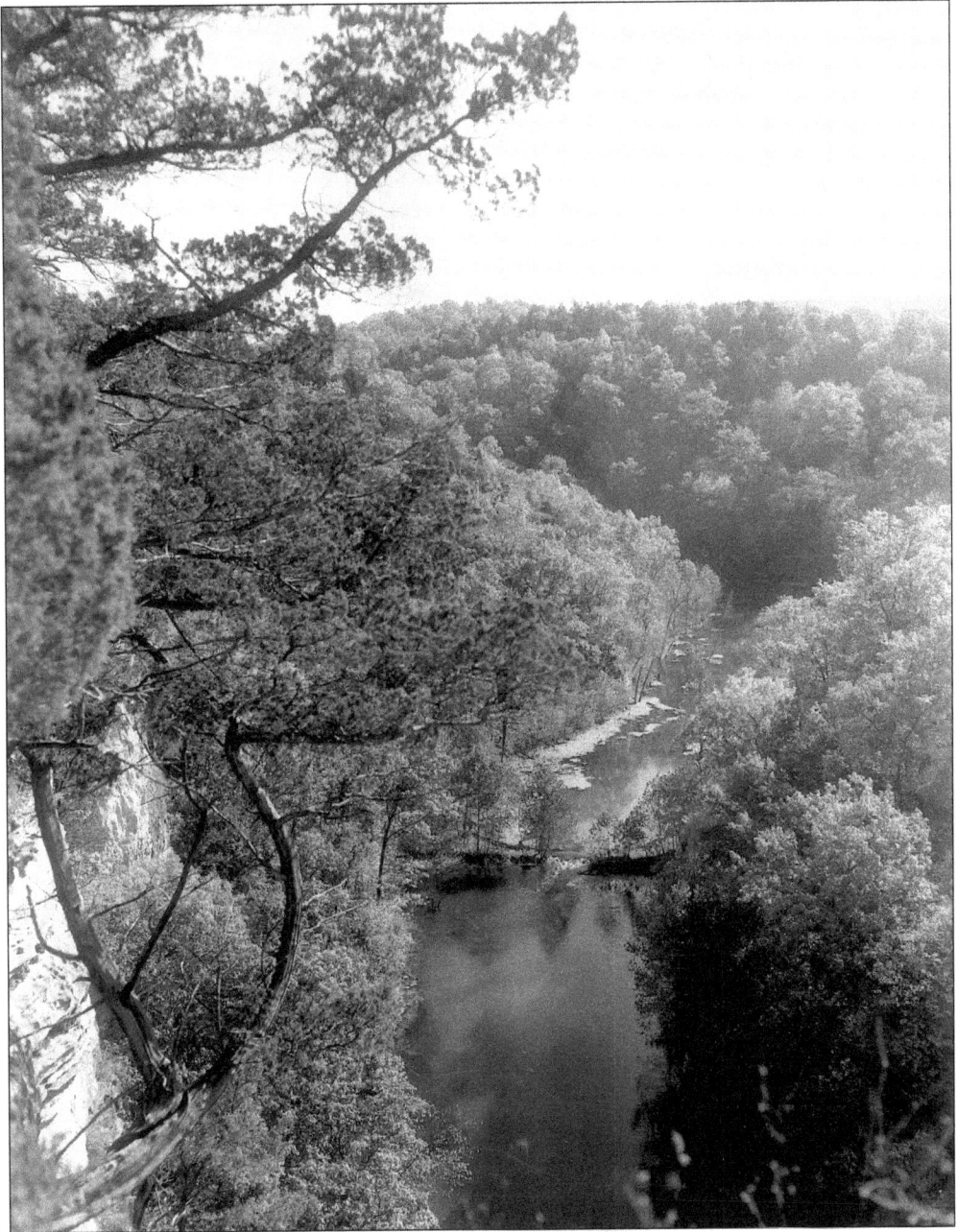

Standing upon the wind swept heights of the great north wall of the chasm at Ha Ha Tonka, one can catch this view of the chasm and Trout Glen. The entrenchment of the stream and chasm lake form a question mark in the foliage of the photo and it is near the top of the question mark that the spring emerges from miles of deep-seated, water-filled cave passages, some of which gather water from distances as great as 20 and 30 miles. The person who captured this view sometime in the 1950s or '60s is unknown, but the park has preserved this beauty and today, an observation platform that overhangs the canyon near this spot allows modern day visitors to capture the same pristine beauty on film. The lake in the chasm was once stocked with trout, and trout fishing was popular in the chasm as early as 1910.

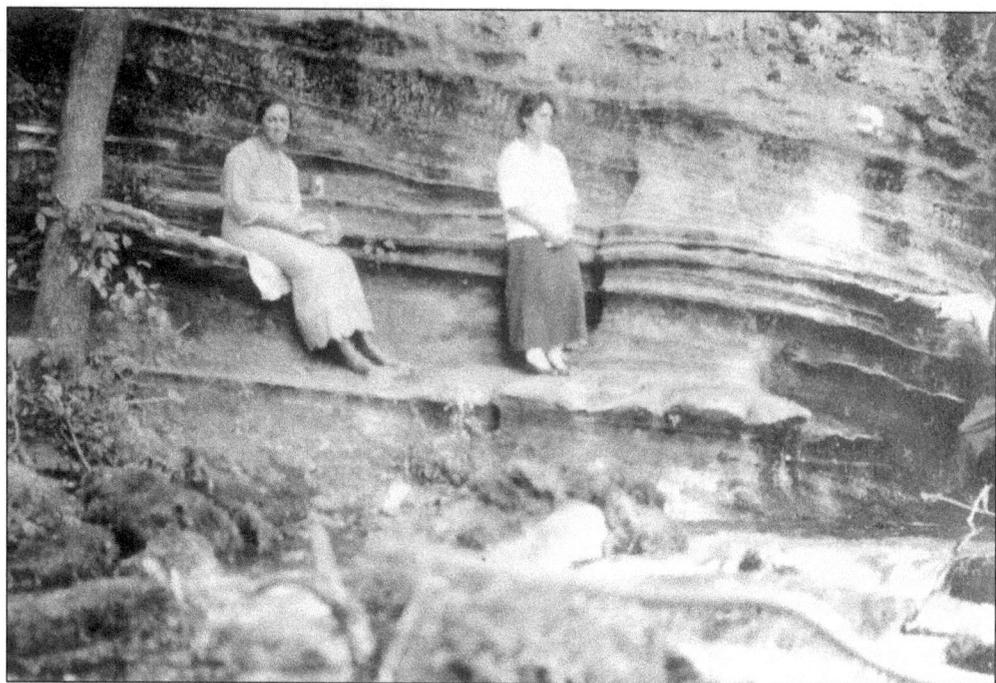

Two ladies, c. 1920s, enjoy leisure time along the Gunter sandstone ledges that outcrop in Ha Ha Tonka State Park. The reddish and buff-colored sandstone was used in the construction of the Ha Ha Tonka Castle. The rock here is well-covered with vintage names and dates that are not discernable today because they have weathered away. (Photo courtesy of Danny Lane.)

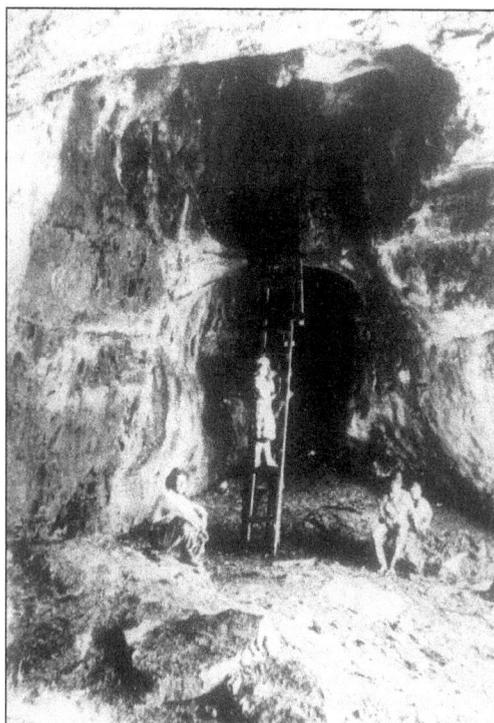

In this vintage photo, a group of early day spelunkers are exploring the upper reaches of Counterfeiters' Cave in Ha Ha Tonka State Park. Even today, a ladder is required to reach the upper level which, contrary to rumors, does not lead to extensive passage. The cave acquired its name in the 1830s when a band of counterfeiters used it as a hideout for the production of counterfeit United States, Mexican, and Canadian bank notes and coins. (Photo courtesy of Bob Gitchell.)

River Cave, the largest cave in Ha Ha Tonka State Park, has its entrance at the bottom of a huge sinkhole. Before the days of air conditioning, summer visitors to the area enjoyed cooling off in the cave opening. To explore the cave's large rooms and passages means getting wet and muddy. Water can get deep within the cave during rainy seasons and in the early days, a boat was often kept at the mouth of the cave for exploring parties. (Photo courtesy of Bob Gitchell.)

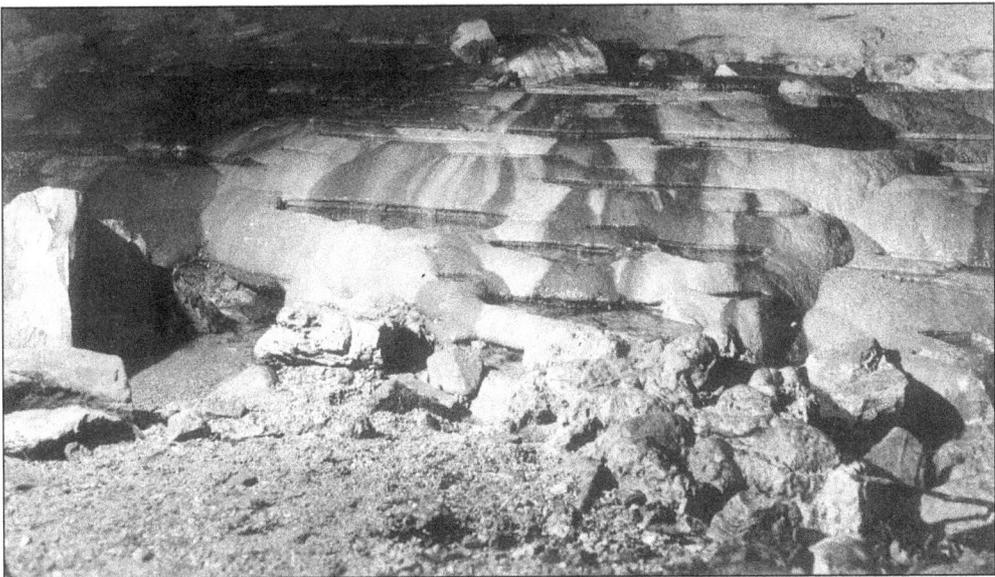

This cascade of crystalline rimstone terraces and pools within River Cave have attracted a fair amount of attention from biologists since the beginning of the 20th century because they are rearing pools for the cave's annual crop of hundreds of Ozark blind cave salamanders. The cascade is 50 feet wide and tapers upward for 30 feet. Behind the cascade is a long, narrow, winding cave passage with more rimstone dams. (Photo c. 1950s.)

During the late 1940s and early 1950s, J Harlen Bretz, a well-respected geologist from the University of Chicago, studied Missouri caves to determine their geologic origin. His book, *Caves of Missouri*, was published in 1956. In this photo by Massie, he is seen in River Cave with his faithful companion, a collie dog. (Photo courtesy of the Missouri Department of Natural Resources/Missouri Speleological Survey Cave Files.)

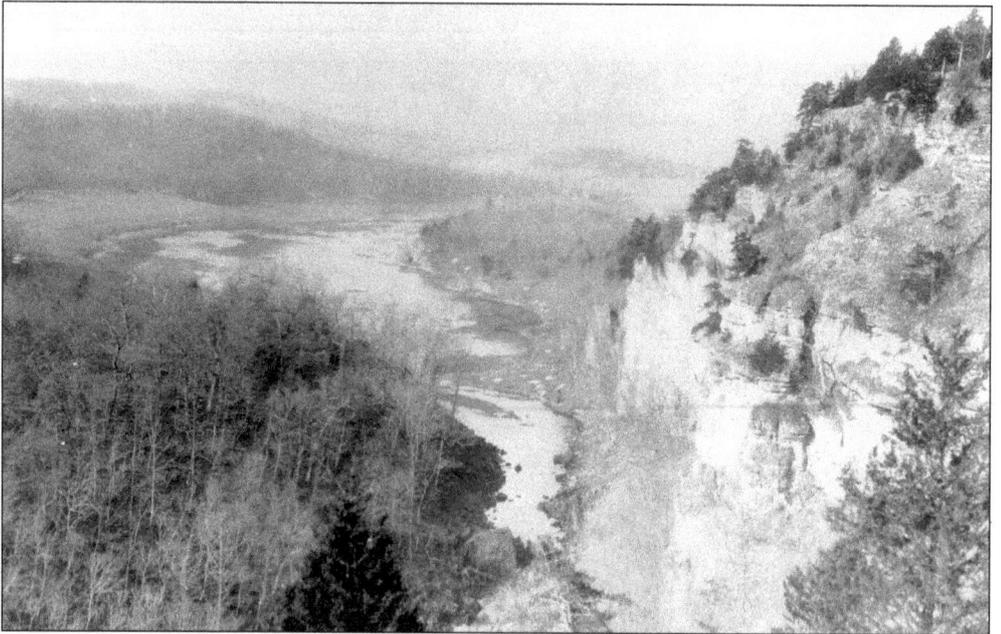

In this photo of the Ha Ha Tonka Chasm, the great north wall is on the right, and Onyx Cave Island, which is a cave-riddled island in the middle of the chasm, is visible on the left. The photo was taken in 1931 as the waters of Lake of the Ozarks began to back up into the Niangua River and the spring branch of Ha Ha Tonka Spring. (Photo courtesy of the Camden County Historical Society.)

Robert McClure Snyder bought the Ha Ha Tonka property in 1903 and immediately began the construction of his dream: a remote Ozark retreat complete with a huge mansion (castle) upon the bluff above the chasm. He was a wealthy businessman from Kansas City whose principal business interests were supplying natural gas to Kansas City from the gas fields of Kansas and Oklahoma. He died in 1906 in an auto accident before the castle was completed. (Photo courtesy of the Camden County Historical Society.)

Robert Snyder's death in 1906 brought the construction of Ha Ha Tonka Castle to a halt, with the outside walls up, but the interior unfinished. In 1922, the Snyder sons resumed the work, ironically enough, from the top down. When the third floor was complete, the Snyders occupied it as a summer retreat. (Photo c. 1915.)

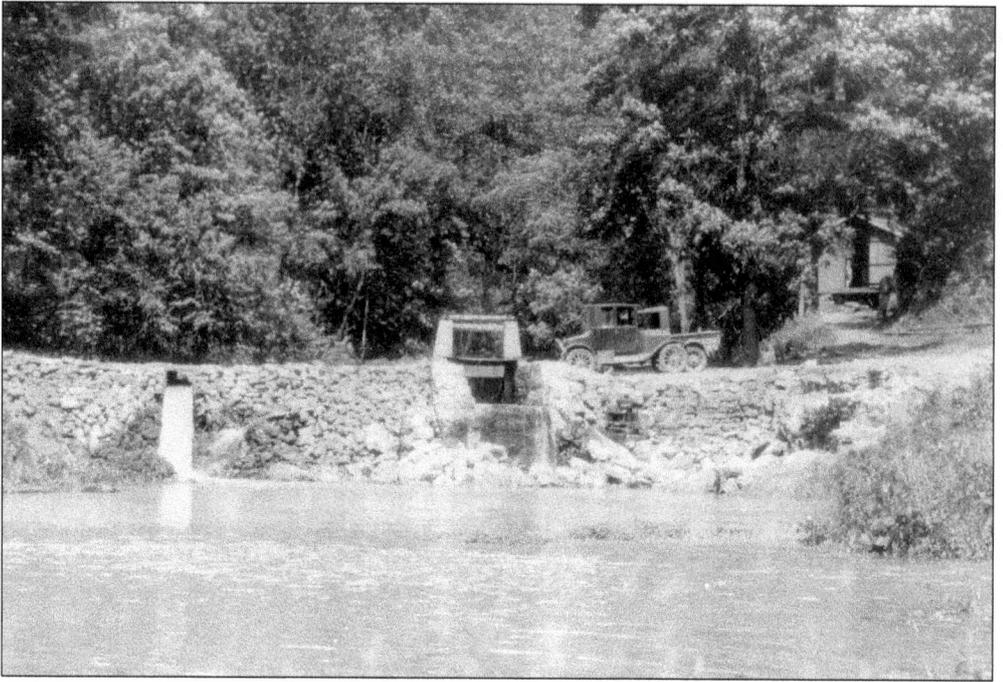

This dam is on the south side of Onyx Island. The old Ha Ha Tonka Mill, burned by the men clearing the lake basin in 1930, stood here. The dam still exists but the building shown in this photo is long gone. The trail to Ha Ha Tonka Spring enters the chasm here. Another trail leads up onto the Island and Island Cave. (Photo courtesy of the Camden County Historical Society.)

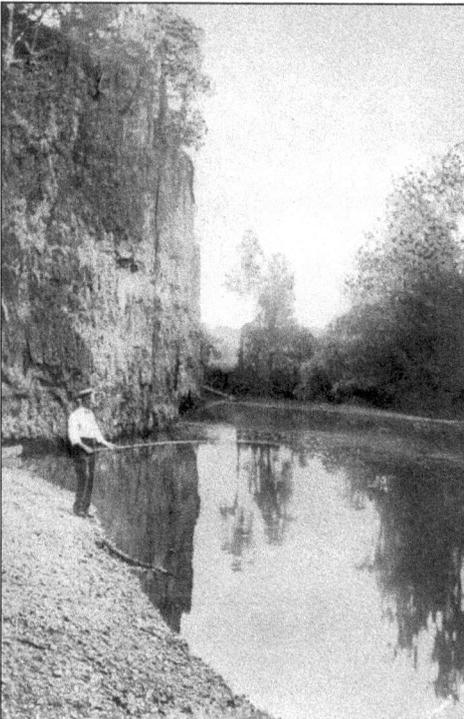

Snyder bought Ha Ha Tonka because of his love of nature, fishing, hunting, and the many natural wonders the property contained. It was called Ha Ha Tonka Park long before the state purchased it and made it a state park. Included at its extreme western edge was Juanita Bluff along the Niangua River. It was one of Snyder's favorite fishing spots. This postcard, c. 1905, shows a fisherman near Juanita Bluff.

This bungalow at Lakeside Resort, a group of cabins that were built along Lake Ha Ha Tonka around 1910, was called Dew Drop Inn. Each building had its own name. The resort was most popular between the years 1915 and 1925. Some people actually preferred the cabins to the castle, going up to the castle only for special meals and other events. (Photo courtesy of Danny Lane.)

The bungalows were a mixture of building styles and materials that were very rustic. This particular bungalow was known as Bide-A-While Inn. Koch, who managed the resort, was a retired railroad engineer living on an adjacent farm. He had a small dairy herd, horses, and an orchard. (Photo courtesy of Danny Lane.)

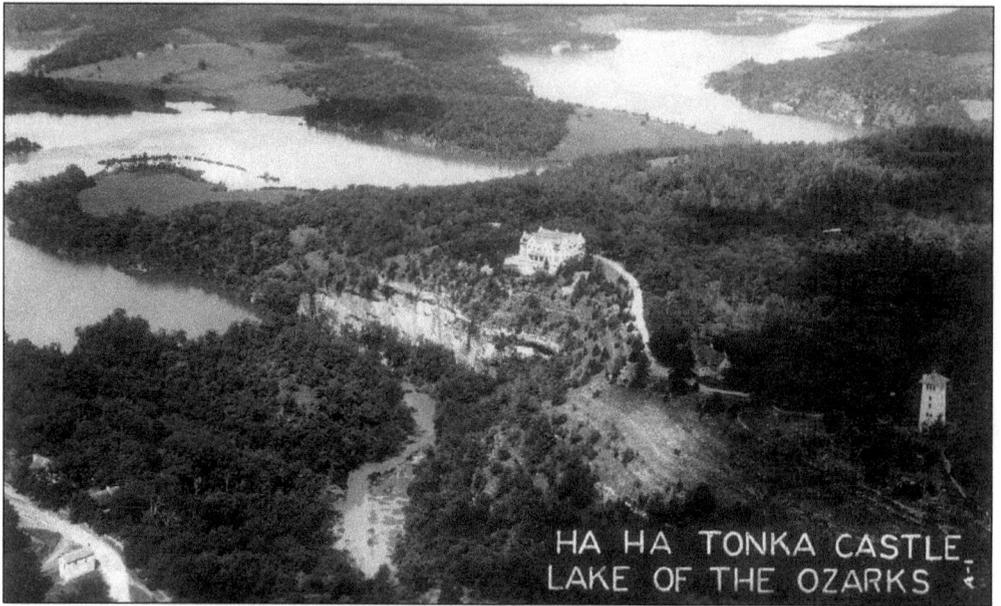

HA HA TONKA CASTLE.
LAKE OF THE OZARKS

This photo aerial postcard view of Ha Ha Tonka was made about 1940. In it you can see the Castle with the Carriage House and Water Tower to the right; the Post Office in the lower left corner; the Chasm and Trout Glen Lake in the Chasm; and the Niangua Arm of Lake of the Ozarks. The castle burned in 1942.

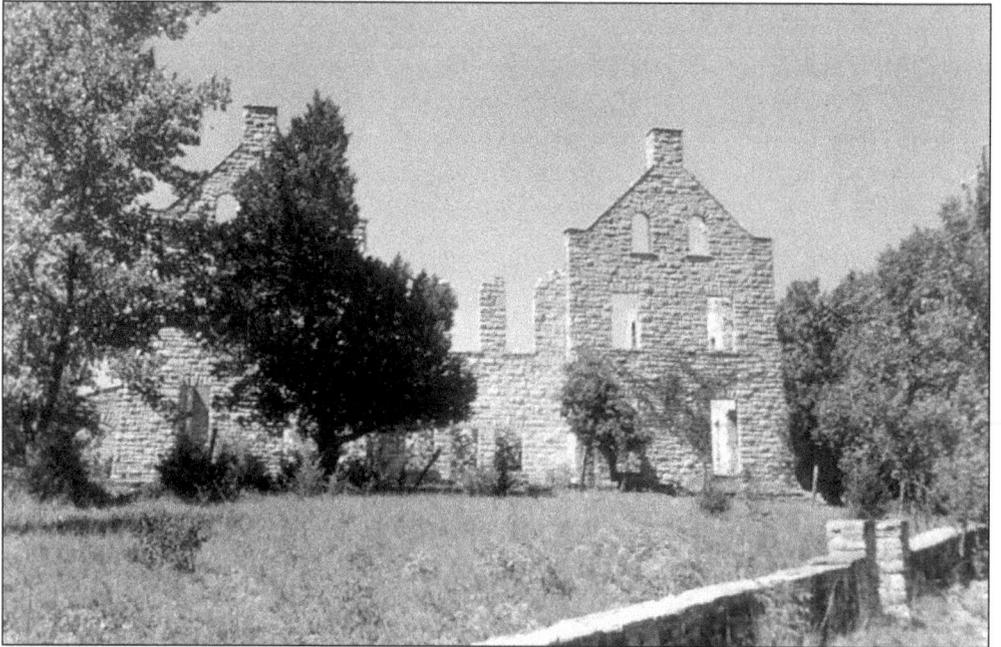

The Castle had 8 bedrooms and 2 baths on the third floor; 8 bedrooms and 4 bathrooms on the second floor; and a large, unfinished attic above the third floor. The first floor had a large living room, dining room, billiards room, sun room, and a smaller dining room. These were grouped around a central hall with a skylight three-and-a-half stories high. Only historic ruins now greet visitors but they are much loved and photographed. (Photo courtesy of Danny Lane.)

100

Eight

HURRICANE DECK AND SUNRISE BEACH

Sunrise Beach was born when the post office was established in 1932 at the junction of Hwy. 5 and Lake Road 5-35, which was then 5-17. "A small tent-town was established (here)… across the road from the home of H.A. Thickstun… The home soon became a store, restaurant, and meeting place for workmen building roads, clearing brush, and removing fire-place masonry left standing after farm homes in the lower level of the lake had been burned down to expedite their removal," says a history of the area by Sharon Robinson.

The old Village of Purvis, now gone, was along the Osage River at the end of Lake Road 5-29, originally Lake Road 5-14. It also had a post office, which was established soon after the Civil War. Various members of the Purvis family served as postmaster until 1945, when it was discontinued.

Hurricane Deck is the name of a bluff along the Osage River. Both Sunrise Beach and Purvis Beach are in the business community of the Hurricane Deck Association, which promotes tourism for the area. Although the Sunrise Beach resort area is some distance from Bagnell Dam by highway, the area is virtually surrounded by the lake in all directions but to the northwest. A new bridge across the lake is now bringing a surge of new development to the area.

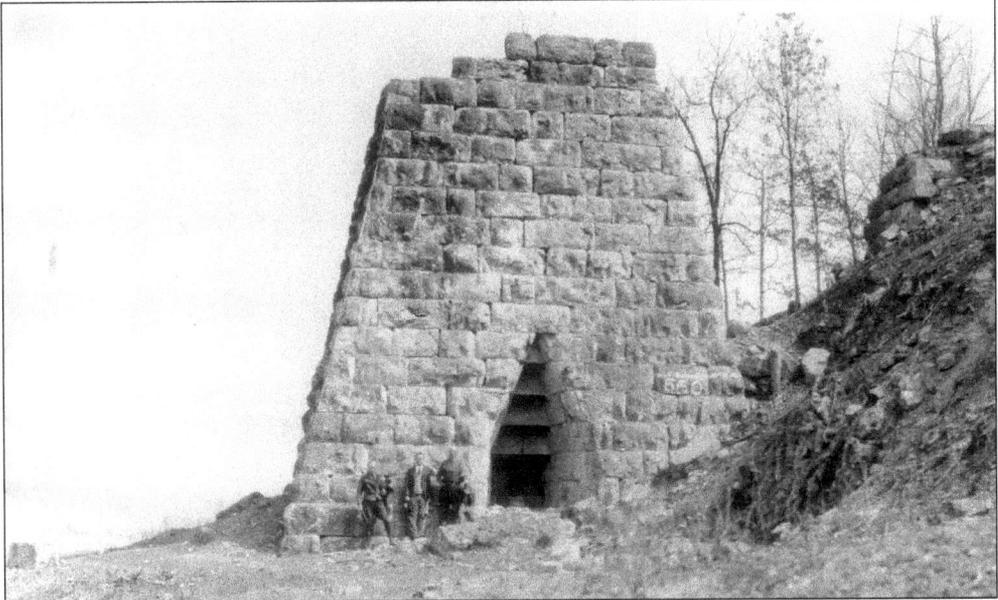

Boaters on Lake of the Ozarks, about 9 miles upstream from the Hurricane Deck bridge, see the top of this old iron smelter projecting above the lake's surface along the southwest shoreline and wonder about its history. It is a relic of the Osage Iron Works dating to 1872. The above photo of the smelter was taken in 1930 by survey crews establishing the 660 foot elevation of the lake while the basin was being cleared. (Photo courtesy of AmerenUE.)

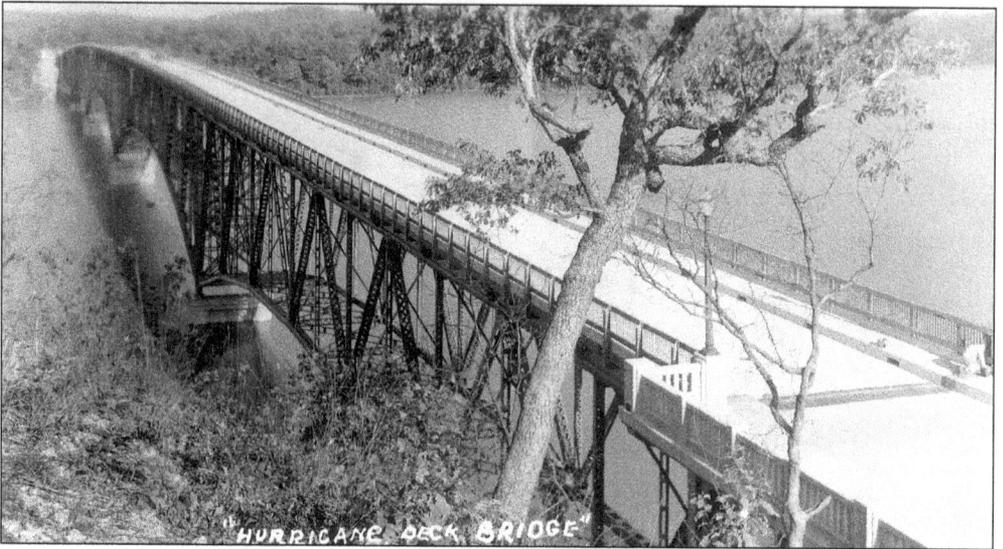

"HURRICANE DECK BRIDGE"

Above, is the 1936 award-winning Hurricane Deck Bridge, upon which Hwy. 5 runs from Versailles to Camdenton. The bridge deck is 65 feet above the lake. When the bridge was formally opened on Dec. 28, 1936, it was said to be the second largest bridge in the country, second only to the Golden Gate Bridge in California. The statement may have stretched the truth just a bit.

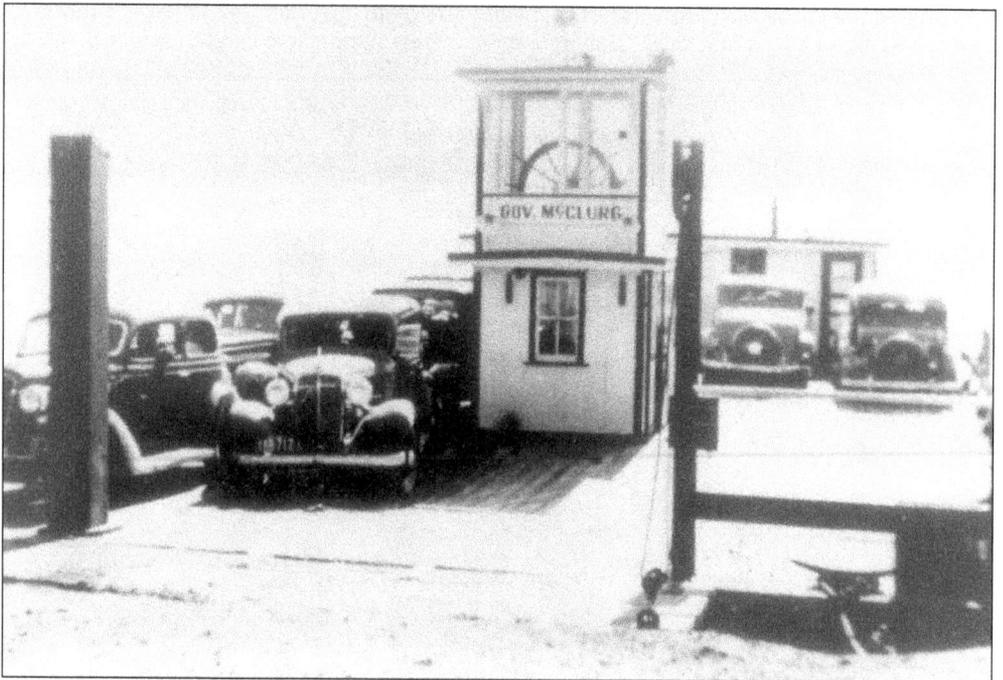

GOV. McCLURG

Creation of the lake severed Hwy. 5, which connects Versailles and Camdenton. The lake would also have severed U.S. Hwy. 54, but Union Electric was required to build bridges over two arms of the lake on that highway. Until the completion of the Niangua and Hurricane Deck bridges on Hwy. 5 by the state, traffic on Hwy. 5 had to cross the lake on the Gov. McClurg Ferry, shown here with a load of cars. (Photo courtesy of the Camden County Historical Society.)

102

For south bound traffic, the privately owned Gov. McClurg Ferry left here from Green Bay Terrace Resort at the end of Route F. The car on the left in this photo is at the top of the slope that leads down to the ferry's loading dock. The ferry was turned into a showboat after the Niangua and Hurricane Deck bridges were completed. Green Bay Terrace Resort is still in operation but much changed in its appearance.

W.L. Green, who managed Green Bay Terrace Resort, billed himself as "Sittin Bill, Chief of the Ozark Hillbillies." His likeness on this card is from a 1934 drawing by C.C. Cajwell. Sitting Bill was well-known in the area. One account from the early 1940s said his place was "a small lake-side community 'ruled' by William Green, the genial, self-styled Sitting Bill...a living information bureau (who) spins tales of the region prior to the lake's formation."

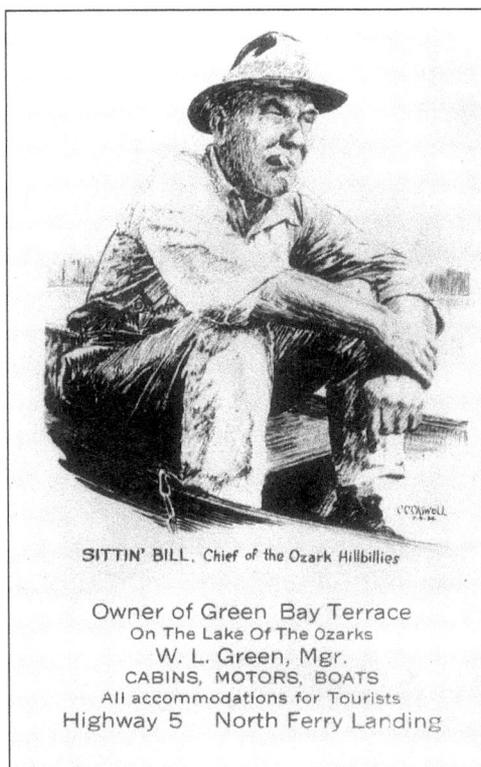

SITTIN' BILL, Chief of the Ozark Hillbillies

Owner of Green Bay Terrace
On The Lake Of The Ozarks
W. L. Green, Mgr.
CABINS, MOTORS, BOATS
All accommodations for Tourists
Highway 5 North Ferry Landing

White-Way Beach Resort was built in the mid 1930s in the Purvis Beach area. The resort was at the 35 mile mark on the lake and their ads in the early '50s said, "Enjoy yourself, it's later than you think."

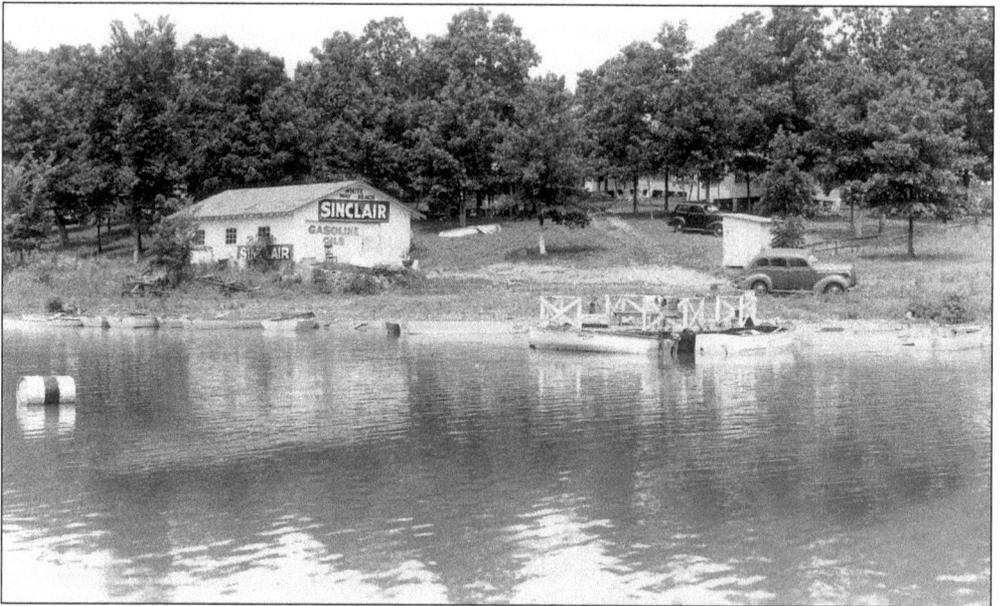

Located at the end of what is today Lake roads 5-27 and 5-29 (formerly Lake Road 5-14) south of Laurie, White-Way Beach Resort offered many services for it was, in the 1930s and '40s, a seemingly remote location. They offered complete fishing services, boats, motors, guides, bait, and among other opportunities, surfboarding, speedboat rides, and "rumpus room dancing."

The Ellis Rod and Gun Resort of Sunrise Beach was located at the end of Lake Road 18B northeast of Hwy 5. Its neighbors included the Valley of Springs Resort and Ti-Sun Terrace. Probably more fishing than hunting was done at the resort. They had good crappie beds and their cove was fed by springs.

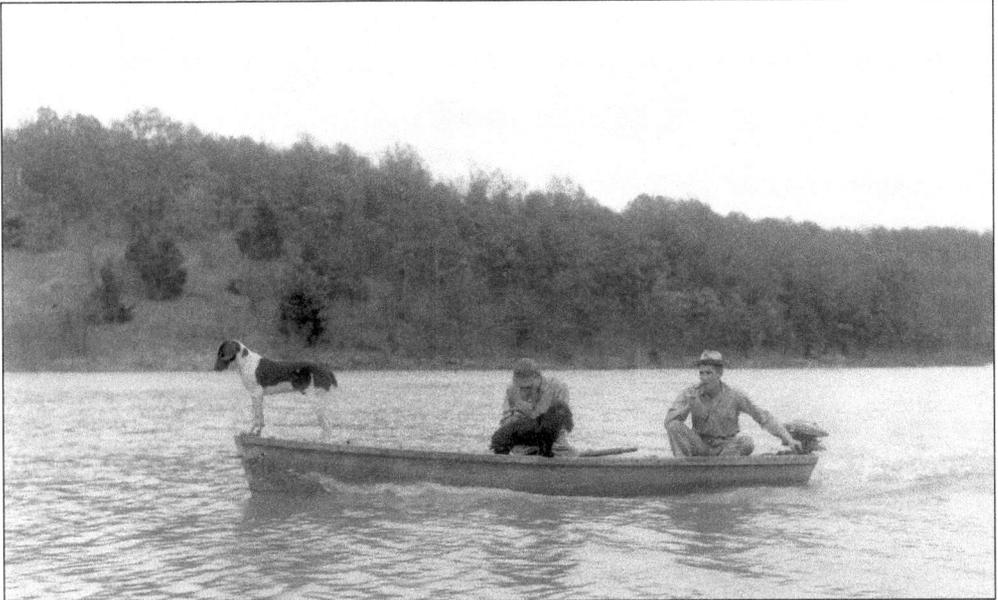

Until the creation of Lake of the Ozarks, there was no large body of water in south central Missouri to attract ducks and geese. Water fowl were noted on the lake almost immediately and began to attract hunters to the area. It was not unusual for sportsmen to take both guns and fishing gear with them out onto the lake. The result was an upsurge in game violations for a time. (Photo by Massie; courtesy of the Missouri State Archives.)

105

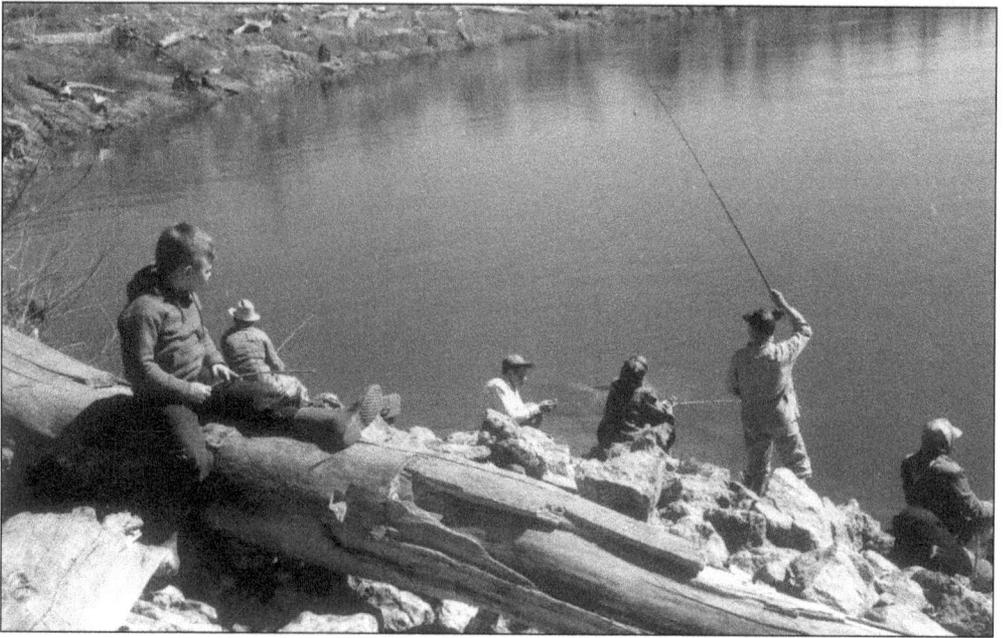

In 1932, Missouri State Game and Fish Commissioner, John H. Ross, said "The department is badly in need of additional wardens on Lake of the Ozarks. Two wardens have been assigned to this vast area of water and they are assisted by extra help at times when fishing is heaviest. There should be at least four good wardens, who are capable lake men, assigned to this lake area permanently." (Photo by Massie; courtesy of the Missouri State Archives.)

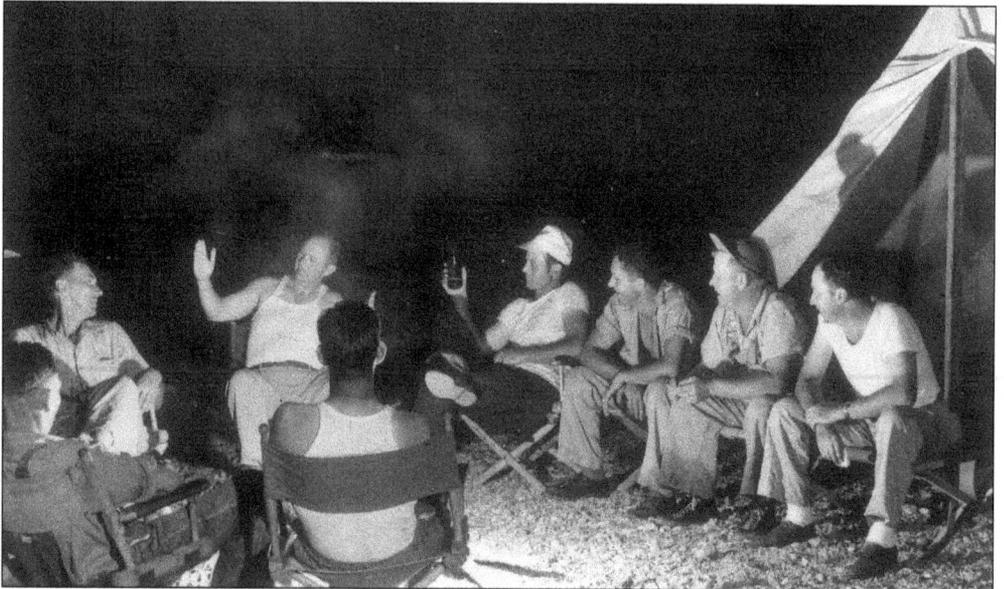

Today, it is only in the upper reaches of the lake above mile marker 50 that fishermen can truly get away from heavy lake traffic, heavy commercial development, and find quiet waters for the brand of laid-back fishing that many fishermen prefer. Here, fishermen gather around a fire to eat, relax, and spin tales about the big one that got away. (Photo by Massie; courtesy of the Missouri State Archives.)

For vacationists, as tourists were called in those days, who really wanted to get away from it all and rough it, there was Uncle Jim's Fishing Camp. It was accessible from Lake Road 5-14 and was near White-Way Beach Resort. The early fishing camps of the Hurricane Deck area were promoted to the sportsmen because fishermen often preferred unsophisticated accommodations. Today, such camps are dying, giving way to water recreational pursuits that do not including hunting and fishing.

Anderson's Cottages were among the camps of the Sunrise Beach development area in the early days. They could be reached via Lake Road 5-17, now Lake Road 5-35. The Sunrise Beach Post Office was nearby and so were the facilities of The Democratic Club of Missouri.

This postcard, with its three views of Wings Bridgewater Resort in the Hurricane Deck area in the late 1950s, shows the kind of shoreline boating facilities common in the early days—a flat, unroofed dock with aluminum fishing boats for guests. Today, covered boat docks are more common, and the boats are much more luxurious and few guest cabins are still paneled with knotty pine.

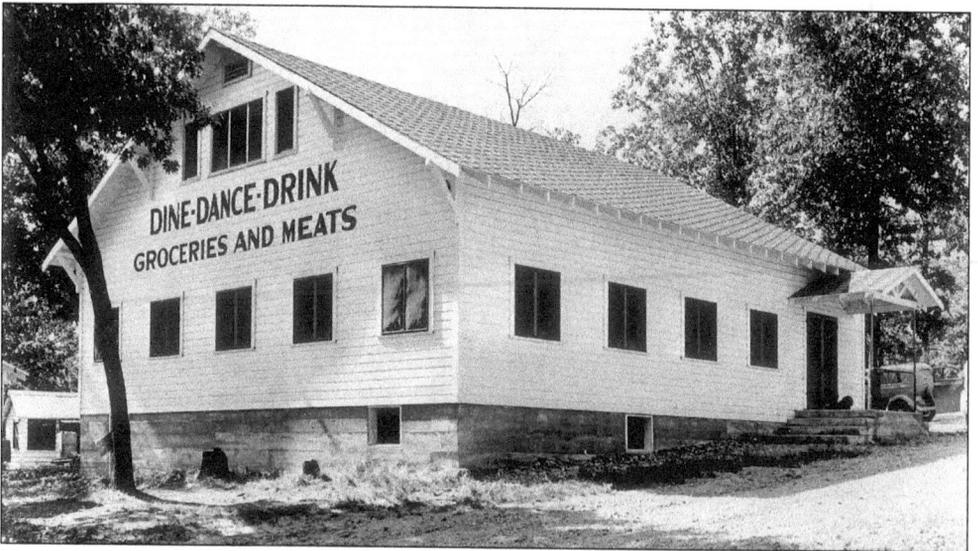

Dr. Kaiser built the first resort in the Sunrise Beach area and it was known as Dr. Kaiser's Lakeside Apartment Cottages. This 1938 photo demonstrates the quality of his accommodations. He took pride in the quality of his establishment, calling his rental units "superior apartments." The camp could accommodate 50 people at a time. The site later became known as "The Three Coves."

Nine

GRAVOIS MILLS AND VERSAILLES

Early promotional literature for the Lake of the Ozarks often used a literary style. A good example is how the Versailles and Gravois Mills areas were described in 1939 in a promotional booklet:

"The Ozark foothills become more rugged as you travel south on No. 5, and only a short time is required to reach the most beautiful bridge in America, over the main channel of the Lake of the Ozarks. . . .

"Take time to absorb the beauty of a hillside covered with wild flowers, a peaceful valley—grazing sheep—quiet water. As you rush by, the gentle murmur of a waterfall is lost in the roar of your passing, only a glimpse of a magnificent panorama is your reward as you hasten along. These friendly hills and restful waters will linger long in your book of memories, [for] they contain the old Mill on Gravois Creek, the famous trout hatchery, the great heights of Hurricane Deck, the beautiful vista from Sunrise Beach, the mystic art of nature in Jacobs Cave, the historical background of the old Iron works, and the by-ways which lead to secluded nooks and springs.

"The beautiful serene Gravois Arm with its many spring fed tributaries is a natural habitat of Bass, Crappie, and Jack Salmon and very popular with fishermen and boatmen. All facilities for a successful vacation awaits you in fishing, sports, boating, or just "vacation.""

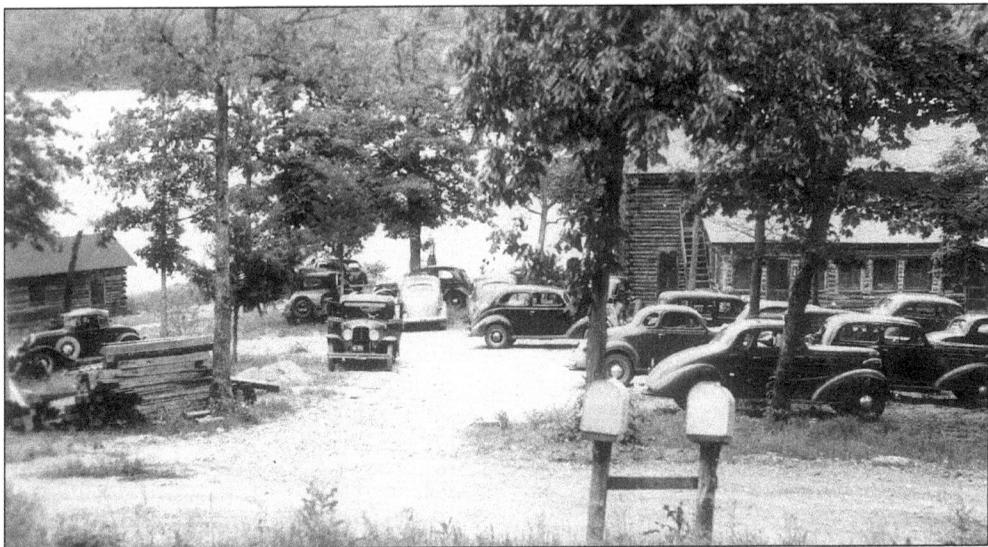

Washburn's Point was the first fishing camp established on the Gravois Arm of the lake. Bill and Lottie Washburn ran it until Bill's death in 1935, after which their sons and their families joined the operation to help Lottie. They were very active members of the Lake Association in the 1940s. Among the notable fishing guides working for them was Guido Hibdon and his sons.

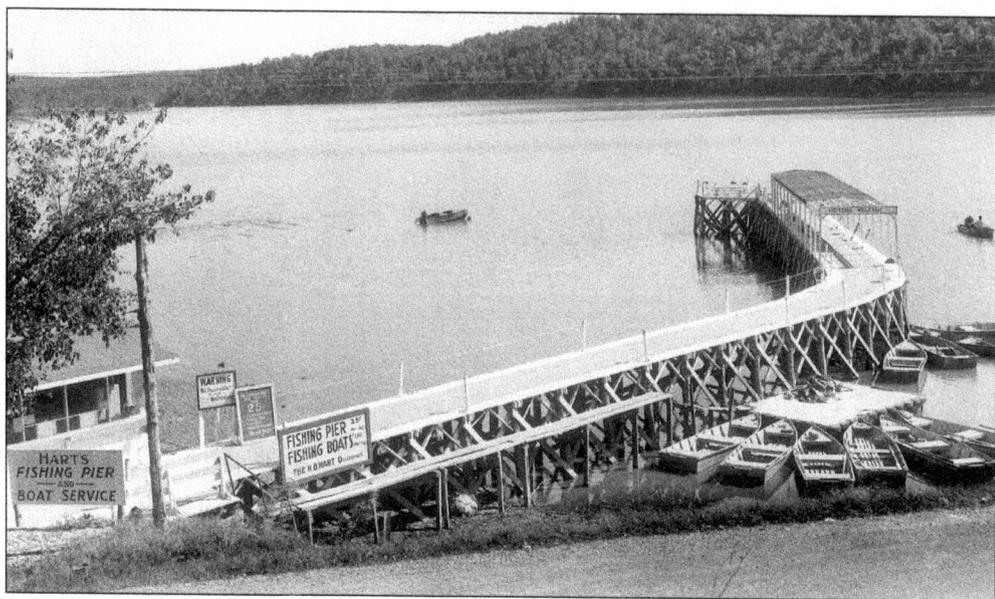

The H.B. Hart Fishing Pier, built in the 1930s, was the most unusual pier on the lake in the early years. Hart, an entrepreneur who dabbled in numerous business ventures, including mining in Morgan and Camden Counties, had partners in the fishing pier business. In 1958, the pier was sold to Harlen and Mary Shipley from Kansas City. This is the very upper end of the Gravois Arm.

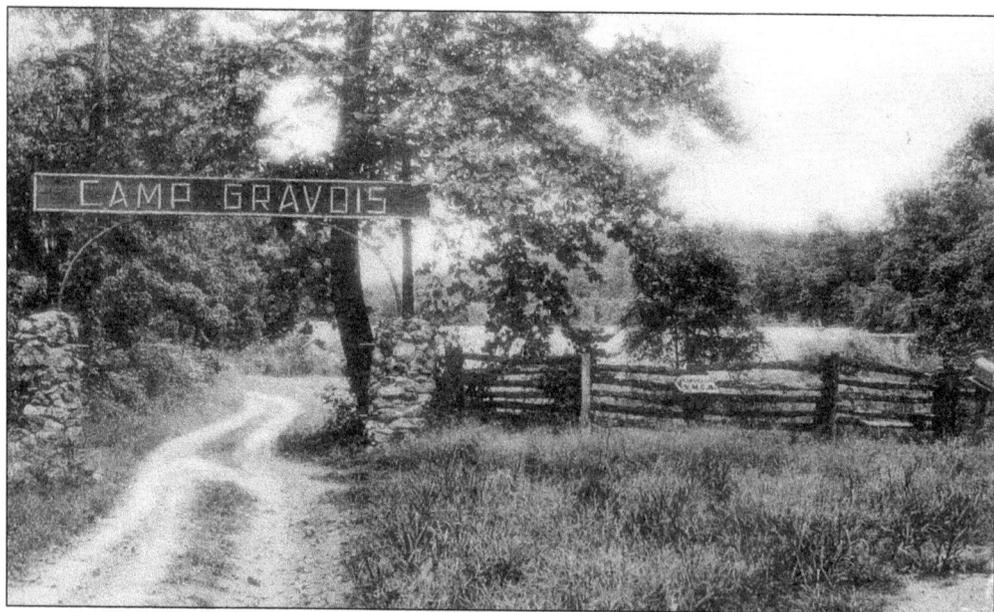

The entrance to Camp Gravois, "Where Dreams Come True," the face of this 1943 postcard proclaims. Camp Gravois was a boys' summer camp. The young lad who sent this card home to his parents wrote: "We are going to play baseball tonight. We have a tournament here every night." And concerned about his pet he asked "How is Prince? Is he staying home?"

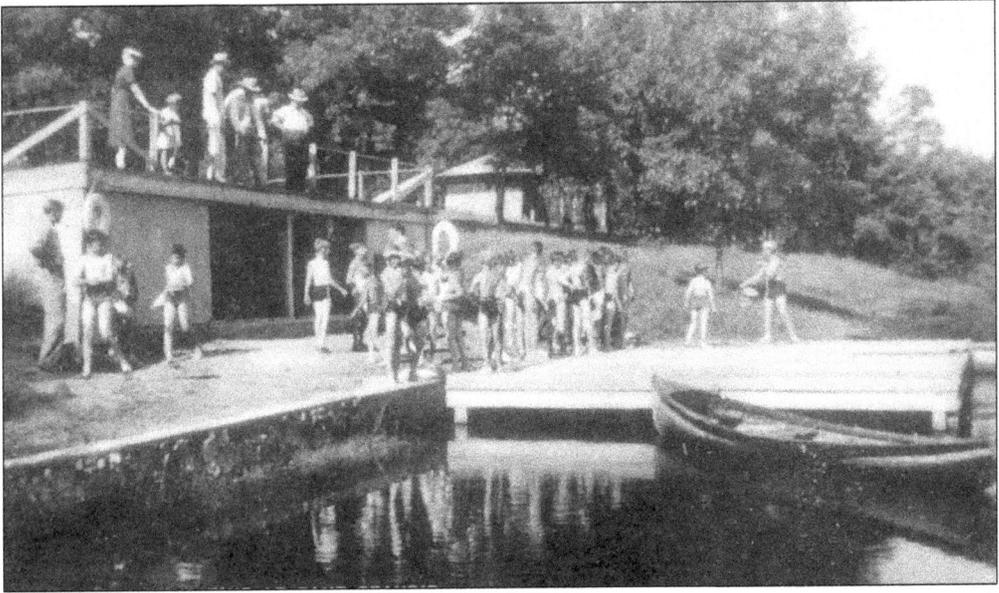

A group of boys prepare to go swimming and boating at Camp Gravois. The building to the left beneath the deck where adults are standing is the boat house. In the background is the craft shop. The best known scout camps for both boys and girls on the lake today are located in Lake of the Ozarks State Park at the east end of the lake.

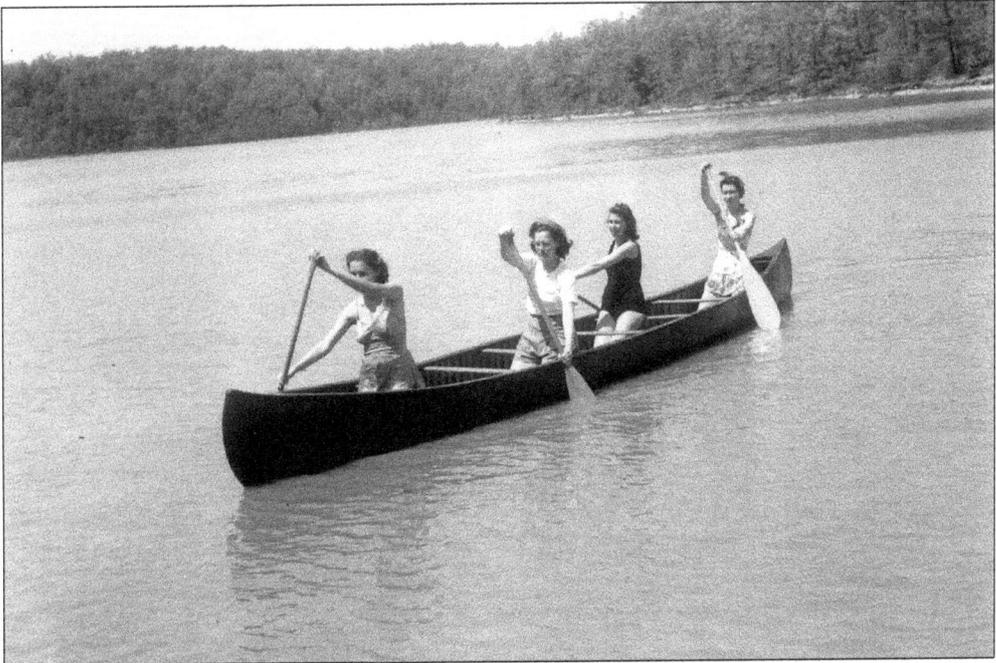

Something vacationers saw fairly often in the early days were young people canoeing, particularly in lake areas where Boy Scout and Girl Scout camps were located. Today, you seldom encounter people in canoes. The surface water of the lake is so choppy with the overlapping wakes made by powerful speedboats, cruisers, and jet ski boats that finding placid waters for gentle canoeing is nearly impossible. (Photo by Massie; courtesy of the Missouri State Archives.)

On the "west end of the lake," as that area from Hurricane Deck to Versailles is often called, fishing was the recreational preference in the early years and it is still king. In this late 1950s photo by Massie, two boys proudly display their catfish, a channel cat of, no doubt, substantial weight. It was probably the featured guest at a weekend fish fry. (Photo courtesy of the Missouri State Archives.)

Gravois Mills Spring, known today as the Troutdale Hatchery Spring, is the most historic spot in the Gravois Mills area. Josiah S. Walton built a water-driven gristmill here in 1835. Later, the Hume Brothers operated a woolen mill at the site. In 1895, Asa Webster became owner and added a sawmill and stone dam. By 1931, it had become Troutdale where commercial rainbow trout are reared. (Photo by Massie; courtesy of the Missouri State Archives.)

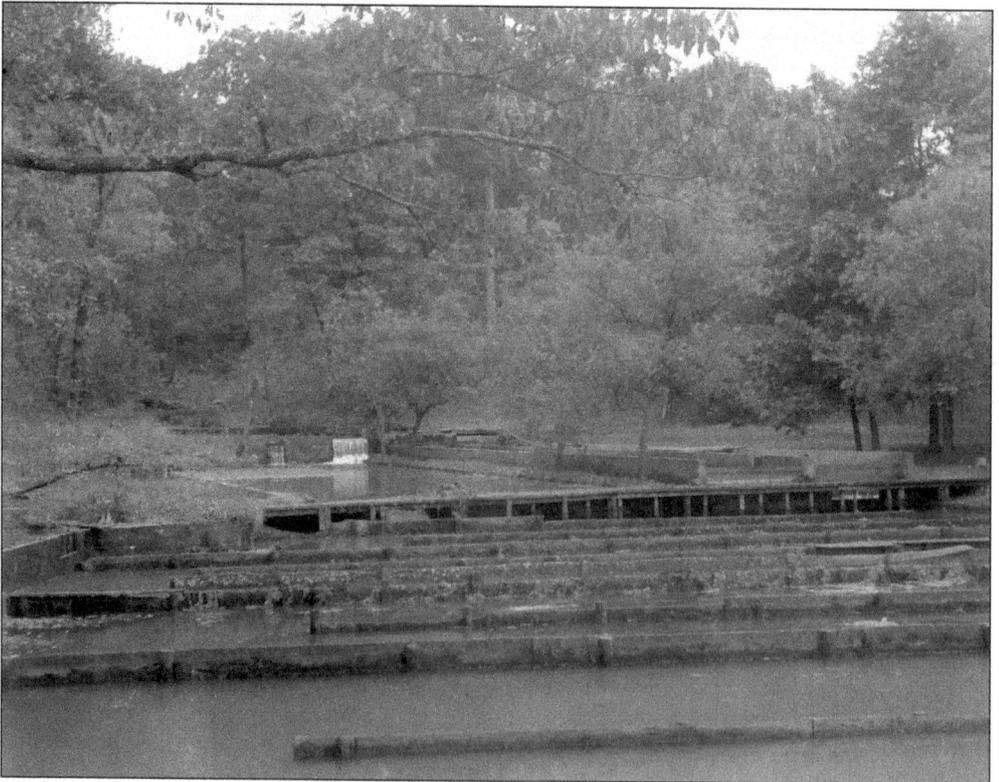

In this vintage photo from the 1950s, we see a Missouri Conservation Agent fueling his boat at a dockside gas pump. These visible pump gas dispensers were introduced in the late teens. They stood 10 to 11 feet high with a 5 to 10 gallon glass cylinder on the upper part with ladder-like measuring indicators mounted inside. They were hand-pumped. Many of these old pumps on lake docks were used far longer than their counterparts at highway filling stations. (Photo courtesy of the Missouri State Archives.)

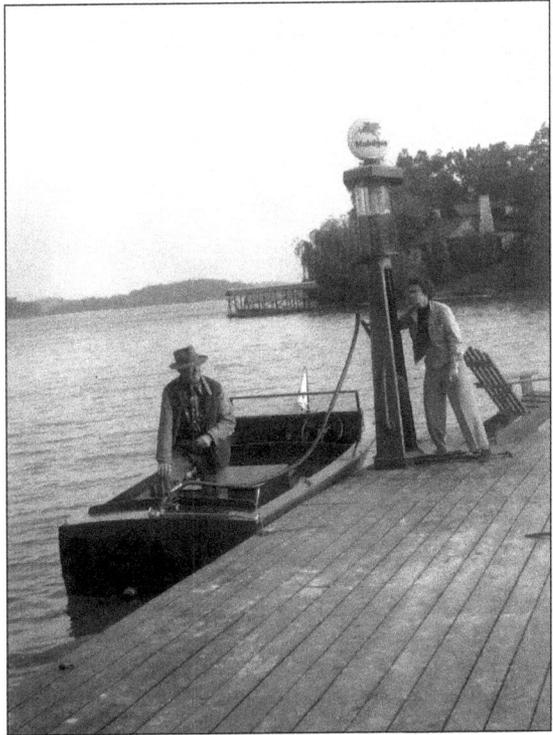

Fishing contests began early on Lake of the Ozarks. In July of 1932, the Lake of the Ozarks Improvement and Protective Association sponsored a contest to "encourage a high standard of angling in the Lake," said their announcement. There were strict rules and a variety of fish types were included. The prizes included flyrods, reels, tackle boxes, a refrigerator basket, and fly and spinners. The lady shown here with a big string of fish was Mrs. Ernest Kellerstrass of Kansas City.

In the boat is Ernest Kellerstrass (on the right) and his wife along with an unidentified man. Kellerstrass was an avid bass fisherman. He made his fortune early in the 20th century raising chickens on a farm where Central High School now stands in Kansas City, Missouri. He was known as the originator of the Crystal White Orpington Chicken, and was also noted for his bass fishing promotions at Lake of the Ozarks in the 1930s, '40s, and early '50s.

Jacob's Cave was discovered in 1875 by Jacob Craycraft while prospecting for lead. He and two other men were digging test pits near the cave's original entrance and dug into the cave. He left his name and the date August 8, 1875, on the limestone wall inside the cave. The building above was built in 1950. It later burned and a newer one now stands in its place.

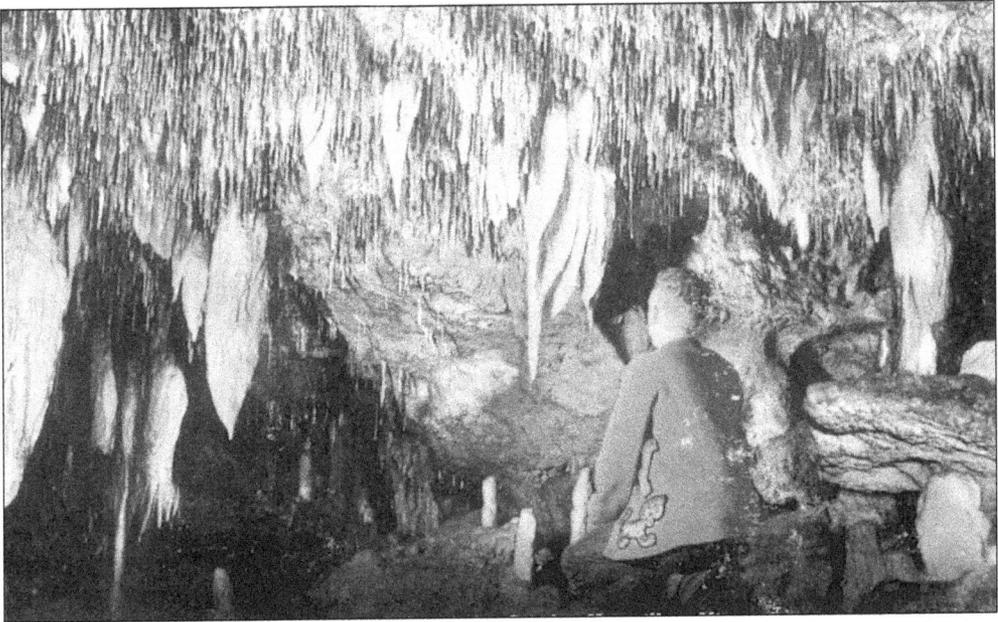

When Craycraft died, he left the cave to the Kansas City Children's Home and Service. The first attempts to commercialize the cave were in the early 1900s. It was finally opened to the public in 1932 and became the first show cave in the lake area after the completion of the dam. The first operators of the cave were Mr. and Mrs. Eli Hays from South Dakota. They gave tours by lantern.

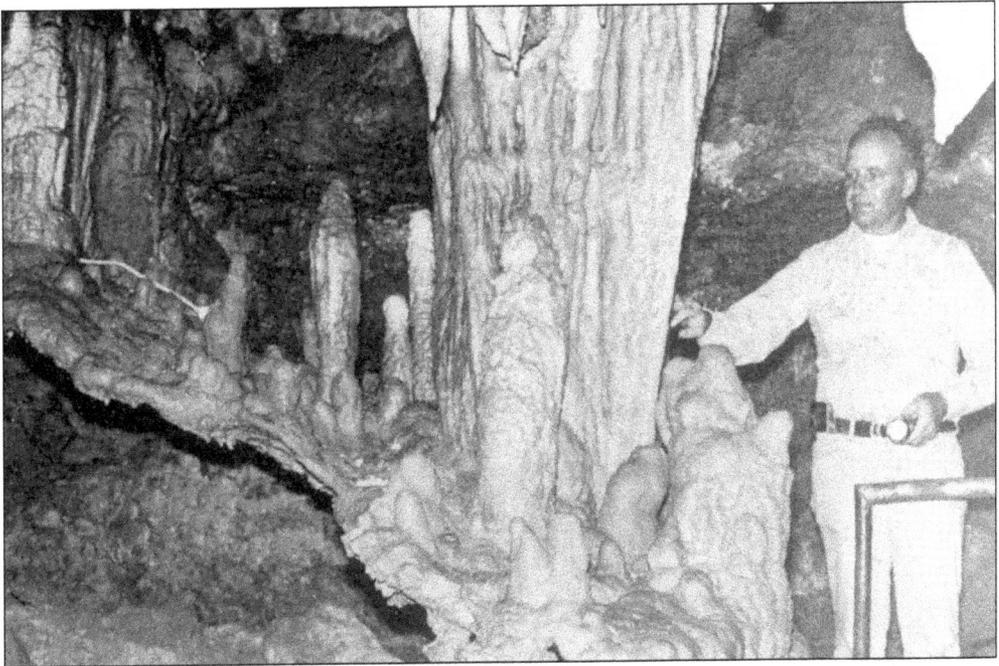

The cave was owned and operated by Russell P. Hall from 1950 to the early 1960s when it was purchased by Frank and Jane Hurley. They still own and operate the cave. Above, Frank Hurley shows off one of the cave's many unusual formations. The cave is highly decorated and an easy cave to tour, even for people who must use a wheelchair.

Pictured here is the quaint grocery store at Lucky Strike Camp in the 1940s. Although the resort was located in the Sunrise Beach area, it used a Versailles mailing address. The resort was built in the mid-1930s and was under the management of Ell Reed by the time this photo was taken. It was operated under the name Lucky Strike Resort for more than 40 years.

Here is a vintage look at downtown Versailles along the north side of the square. Keith McCanse, who produced a series of guide books to the Ozarks between 1928 and 1936 said, in his 1932 guide, that Versailles "has a new spirit of progress in keeping with the great new Lake." Today, a tourist business must struggle to survive in the downtown area of Versailles. (Photo courtesy of Danny Lane.)

Ten

WARSAW

Warsaw, Missouri, billed itself as the "Hub of the Headwaters of Lake of the Ozarks" for many decades. It also calls itself the "Gunstock Capitol of the World." The town was platted in 1837. Many of its early settlers were Germans and in 1838, it was named Warsaw after the capital of Poland. It is the county seat of Benton County, Missouri.

In the 1800s, Warsaw became a prominent frontier river port as well as a station on the Butterfield Overland mail route. The community saw much turmoil during the Civil War. Steamboats regularly came up the Osage River as far as Warsaw, which is 166 miles from the river's mouth.

The construction of Bagnell Dam 91 miles downstream on the Osage and creation of Lake of the Ozarks transformed the community into a busy tourist destination for the people of Kansas City.

Until 1979, when the U.S. Army Corps of Engineers completed the construction of Harry S. Truman Dam across the Osage River at Warsaw, the town was identified only with Lake of the Ozarks. Today, it is focused on the recreational advantages of both Lake of the Ozarks and Truman Dam and Reservoir. The town is a great mixture of old and new and one of its old attractions is a suspension bridge across the Osage, preserved for pedestrians. There used to be eight "swinging" bridges in the Warsaw area when it was called the "Land of Swinging Bridges" before the days of Lake of the Ozarks.

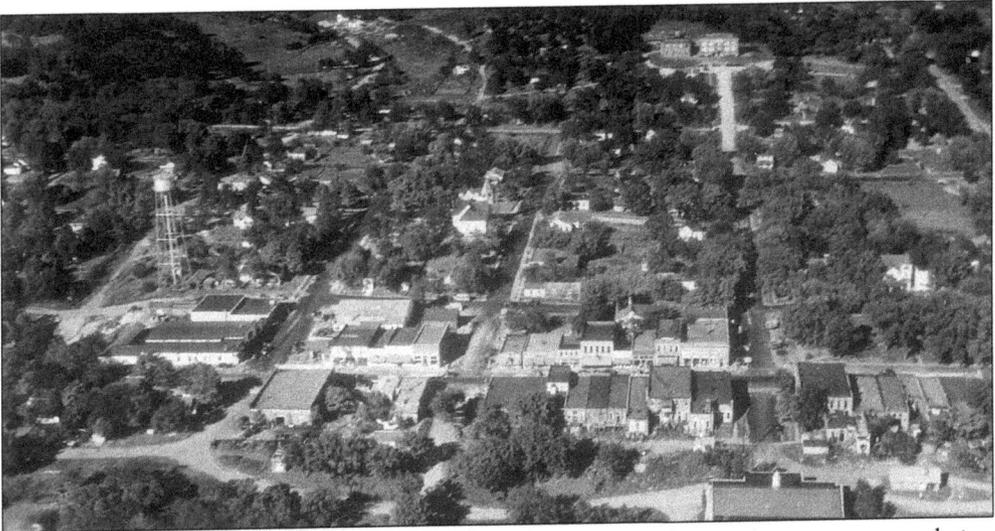

An aerial view of Warsaw, Missouri, as it appeared in the 1940s. The town's permanent population is less than 2,000, but during the summer months, its population triples because of tourism. In the 1940s and '50s, promotional literature promoted its spring-fed streams for anglers and said the hills and woodlands were full of game for hunters. It is still a fisherman's domain, but is now also a paradise for people who enjoy water recreation and hunting antiques and collectibles.

117

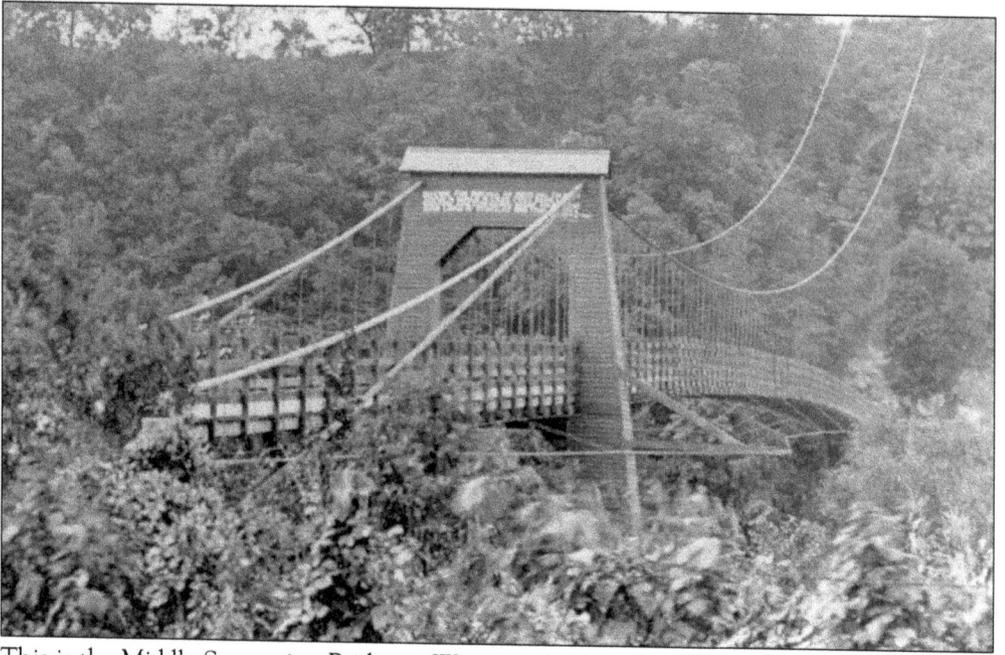

This is the Middle Suspension Bridge at Warsaw, which no longer exists. It was built in 1894 by Joe Dice. Note how the cables on the opposite end are anchored on the ridge, rather than to a matching tower at the opposite end of the bridge framework. This made the bridge unstable and subject to movement, a weakness which may have contributed to the collapse of the bridge 18 years later. (Photo courtesy of Danny Lane.)

In 1912, the Middle Bridge collapsed when a cattleman named Olmstead drove a herd of 95 big steers across the bridge on his way to the railroad yards in Warsaw. He was on horseback. Fortunately, both he and his horse survived the plunge into the river, as did 66 head of his cattle; however, 27 cattle were killed outright and 2 died later.

118

In this view, the carcasses of several steers can be seen still hanging in the cables of the wrecked bridge, and men can be seen approaching the wreckage in a boat. One can just imagine what kind of lawsuits this kind of accident wound engender today. The weight, speed, and loping canter of the cattle probably contributed to the collapse of the bridge. (Photo courtesy of Danny Lane.)

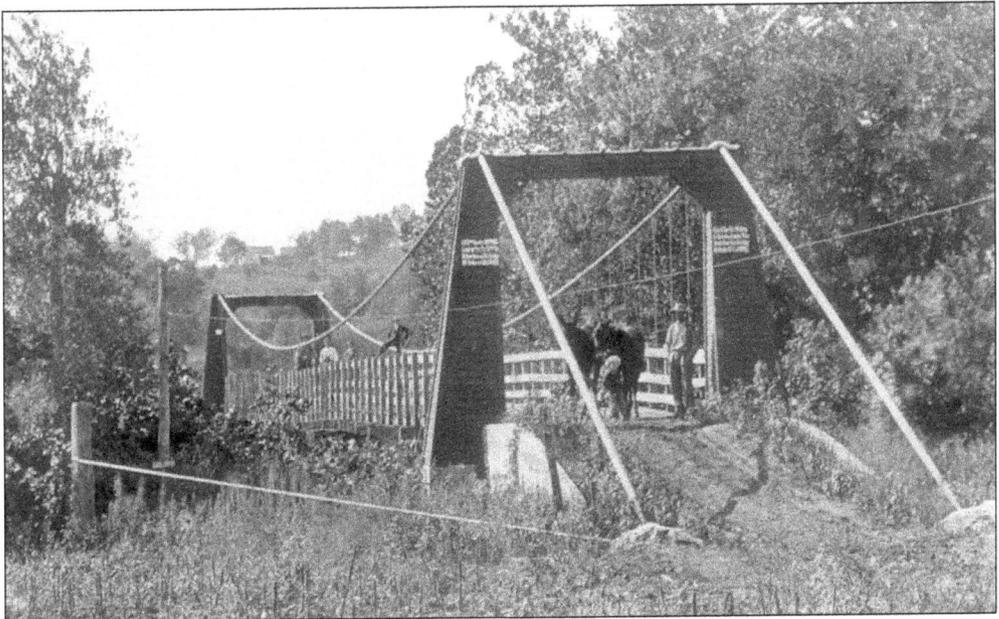

The Warsaw area needed many bridges because of the meandering of the Osage River. The bridges replaced ferries, which were considered less reliable. Signs on this bridge warn travelers of a $25 fine for moving any load across the bridge heavier than 5,000 lbs., or a $5 fine for going across faster than at a walk. Such signs went up on the suspension bridges of the area after the accident with the Middle Bridge.

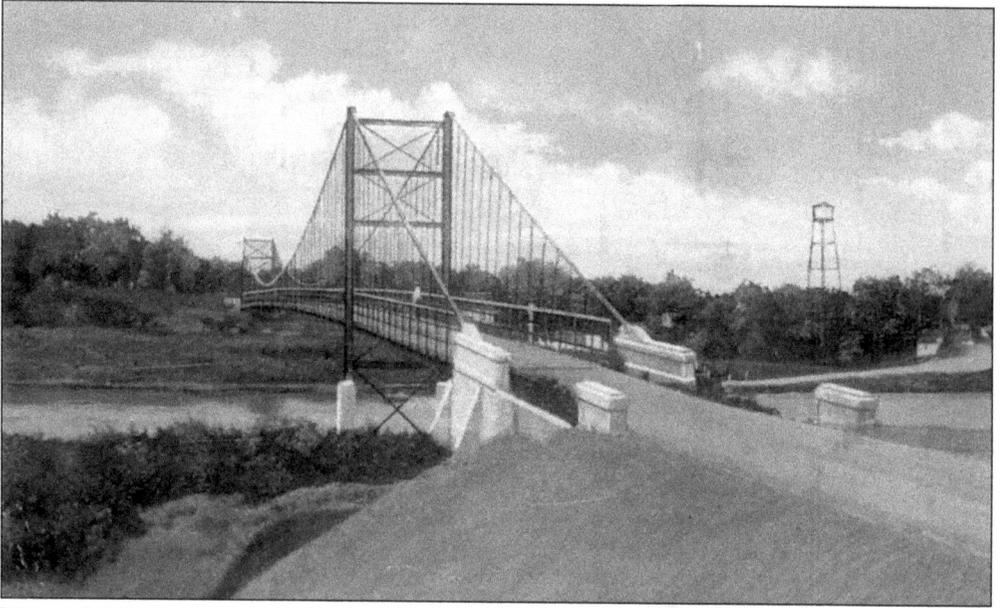

Warsaw's "Upper Suspension Bridge" was first built in 1907 as a toll bridge. It was destroyed by a tornado in 1927. The bridge shown here replaced it. The bridge carried Hwy. 35 to Clinton. In 1975, a truck broke through the west section of this bridge. It was repaired and used until 1979 when it was replaced by a concrete bridge nearby. This historic suspension bridge has been preserved for foot traffic only and is a tourist attraction today.

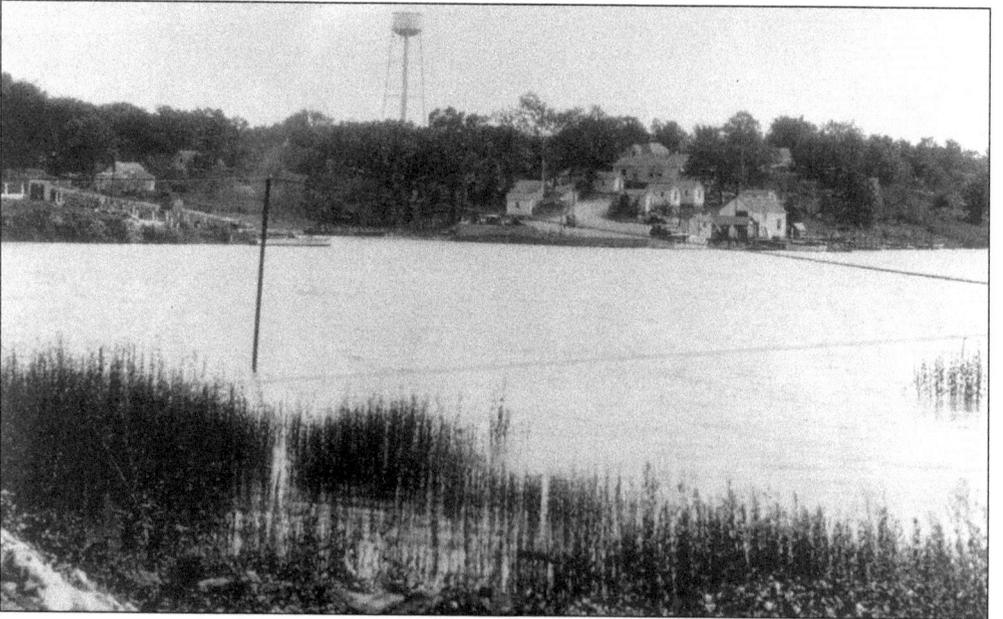

This 1931 photo looks across the Osage River at the Warsaw shoreline. Brill's Hill on the right, the largest and most prominent resort in Warsaw in the 1930s, can be seen. Today, only a few of the cabins along the left side of the road are still standing. Where the utility line crosses the lake in this photo there is a modern steel and concrete highway bridge today. This photo was taken near the end of the Upper Suspension Bridge at Warsaw. (Photo courtesy of AmerenUE.)

Brill's Hill, owned by T.C. Brill, was one of the first lake resorts built at Warsaw. It had facilities for launching large boats. G.H. Crosby, of Union Electric, docked here after his first cruise up the lake in a 28-foot cabin cruiser after the completion of Bagnell Dam. The Gov. McClurg, a 45-ton ferry boat, was also launched here and put into service at the 31-mile mark to ferry Hwy. 5 traffic before the construction of the Hurricane Deck and Niangua River bridges.

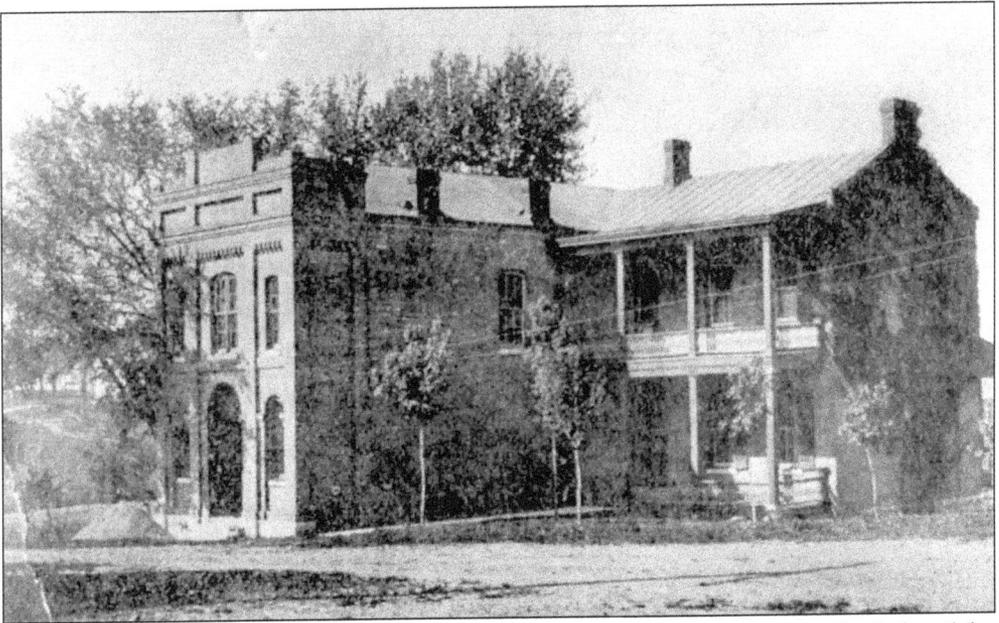

This is one of the oldest buildings in Warsaw still standing and still in use in the Lake of the Ozarks region. It was built in 1855 by the Boatman's Bank of St. Louis and used as a collection point for the fur trade. In the early 1900s, it became the Benton County Jail and is still used as a jail. The jail was the scene of a jailbreak in the 1940s, which led to the sheriff's death. (Photo courtesy of Danny Lane.)

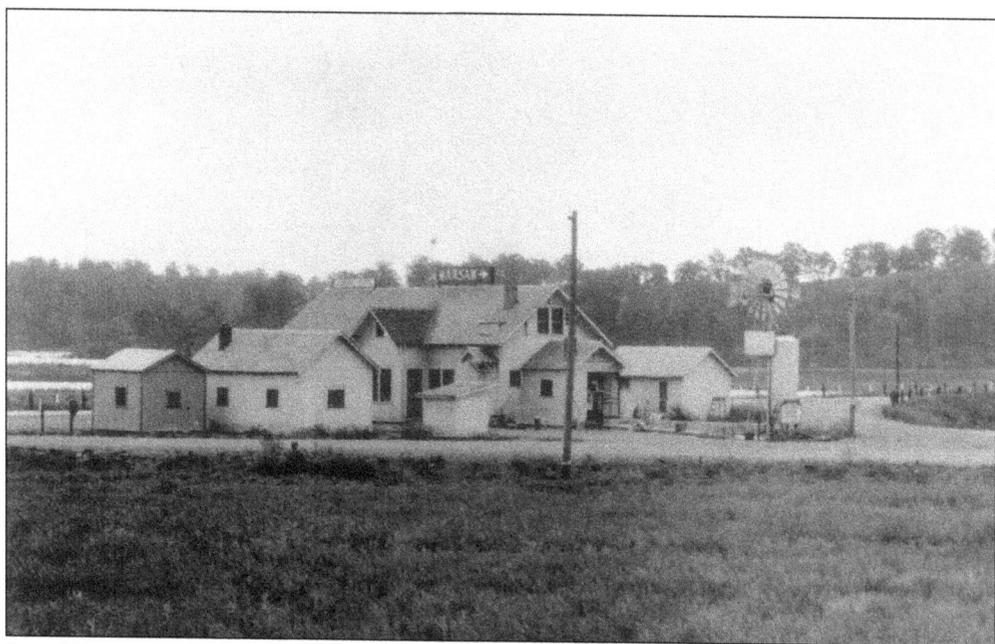

Two Warsaw roadside businesses achieved much notice in the 1930s for the quality of their service as well as the way they competed. One was the Gateway Café (above) on Hwy. 65 north of the Hwy. 65 bridge crossing the Lake of the Ozarks. The menu here listed catfish, chicken, steak dinners, and frog legs. Their advertisements said "We Never Close." The 1939 proprietor was Harold Bugeon. (Photo courtesy of AmerenUE.)

The competing establishment was the Westview Tavern, Hotel, Café, and Service Station south of the Hwy. 65 bridge. Catfish dinners were their specialty. They also sold beer and served as a hunting and fishing headquarters for sportsmen. To compete with Gateway, they were also "Open At All Hours." The 1939 proprietor was A.F. (Turk) West. The Gateway Café and buildings didn't survive the decades, but this building has. Today it is called The Roadhouse.

Headwaters Motel was one of the first motels to open in Warsaw on Hwy. 65 just south of the Hwy. 65 bridge over the Osage River. Today, it is on old Hwy. 65 about a quarter mile south of The Roadhouse and still in business. In its early years, it catered to honeymoon couples and billed itself as the "Home of the Honeymoon Cottage." The appearance of the motel has changed very little.

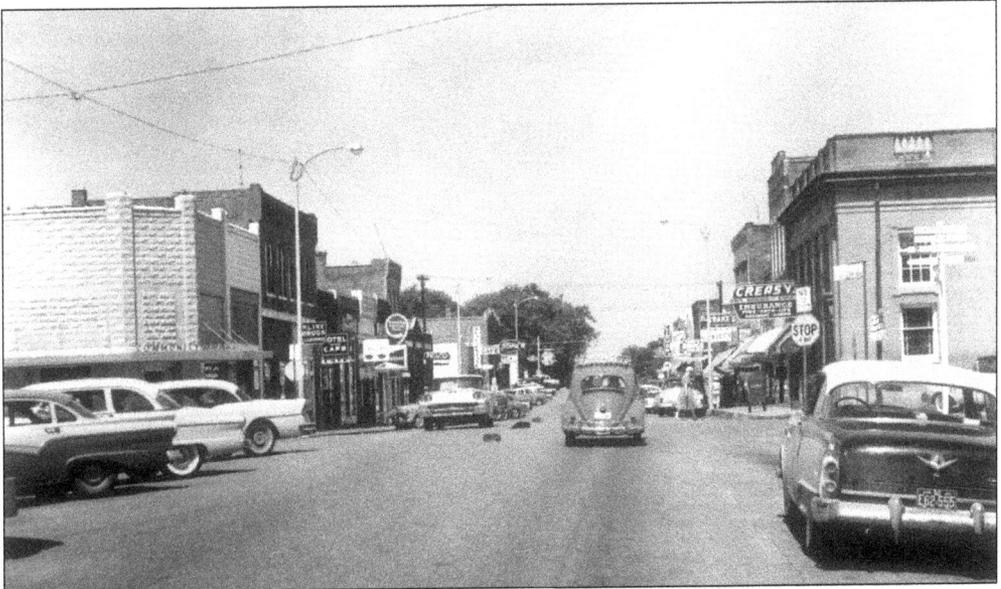

Pictured here is a view of downtown Warsaw at a busy intersection in the 1950s. Community Bank is on the left corner and Creasy Dry Goods on the right corner. The sign pole along the right is not a conventional street sign. It reads "Gunstock Capitol of the World." The right arrow points the way to "Fajen Gun Stocks," and the left arrow points the way to "Bishop Gun Stocks." (Photo by Gerald Massie; courtesy of the Missouri State Archives.)

The story of gun stocks at Warsaw began in 1939 when John Bishop began making semi-finished gun stocks. Reinhart Fajen joined him in the new venture. It was Fajen's job to make the custom finished stocks from the machine-made semi-finished ones. Their business grew until by the 1950s, they were furnishing about 90 percent of all replacement and sport gun stocks in the U.S. (Photo courtesy of the Danny Lane.)

The emphasis on gun stock manufacturing, hunting, and fishing at Warsaw has made the town a focal point for sportsmen over the past 60 years. Here, a couple of lucky fishermen at White Branch Resort display their catch, which is so heavy they need a sturdy pole to hold it. (Photo c. 1957)

Harry S. Truman Dam, impounding the Osage River and forming the Truman Reservoir, was completed at this site in 1979 by the U.S. Army Corps of Engineers. It took the Corps years to complete the project because of technical problems and protests by environmentalists. In the background is Kaysinger Bluff. (Photo c. 1910.)

Kaysinger Bluff is one of the beautiful spots of Warsaw overlooking the valley where the Lake of the Ozarks, the Osage River, Truman Reservoir, the Pomme de Terre River, and the Grand River join. In the above photo, c. 1910, a group of sightseers enjoy the rugged scenery. Very near this spot today is the Truman Reservoir Visitors' Center with museum and windowed observation rotunda. (Photo courtesy of Danny Lane.)

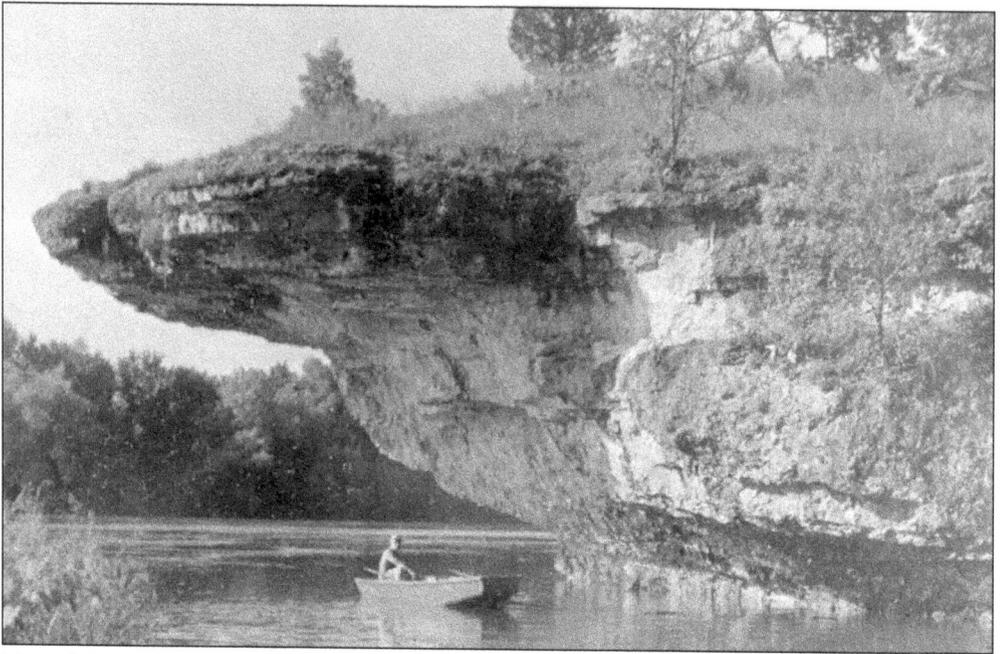

One of the endearing qualities of Lake of the Ozarks for vacationers is the scenic beauty of its setting. It is the same quality that made the Osage River a favorite of steamboats pilots despite the river's sometimes treacherous nature. "The river...cuts its channel deep through solid rock, presenting a constant series of perpendicular bluffs..." said Henry King, a geologist who explored the river in 1839. Lovers Leap (above) near Warsaw is but one example.

The sun sets on the Lake of the Ozarks. It is a lake of seasons and moods and has been attracting Midwesterners to the Ozarks for 70 years. Each year, millions of people visit and vacation at Lake of the Ozarks to capture some of its tranquil beauty, and to spend a little time communing with its soul, for the lake is a shimmering deity that transforms the hills into a vacation paradise.

ACKNOWLEDGMENTS

Lake of the Ozarks: Vintage Vacation Paradise is a book with content that stretches for 91 miles up the Osage River, extending from Bagnell Dam to Warsaw, and along the way the pages of this book pass through a number of towns. The author is deeply indebted to the people who generously extended him the courtesy of their time and information and the use of their historic images.

Early postcards and promotional literature also aided in the creation of this book. Early recreational guides and maps produced by the Lake of the Ozarks Association, Bagnell Dam Chamber of Commerce, Hurricane Deck Association, Camdenton Chamber of Commerce, Osage Beach Chamber of Commerce, Niangua Arms Association, and the Headwaters Association were especially helpful. Helpful too were postcards, brochures, and programs produced by the Ozark Opry, J Bar H Rodeo, Country Music Hall, Austin's Nashville Opry, Ozark Deer Farm, Max Allen's Zoological Gardens, Tom's Monkey Jungle, Indian Burial Cave, Ozark Caverns, Bridal Cave, Jacob's Cave, Les Gotcher Collection, and Western Fun.

The author wishes to extend a special thank you to the following people: Danny Lane of Oak Grove; John Bradbury of Rolla; Bruce F. James of Lake Ozark; James E. Lawrence of Eldon; Sylvia Brinkman of Eldon; Victoria Hubble of Osage Beach; Diane Warner of Osage Beach; and Lloyd Slone of Eldon.

A thank you is extended to the City of Osage Beach for permitting me to use freely from their collection of historic images assembled by Victoria Hubble when she was preparing the history of that community for the book *The Town of Two Rivers*.

Without the generous cooperation of Dan Jarvis, Osage Plant Manager at Bagnell Dam, and Allen Sullivan, Superintendent of Maintenance at Bagnell Dam, and access to the Bagnell Dam archives, this book would have been seriously lacking in some important images. AmerenUE and its employees are always kind when someone comes looking for help in writing about the Lake of the Ozarks and their role in its creation and development.

I am also indebted to the Missouri State Archives and their knowledgeable staff and extensive collection of early day images; to the Miller County Historical Society; and to the Camden County Historical Society. They have encouraged and continue to support my efforts to research and write about the early history of the Lake of the Ozarks region.

I also want to thank Samantha Gleisten of Arcadia whose support, encouragement, and ideas guided me toward revisions of the original manuscript that greatly improved this book.

And last, but not least, I want to offer my thanks and gratitude to the many people of the Lake of the Ozarks region and throughout the Midwest who have told me personally how much they enjoy my books about the history of the lake area, and who have urged me to keep writing because they want to learn more about the early days at the Lake of the Ozarks.

BIBLIOGRAPHY

Benton County Enterprise newspaper, Warsaw. Various early issues.

Burke, Lorraine. *50th Anniversary Bagnell Dam 1931–1981*. Lake of the Ozarks Area Council of the Arts, 1981.

Daily Capitol News newspaper, Jefferson City. Various early issues.

Eldon Advertiser newspaper, Eldon. Various early issues.

Flader, Susan. *Exploring Missouri's Legacy, State Parks and Historic Sites*. University of Missouri Press, 1992.

Gallaher, Jno. A. *Preliminary Report on the Structural and Economic Geology of Missouri*, Jefferson City, MO: Bureau of Geology and Mines, 1900.

Harpham, Lucille Keller. *Camden County History*.

Hubbell, Victoria. *A Town On Two Rivers, A History of Osage Beach, Missouri*. City of Osage Beach, 1998.

Jefferies, T. Victor. *Before the Dam Water*. 1989.

Lake of the Ozarks News newspaper, Lake Ozark. Various early issues.

Miller County Autogram newspaper, Tuscumbia. Various early issues.

Missouri's Lake of the Ozarks (map and guide). Lake of the Ozarks Assocation. Various editions from 1935 to 1980.

Missouri, The WPA Guide to the "Show Me" State. St. Louis, MO: Missouri Historical Society Press, 1998.

Moreland, Fern. *A History of Camdenton*. Camden County Historian. Camden County Historical Society, 1977.

Moulder, Nelle. *Early Days In Linn Creek*. Camden County Historian. Camden County Historical Society, 1969.

Ross, John H. *Annual Report of the State Game and Fish Commissioner*, Jefferson City, MO, 1932.

Raynor, Tina. *Eldon, Missouri, A Look Back, 1882-1982*. Eldon Centennial, Inc.

Strange, Gaylord. *Dam Site, Missouri. Osage River Country, A History of the People and the Places of Miller County, Missouri*. Jefferson City, MO: Ketch's Printing, 1995.

The History of Ha Ha Tonka. Camden County Historian. Camden County Historical Society, 1985–87.

The Reveille newspaper, Camdenton. Various early issues.

Union Electric Magazine. Union Electric Light and Power Company.

Vacation in the Heart of the Ozarks. Lake of the Ozarks Association, 1939.

Versailles Leader newspaper, Versailles. Various early issues.

White, Mahlon N. *They Call It Truman Dam*, 1975.

Visit us at
arcadiapublishing.com

..

www.ingramcontent.com/pod-product-compliance
Lightning Source LLC
Chambersburg PA
CBHW050645110426
42813CB00007B/1922